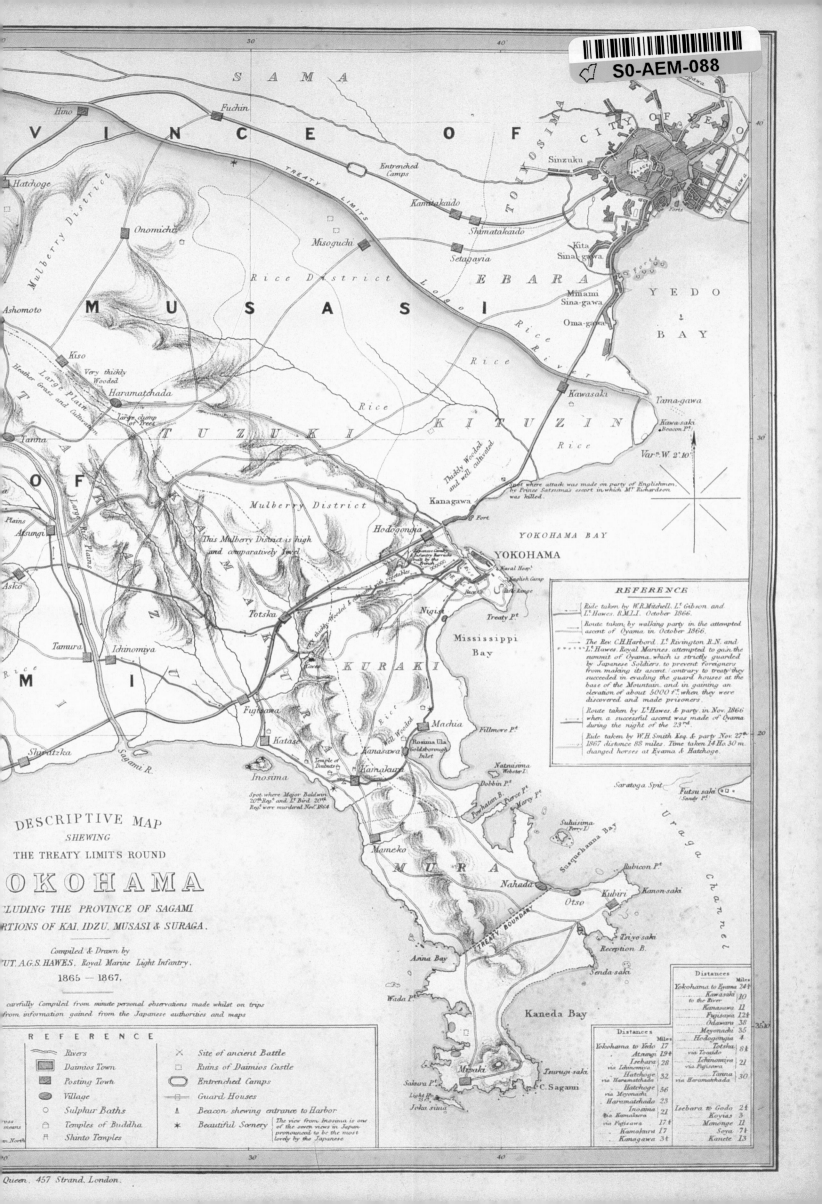

DESCRIPTIVE MAP
SHEWING
THE TREATY LIMITS ROUND
OKOHAMA
CLUDING THE PROVINCE OF SAGAMI
RTIONS OF KAI, IDZU, MUSASI & SURAGA.

Compiled & Drawn by
UT. A.G.S. HAWES, Royal Marine Light Infantry.
1865 — 1867.

carefully Compiled from minute personal observations made whilst on trips
from information gained from the Japanese authorities and maps

REFERENCE

Rivers		×	Site of ancient Battle
Daimios Town		□	Ruins of Daimios Castle
Posting Town			Entrenched Camps
Village			Guard Houses
Sulphur Baths		⚓	Beacon shewing entrance to Harbor
Temples of Buddha		✳	Beautiful Scenery
Shinto Temples			

The view from Inosima is one of the seven views in Japan pronounced to be the most lovely by the Japanese

REFERENCE

Ride taken by W.R.Mitchell, L.t Gibson and L.t Hawes. R.M.L.I. October 1866.

Route taken by walking party in the attempted ascent of Oyama in October 1866.

The Rev.d C.H.Harbord. L.t Rivington R.N. and L.t Hawes. Royal Marines. attempted to gain the summit of Oyama, which is strictly guarded by Japanese Soldiers. to prevent foreigners from making its ascent. contrary to treaty they succeeded in evading the guard houses at the base of the Mountain. and in gaining an elevation of about 5000 f.t when they were discovered. and made prisoners.

Route taken by L.t Hawes. & party in Nov. 1866 when a successful ascent was made of Oyama during the night of the 23.rd

Ride taken by W.H.Smith Esq. & party Nov. 27.th 1867 distance 88 miles. Time taken 14 Ho. 30 m. changed horses at Evama & Hatchoge.

Distances

	Miles
Yokohama to Yedo	17
Atsungi	19½
via Ichinomiya	
Isebara	26
via Ichinomiya	
Hatchoge	32
via Haramatchada	
Hatchoge	36
via Meyonachi	
Haramatchada	23
Inosima	21
via Kamakura	
Fujisawa	17½
via Fujisawa	
Kamakura	17
Kanagawa	3½

Distances

	Miles
Yokohama to Evama	24½
Kawasaki	10
to the River	
Kanasawa	11
Fujisana	12½
Odawara	38
Meyonachi	35
Hodogongia	4
Totska	8½
via Tooaido	
Ichinomiya	21
via Fujisawa	
Tanna	30
via Haramatchada	
Isebara to Godo	2½
Koyas	3
Mononge	11
Soya	7½
Kanete	13

圖 之 見 細

Arthur M. Sackler Gallery
Smithsonian Institution
Washington, D.C.

Ann Yonemura

YOKOHAMA

PRINTS FROM NINETEENTH-CENTURY JAPAN

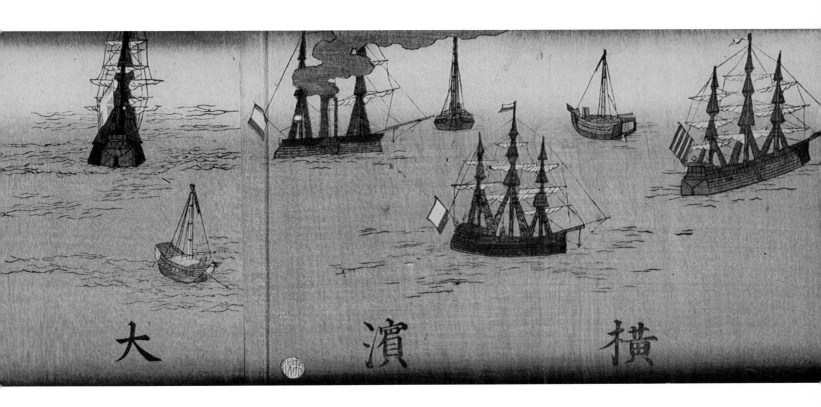

I T IS A SPECIAL honor for the Yamanouchi Pharmaceutical Co., Ltd., to assist the Arthur M. Sackler Gallery of the Smithsonian Institution in presenting the museum's first major exhibition of Japanese art, *Yokohama: Prints from Nineteenth-Century Japan*. Japanese woodblock prints, which have enjoyed appreciation throughout the world, were the first artistic medium to respond to the profound changes affecting Japanese technology, society, and institutions during the years following the opening of Yokohama to international trade in 1859.

To the people of Japan more than one hundred years ago, Yokohama prints provided the first views of the customs and achievements of the technologically advanced nations of the United States and Europe. The colorful prints enhanced Japanese understanding of nations as yet unseen except by a few official travelers.

Woodblock prints also documented Japan's rapid and enthusiastic acceptance of Western technology, especially in the field of transportation. Steam-powered ships of magnificent dimensions dominate prints of Yokohama produced in the early 1860s. From the early Meiji period (1868–1912), prints recorded the swiftly spinning wheels of horse-drawn carriages, omnibuses, streetcars, and jinrikisha, a Japanese invention, all of which replaced, almost overnight, traditional conveyances such as the palanquin. The opening in 1872 of Japan's first railway—between Yokohama and Tokyo—was celebrated by the publication of hundreds of colorful prints. The emperor commemorated that milestone by riding aboard a private rail coach on the inaugural day.

Since 1853, when the American commodore Matthew C. Perry arrived in Japan with his fleet of black ships, the destinies of the United States and Japan have been closely linked. This year we celebrate the 130th anniversary of the first Japanese embassy to the United States. It is especially appropriate that the collection of William and Florence Leonhart, formed during Ambassador Leonhart's diplomatic service in Japan, will open in the capital of the United States and travel to San Francisco and Los Angeles. I can think of no better way to commemorate the enduring and momentous relationship between our two nations, and to foster understanding of our common history.

SHIGEO MORIOKA
Chairman of the Board, President, and Chief Executive Officer
Yamanouchi Pharmaceutical Co., Ltd.
Tokyo, Japan

Copyright © 1990 by Smithsonian
Institution
All rights reserved
Printed in the United States of America

The trade edition of this book is copub-
lished and distributed by the Smithsonian
Institution Press, Washington, D.C.

Exhibition Dates

Arthur M. Sackler Gallery
Smithsonian Institution
Washington, D.C.
May 27–September 9, 1990

Asian Art Museum of San Francisco
October 10–December 9, 1990

Los Angeles County Museum of Art
January 10–March 10, 1991

Prints in the exhibition *Yokohama: Prints
from Nineteenth-Century Japan* are on loan
from the collection of William and Florence
Leonhart of Washington, D.C., with the
participation of the Daval Foundation. The
exhibition is made possible by a generous
grant from the Yamanouchi Pharmaceutical
Co., Ltd. Showings in San Francisco and
Los Angeles also are made possible by the
Yamanouchi Pharmaceutical Co., Ltd., in
collaboration with the Shaklee Corporation.

Cover: Detail, cat. no. 8.

Title page: Detail, cat. no. 5.

Endleaves: *Descriptive Map Shewing* [sic]
the Treaty Limits Round Yokohama, 1867,
by Lieutenant A. G. S. Hawks, Royal Ma-
rine Light Infantry. Yokohama Archives of
History.

Photographic Credits

Freer Gallery of Art, Smithsonian Institu-
tion, Washington, D.C.: fig. 28; Kanagawa
Prefectural Museum, Yokohama: figs. 6, 12,
18, 19, 21, 22, 26, 27, 30, 31; Kobe City Mu-
seum, fig. 23; National Museum of Ameri-
can History, Smithsonian Institution,
Washington, D.C.: fig. 24; The White
House, Washington, D.C.: fig. 3; Yokohama
Archives of History: endleaves, figs. 5, 7,
13–15, 17, 29, 32.

Library of Congress Cataloguing-in-
Publication Data:

Yonemura, Ann, 1947–
Yokohama : prints from nineteenth-
century Japan / Ann Yonemura.
p. cm.
Catalogue of an exhibition held at the Ar-
thur M. Sackler Gallery, the Asian Art Mu-
seum of San Francisco, and the Los Ange-
les County Museum of Art.
Includes bibliographical references.
ISBN 0–87474–993–X (alk. paper).—
ISBN 0–87474–999–9 (pbk. : alk. paper)
1. Color prints, Japanese—Edo period,
1600–1868—Exhibitions. 2. Color prints,
Japanese—Meiji period, 1868–1912—Exhi-
bitions. 3. Yokohama (Japan) in art—Ex-
hibitions. 4. Leonhart, William—Art col-
lections—Exhibitions. 5. Leonhart,
Florence—Art collections—Exhibi-
tions. 6. Color prints—Private collec-
tions—Washington (D.C.)—Exhibi-
tions. I. Arthur M. Sackler Gallery
(Smithsonian Institution) II. Asian Art
Museum of San Francisco. III. Los Ange-
les County Museum of Art. IV. Title.
NE1321.8.Y64 1990
769′.499521364031—dc20 90–9479
 CIP

The paper used in this publication meets
the minimum requirements for the Ameri-
can National Standard for Permanence of
Paper for Printed Library Materials,
Z39.48–1984.

CONTENTS

FOREWORD

AS WE ENTER the last decade of the twentieth century it is sobering to realize how rapidly physical and informational access to diverse parts of the world has changed in the last hundred years. Ever-swifter air travel has overcome the barrier of physical distance, and remote regions can be visited in hours when once weeks and months were the norm. Nearly instantaneous communication across vast expanses has altered the character of modern life as profoundly as the Industrial Revolution affected life in the nineteenth century.

Constant interactions among diverse cultures and regions now daily influence the political, economic, and cultural circumstances of our lives, and certain historical events provide especially rich models for understanding those aspects of the contemporary world. In 1853, Commodore Matthew C. Perry sailed into Edo Bay (modern Tokyo Bay), with the result that Japan abandoned its centuries-long policy of national seclusion. Few events have so substantially touched our world. The reinitiation of active commerce among the most technologically advanced nations precipitated innovations in Japanese politics, society, economics, and technology that continue to evolve and universally transform the fabric of life and foreign relations.

The period immediately following Commodore Perry's voyage is the subject of this exhibition of prints from the collection of William and Florence Leonhart of Washington, D.C. The works, which Ambassador and Mrs. Leonhart assembled during Mr. Leonhart's tours of duty in Japan, illustrate the Japanese response to the new peoples and ideas to which they were introduced in that eventful midcentury era. They also embody the Leonharts' serious interest in Japan and the United States.

It is particularly appropriate that *Yokohama: Prints from Nineteenth-Century Japan* is the first major exhibition of Japanese art at the Arthur M. Sackler Gallery, which has itself benefited substantially from contact with Japan. On 1 May 1979 the Japanese prime minister, the late Masayoshi Ohira, presented to the Smithsonian Institution on behalf of his government a gift of $1 million toward a new museum of Asian art. As the first national contribution for what was to become the Arthur M. Sackler Gallery, that endowment was followed by generous contributions from the Japan Foundation and Japanese corporate and private donors. The Smithsonian Institution remains thankful for those extraordinary gifts.

The Sackler Gallery is indebted to Ambassador and Mrs. Leonhart for so enthusiastically making their collection available for study and exhibition, and to the Daval Foundation for important financial support toward preliminary research. The selection of prints and thematic organization of the exhibition and its catalogue are the skillful work of Ann Yonemura, assistant curator of Japanese art for the Arthur M. Sackler Gallery and the Freer Gallery of Art.

Nineteen-ninety celebrates the 130th anniversary of the arrival in San Francisco of the first Japanese diplomatic mission to the United States. I am therefore especially pleased that *Yokohama: Prints from Nineteenth-Century Japan* will also be shown in California. For those arrangements, I am delighted to thank Rand Castile, director of the Asian Art Museum of San Francisco, and Earl A. Powell III, director of the Los Angeles County Museum of Art.

Notwithstanding all of the generous gifts to the Sackler Gallery, it is the support of the Yamanouchi Pharmaceutical Co., Ltd., and its president, Shigeo Morioka, that has made this exhibition possible. Michael R. Sonnenreich and Masahiro Yamagata have been instrumental in bringing about the successful presentation of the exhibition. On behalf of the Arthur M. Sackler Gallery, I am especially grateful for their beneficent assistance.

MILO CLEVELAND BEACH
Director, Arthur M. Sackler Gallery and Freer Gallery of Art

ACKNOWLEDGMENTS

L IVING IN the midst of a period of rapid social and technological change, where the consequences cannot yet be completely anticipated, we can perhaps appreciate more fully the impact of Japan's abandonment of its official policy of national seclusion following the arrival of the American commodore Matthew C. Perry on Japanese shores in 1853. The drama of Japan's opening to international trade in 1859 and its swift metamorphosis into the first industrialized nation in Asia continues after more than a century to intrigue writers and scholars on both sides of the Pacific. Diplomats, statesmen, travelers, artists, scholars, and writers of poetry and prose have left a rich legacy of literature encompassing the full scope of Japan's modern history as seen from within, and through the eyes of observers from the United States and Europe.

To a great extent, the most important events for directing the general course of modern Japanese history and of Japan's evolution to a status of parity with the most powerful nations of the West were determined within the period encompassed by this exhibition of prints from the collection of William and Florence Leonhart of Washington, D.C. Ambassador Leonhart's interest in Japanese foreign relations, particularly with the United States, was developed during his diplomatic service in Japan. It was Ambassador Leonhart's belief in the ability of Japanese prints to communicate and educate across language barriers in a direct and engaging way that motivated his collecting and convinced him of the importance of sharing his collection with a broad, international audience.

On behalf of the Sackler Gallery, I would like to express special gratitude to the Leonharts for the generous terms by which they have lent their collection of Japanese prints for more than two years to allow for the research and preparation of this exhibition. Equally valuable has been their enthusiastic encouragement of the project, from its inception through its evolution into a more extensive endeavor than was initially envisioned.

The Daval Foundation not only supported my research in Yokohama in 1988 but also made the prints available for exhibition at the Sackler Gallery and two other American museums. I am grateful for that assistance.

Directors Rand Castile of the Asian Art Museum of San Francisco and Earl A. Powell III of the Los Angeles County Museum of Art cooperatively arranged for the Leonhart collection to be shown in California. Curators Yoko Woodson and Yoshiko Kakudo of the Asian Art Museum and Robert Singer of the Los Angeles County Museum have responded with prompt and effective advocacy and guidance for the project. It has been a privilege and pleasure to work with these fine colleagues.

The Yamanouchi Pharmaceutical Co., Ltd., has generously underwritten the cost of the exhibition at all three American museums. For the museums, I would like to express my profound gratitude for the magnanimous interest of the Yamanouchi Co. and its president, Shigeo Morioka.

The catalogue and exhibition have benefited from the generosity and talents of many colleagues and friends. I am deeply indebted to them all. Special thanks are due to Jane McAllister for her thoughtful and unrelenting attention to the text as editor for the catalogue and exhibition; and to Carol Beehler, whose creative talents assured the book's vibrant design. Barbara Brooks devoted her excellent skills

to typing the manuscript and managing many aspects of the project. James Hayden produced the fine photographs of the Leonhart collection. Departmental intern Paul Song and volunteers Marie Deemer, Futoshi Ogo, Mari Shirayama, Keizo Tsutsui, Tomoko Matsuo, and Miki Isome all assisted in assembling files, records, and research materials. Curatorial assistant Lee Bruschke-Johnson provided support in a multitude of tasks. Librarians Lily Kecskes and Kathryn Phillips responded to many requests for interlibrary loan and acquisition of research materials, and Reiko Yoshimura assisted in proofreading Japanese terms. Karen Sagstetter, editor-in-chief, oversaw many administrative details of the catalogue, and Nancy Eickel also was helpful as a proofreader.

Milo C. Beach, director of the Sackler Gallery, and Patrick Sears, assistant director for exhibitions and facilities, have guided the project from its inception. Sarah Newmeyer, assistant director for administration, has overseen many demanding aspects of administration and financial management. Forrest McGill, assistant director for the Sackler Gallery, has been responsible for coordinating the final stages of preparation of the catalogue and exhibition. John Zelenik, Yael Gen, Cornell Evans, Richard Skinner, John Bradley, Jan Mehn, Tom Moriarty, Jeff Baxter, and other members of the staff of the Department of Design and Production have given the installation its distinguished presentation in the Sackler Gallery. Educational programs have been developed by Lucia Pierce and the staff of the Department of Education. With the skilled assistance of Mary Patton, Susan Bliss has ably overseen public relations and press information. Conservation of the prints shown in the exhibition has been the work of Ryo Nishiumi. Sackler Gallery registrars Tom Bower, Emily Dyer, and Bruce Young and collections managers George Rogers and Rocky Korr have devoted many hours to the orderly management of the hundreds of prints.

Many other colleagues have contributed their expertise and advice. I am especially indebted to Yoichi Yokota and Yoshimitsu Iwakabe of the Kanagawa Prefectural Museum (Kanagawa Kenritsu Hakubutsukan) and to Takio Saitoh and Takashi Sato of the Yokohama Archives of History (Yokohama Kaikō Shiryōkan), who took time from their extremely busy schedules to discuss my questions and provide access to research materials and photographs in their collections. Claudia Brush Kidwell, curator for the Division of Costume, National Museum of American History, Smithsonian Institution, provided helpful comments and references regarding the Western garments depicted in the prints in the exhibition. I am also grateful to James Yarnall for sharing his notes on Western descriptions of nineteenth-century Japan. Fred Notehelfer of the University of California, Los Angeles; Julia Meech; and Henry D. Smith II of Columbia University have contributed articles on Yokohama to a special issue of the Sackler Gallery's journal, *Asian Art*. I have benefited greatly from their research and discussions.

The Kanagawa Prefectural Museum, the Kobe City Museum (Kobe Shiritsu Hakubutsukan), the White House, and the Yokohama Archives of History have graciously granted permission to reproduce photographs of materials in their distinguished collections. On behalf of the Sackler Gallery, I would like to thank them for their cooperation.

Research for this catalogue has yielded unexpected insights derived not only from the fresh and engaging responses of Japanese print artists to changing conditions in their world, but also from many

firsthand accounts describing Japan more than a century ago. I am indebted to William and Florence Leonhart for encouraging my research into a complex and critical historical period. Having begun their collection with the goal of enhancing understanding of the history of the United States and Japan, they will, I hope, be pleased that the catalogue and exhibition of their collection have been accomplished through the collaboration of many scholars and institutions in both nations.

Although this book and the exhibition are the cooperative endeavor of many devoted friends and colleagues, I would like to dedicate my work on the project to the memory of my grandmother, Yukiko Yashima Furuta (1895–1989), who followed the course of the *Kanrin Maru* from Japan to California.

ANN YONEMURA
Assistant Curator of Japanese Art, Arthur M. Sackler Gallery and Freer Gallery of Art

A NOTE ON THE COLLECTION AND ITS ORIGINS

MY WIFE and I are happy to offer for exhibition these mid-nineteenth-century Japanese prints and drawings that celebrate the emergence of Japan from two-and-one-half centuries of splendid isolation under the Tokugawa shogunate (1603–1867). Depicting the early Americans and other foreigners who followed them to the settlements in Japan to live and work, the prints mark the origins of the extraordinary release of Japanese energies that continue to transform both Japan and the United States.

The prints reveal a unique art, which with strong painterly virtues, economy of line, decorative balance, and vividly juxtaposed colors invests the events of their period with spirit, humor, and zest. Their idiom captures a special international moment, at once deeply unsettling and profoundly invigorating as the Edo period (1615–1868) drew to its close. Japanese printmakers aspired to satisfy their countrymen's omnivorous curiosity about the foreigners who had suddenly and unceremoniously arrived in mysterious and powerful black ships, with alien but ingenious articles to sell, unknown languages, exotic manners, and peculiar customs. Theirs was a form that served one of art's oldest and most basic purposes—to teach people how to cope with a wholly new situation.

The art commemorates a notable series of swiftly moving events: the 1853 and 1854 expeditions of the bluff, imperiously intrepid Commodore Matthew C. Perry, the legends of those famed black ships, and the opening of Japan. The Treaty of Peace and Amity that Perry negotiated in 1854 unlocked the ports of Shimoda and Hakodate; provided for United States diplomatic representation; and led to the arrival in 1856 of an experienced American diplomat, Townsend Harris. After two frustrating years at Shimoda, Harris forged in 1858 the Treaty of Amity and Commerce (Harris Treaty), which broadened diplomatic, consular, religious, and commercial privileges, and opened four additional ports—at Kanagawa (which was replaced by Yokohama), Hyogo (modern Kobe), Nagasaki, and Niigata.

Shortly thereafter, in the spectacular visit in 1860 of the first Japanese embassy to the United States, which was headed by three ambassadors with a retinue of seventy-seven officials, a letter from the shogun was delivered to President James Buchanan and treaty ratifications were exchanged. When the embassy toured San Francisco, Washington, D.C., Baltimore, Philadelphia, and New York, it received tumultuous welcomes everywhere, moving Walt Whitman to compose a special poem, "The Errand-Bearers," in its honor. The embassy circumnavigated the globe via the Cape of Good Hope, then returned to Japan at the end of the year.[1] Less than a decade later Japan vaulted into the modern world—inspiring the production of prints on the settlements, trade, recreations, civic rituals, and combined parades of the five treaty nations—and set the origins of a new Pacific age.

The collection stems chiefly from my two diplomatic postings in Tokyo, where under four extraordinarily able but remarkably different ambassadors,[2] I served as first secretary of the original postwar American embassy to Japan (1951–55) and, after intervening tours in Washington and London, as United States minister, deputy chief of mission, and occasional chargé d'affaires (1958–62).[3] The prints my wife and I originally acquired were no doubt influenced by those circumstances: they mark a sense of fresh

Figure 1 *Steamship*, ca. 1854, anonymous. Woodblock print; ink on paper. Collection of William and Florence Leonhart. Perry's black ships inspired numerous Japanese sketches and prints. This print probably depicts the United States steam frigate *Powhatan*. The inscription describes the dimensions of the ship and the number of crew (350). Names of Japanese officials are listed above.

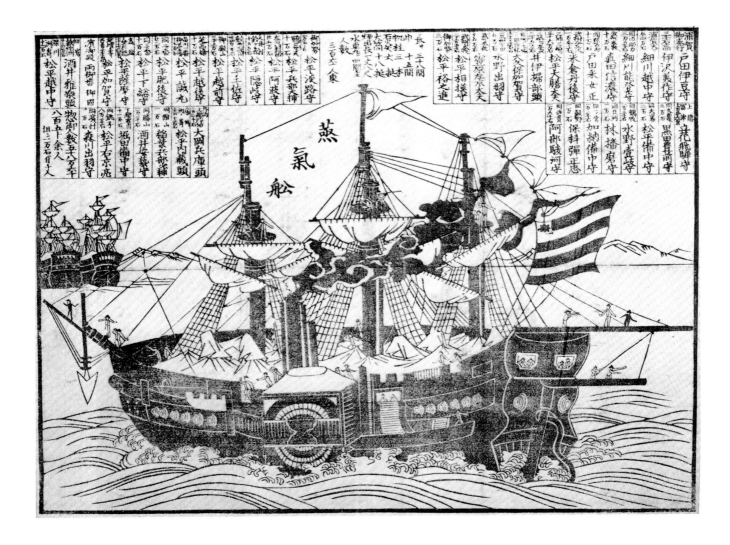

beginnings in the relationship between Japan and the United States, and on a personal level reflect the professional preoccupations of a career diplomat. We have found the appeal of the prints fresh, durable, and potent, and have continued to collect them for almost forty years in a dozen countries.

The combination of their visual sensibility and historical drama prompted me, during both of my Tokyo tours, to install a few of the prints in my chancery offices. The embassy's main concern throughout my tenure was to facilitate a durable adjustment by both Americans and Japanese to the new realities of Japan's regained sovereignty. It was an unusually creative time, which witnessed the immediate phasing out of Occupation forms and institutions and the innumerable transitions to full and equal cooperation. The work involved the complexities of revising the Security Treaty and the Status of Forces Agreement[4]; settling postwar obligations; exploring Okinawa reform and reversion; creating the United States–Japan Friendship Commission; establishing binational committees for trade and economic affairs, science and technology, and cultural and educational exchange; and attending to a host of lesser concerns that helped form a style and practice for the new bilateral relationship. The American side quickly acquired an enormous respect for the quality, vision, and resourcefulness of its negotiating

partners. By the end of that period the great building blocks of our modern relations had been set in place.

Apart from aesthetic vitality, the prints invoke the historical origins of a relationship that today is at the center of the world's mainstream. As we negotiated its evolutions, I convened many working sessions beneath the genial presence of the prints—hopeful that their irrepressible good humor might lend a moderating perspective, a sense of long-term relationships, and a quiet toleration of the occasional asperities of daily business as we sought to create new institutions appropriate to new situations. The prints cast their special reflections on our discussions, informing us with their wisdom and helping both sides successfully cope with the process of resolving unprecedented problems in a formative period.

Then and since, my wife and I have found unexpected values and insights in the prints. Perhaps foreshadowing the negotiations that would follow one hundred years later, their depiction of the rapidity of change in nineteenth-century Japan suggests that there had developed—even in that time of early origins and despite its fluctuations—a symmetry of interest between the two countries. The centuries of Tokugawa seclusion had been interrupted only by Spanish and Portuguese missionaries and traders, the persistence of a small Dutch window at Deshima (home to representatives of the Dutch East India Company), and sporadic but abortive visits by American, British, and Russian vessels. It would be a mistake, I think, to overestimate the American or Western role. New societal forces—the rise of a merchant class, an increasing recognition of the desirability of change, and a gathering readiness for broader international contact—had evidently begun to develop. Perry, Harris, and the treaty nations were perhaps quickening agents, but the extraordinary sweep and pace of the Meiji transformations of 1868 through 1912 as memorialized in the prints clearly indicate that powerful, influential, and indispensable stirrings were already at play inside Japan.

The prints illustrate not only the astonishing velocity of Japan's completion of its own industrial revolution but also the main vectors of its development. The portraiture moves from Kaei (1848–53) and Ansei (1854–59) times, with their monochromatic prints of the first foreign merchant ships and announcements of the availability of foreign goods (see fig. 2), to a consumer galaxy of imported sewing machines, watches, household appliances, musical instruments, and military materiel, and eventually to the applications of steam and transportation. For the Japanese, payments in gold, raw silks, tea, and handcrafts were the currency of trade.

On the theme of transportation the attention of the woodblock artists raced from ships to rail and from bicycles to balloons. The Japanese mission to the United States saw its first balloon demonstrations in Philadelphia in 1860; less than twelve years later the first Japanese balloons were launched in the Tsukiji district in Tokyo. Ships and railroads quickly became the chief focus of the printmakers' attraction. Their works covered ships of all sorts—sail, steam, sail-and-steam, merchant, and naval—including the interiors, exteriors, and fittings as well as naval drills and practices. The first commercial railroad opened in 1872 between Yokohama and the Shimbashi district in Tokyo; having thirty-odd kilometers of track and taking one hour in passage, it was designed by Americans but built by the

Figure 2 *Site for Trade at Kanagawa on the Tōkaidō*, 1859, anonymous. Woodblock print; ink on paper. Collection of William and Florence Leonhart. The opening of Kanagawa was announced throughout Japan by handbills such as this, which was published in the first month of 1859, well in advance of the opening date set by the treaties with the Five Nations. Without official announcement or notice to American and European diplomats, Yokohama was substituted for Kanagawa before the opening in July 1859.

British when the energies of the United States were diverted during the Civil War. Perry's gift of a quarter-scale miniature railway, complete with tender, passenger car, and 370 feet of track, led directly to Japan's first railway in the Yokohama prints and, in our time, to Japan's famed Bullet trains.

Yokohama became a microcosm of Japanese modernization. When it was officially opened to international trade in 1859, it was a collection of fishing huts, hemmed in by swamps and tidal creeks, advantaged only by an excellent harbor. Not even a generation later it had become an important commercial metropolis with a population of more than one hundred thousand. A thriving foreign settlement, it proliferated with banks, churches, a chamber of commerce, and such worldly institutions as a racetrack, a circus, and English-language newspapers, including *Japan Punch*. The printmakers reveled in the city's growth, and left as a special legacy a breathtaking series of Yokohama maps that are masterworks of cartographic artistry.

Supplementing their kaleidoscopes of modernization, the prints make extraordinary use of informational imagery. Often the printmakers inserted ornamental tablets that set out in the calligraphy of the day brief histories of the countries whose citizens or scenes are depicted, descriptions of foreign customs or observances, foreign-language vocabulary drills, explanations of the mechanics of the manufactures displayed, naval or ordnance specifications, and the like. What my wife and I have dubbed the "Inventors' Series" (see cat. nos. 72–75) is particularly notable for its tutorial substance, addressed

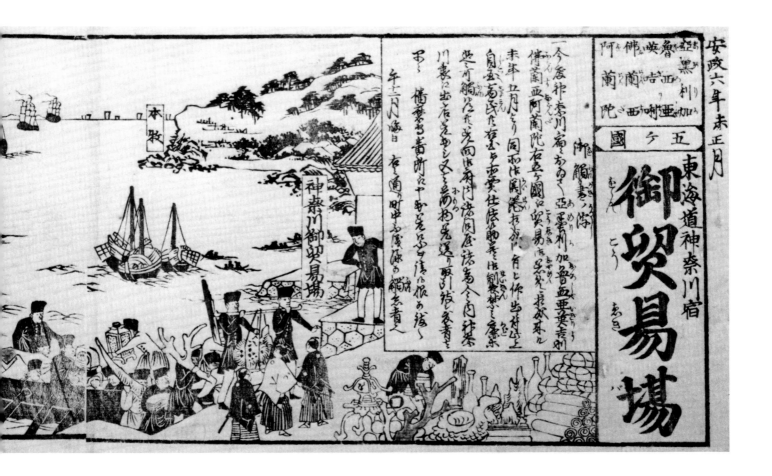

to a wide Japanese public, on Western scientists and their technological discoveries. I am not at all certain that we have found a better way today to transfer across different cultures language, technology, and descriptive information.

My wife and I are particularly grateful to Ann Yonemura for the care she has taken to make these inscriptions available to a generation that finds the cursive Edo script unfamiliar. For perhaps the first time in the United States, the prints are accessible to Western eyes as their Japanese contemporaries originally saw them.

The prints comprise an extraordinary art form, greater and more beguiling than the sum of their parts. They should be seen whole and entire. After examining their intricate detail, one should return to the prints themselves to enjoy the total impression. The polychromatic prints, called *nishiki-e*—many from ten or more color blocks—were a collaborative art, the product of a division of labor among artist, woodcarver, and publisher. Whether their products are in the classical sense fine art—it is no doubt entirely possible to overstate any claims—they have an enduring hold upon our admiration and affection. An enormously popular art, mass-produced and designed for an emerging middle-class, they celebrated a rising democracy, illustrated women in new and independent roles outside their homes, and influenced and altered public attitudes in Japan about the outside world and about Japan itself.

This exhibition presents about one-third of the collection and encompasses the main period,

themes, and acknowledged masters: Sadahide (1807–ca. 1878), Hiroshige II (1826–1869), Yoshifuji (1828–1887), Yoshiiku (1833–1904), Yoshimori (1838–1884), Hiroshige III (1842–1894), and Yoshitora and Yoshikazu, whose lifedates are not precisely known. These eight of the fifty or so artists and sixty publishers represented in our collection, as prolific as they were talented, account for about three-fourths of the universe of Yokohama prints.

In the period of this early flowering, the contemporary encounter of Japan and America was joined and both countries were forever changed. In the process neither country was then, nor is now, wholly a creditor nor wholly a debtor. The Yokohama printmasters left indelible signatures on their times by their vigor, imagination, and singular artistry. They remind us that history is made by men and women from all walks of life who are present during times of astonishing change. The origins of the events the prints depict have become, for our generation, origins not only of our past but also of our future.

WILLIAM LEONHART
United States Ambassador (Ret.)

1. The formal presentation of Chief Ambassador Shimmi Buzen-no-Kami Masaoki and vice-ambassadors Muragaki Awaji-no-Kami Norimasa and Oguri Bungo-no-Kami Tadamasa to President Buchanan at the White House on 25 May 1860 marked the first accreditation of Japanese envoys abroad.

In succeeding years the Tokugawa government dispatched a number of other Japanese embassies: in 1862 to England, France, Holland, Prussia, Russia, and Portugal; in 1864 to the United States; in 1865 to France; in 1866 to Russia; and in 1867 to Europe. The aim was to cultivate broader relationships and generalize the provisions of the Harris Treaty. The nationals of those countries, resident in Yokohama and the other treaty ports of Japan, constitute in the main the population of the collection's prints.

2. The United States embassy in Tokyo was reestablished on 28 April 1952 with Ambassador Robert D. Murphy in charge, pending presentation of his credentials, which occurred 9 May of that year. Ambassador Murphy served as chief of mission until 28 April 1953, and was succeeded by Ambassador John M. Allison, who served from 28 May 1953 to 2 February 1957. The tour of Ambassador Douglas MacArthur II as chief of mission extended from 25 February 1957 to 12 March 1961. Ambassador MacArthur's appointment was followed by that of Ambassador Edwin O. Reischauer, who served from 27 April 1961 to 19 August 1966.

3. The precise tours of duty in Japan were 7 September 1951 to 17 January 1955, and 3 December 1958 to 16 July 1962.

4. Formally titled the Treaty of Mutual Cooperation and Security between Japan and the United States of America, and the Status of Forces Agreement under Article Six of the Treaty of Mutual Cooperation and Security between Japan and the United States of America, both were concluded on 23 June 1960.

THE HISTORICAL SETTING

FEW EVENTS have had such consequence for the course of modern Japanese history as the arrival of the black ships of the American commodore Matthew Calbraith Perry (1794–1858) at Uraga in 1853. Motivated by the mercantile ambition of the United States, which had expanded its territory to the Pacific with the acquisition of California from Mexico in 1848, President Millard Fillmore (1800–1874) sent Perry to compel Japan to enter into negotiations for commercial relations with the United States. A treaty with Japan was expected to promote American interests in the lucrative China trade, which was already well-established along an eastbound route requiring some ten months for a round-trip. In contrast, the transpacific shipping route from San Francisco to China was expected to require only twenty days by steamer.[1]

At the time of Perry's arrival the emperor of Japan resided in Kyoto, whereas the government of the Tokugawa shogun, which controlled the administration of the country, presided at Edo (modern Tokyo). Japan was divided into domains (*han*), each ruled by a daimyo who was supported by an army of samurai. Although the nation had been at peace for nearly two-and-one-half centuries, the shogun's government (shogunate, or *bakufu*) was by 1850 in a weakened financial status and faced with increasing difficulties in controlling powerful and wealthy opponents among the daimyo.

In accordance with the official title *seii tai shōgun* (barbarian-subduing general) conferred by the emperor upon Tokugawa Ieyasu (1542–1616), the shogun's successors had established a policy of national seclusion (*sakoku seisaku*), which was to remain in force from 1639 until the Treaty of Kanagawa of 1854. European access to Japan, which had begun with the arrival of the Portuguese in 1542, was thus severely restricted for more than two centuries, during which time foreign commerce in Japan was limited to the Dutch and Chinese merchants who traded at Nagasaki and the Koreans at Tsushima. Japanese ships, except for those from the domains of Satsuma and Tsushima, which were permitted to trade with the Ryukyu kingdom (modern Okinawa) and Korea, were not allowed to leave Japanese shores, and Japanese were strictly forbidden to travel abroad.

The Netherlands was the only European nation to maintain its trade relations with Japan throughout the Edo period (1615–1868). Although the Dutch were confined to the island of Deshima in Nagasaki harbor, they maintained an active and profitable trade from the isolated outpost. From the standpoint of Japanese cultural history the Dutch presence at Nagasaki also kept a window open to Western scientific studies and technology during the long period of national seclusion. *Rangaku*, or Dutch learning, became a term for all Western studies. Western knowledge of astronomy, linear perspective, cartography, medicine, the physical sciences, and botany came to Japan through the books brought by Dutch traders. Even before Perry's abrupt incursion into Edo Bay in 1853, exposure to Dutch learning had prompted some Japanese leaders to advocate the adoption of Western technology, especially for military and naval equipment, areas in which the West was clearly superior.

On his second visit to Japan, in 1854, Perry successfully negotiated the Treaty of Kanagawa. Officially titled the Treaty of Peace and Amity between the United States and the Empire of Japan (Nichi-

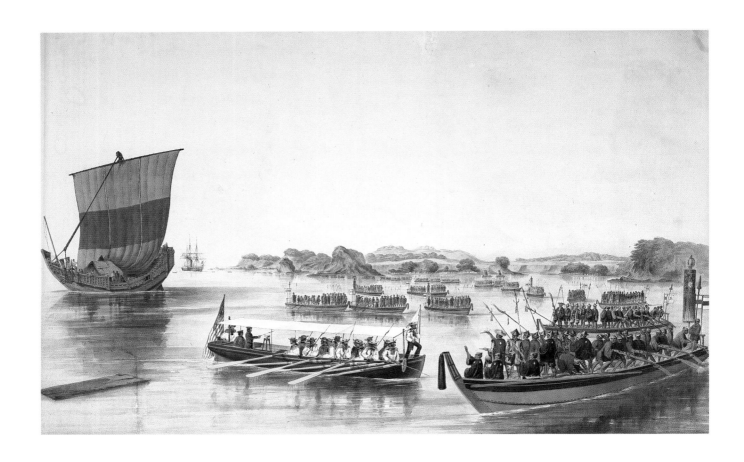

Figure 3 *Passing the Rubicon,* 1855, lithograph after a watercolor by Peter Bernhard William Heine (1827–1885). The White House, Washington, D.C. William Heine, born in Germany, was an artist and photographer for the Perry expedition. This lithograph is one of five published in 1855 after watercolors by Heine. The original painting, dated 11 July 1853, depicts Lieutenant Silas Bent's survey cutter in Edo Bay as it approaches numerous Japanese ships manned with armed guards.

Bei Washin Jōyaku), the treaty provided for limited landing rights for American ships and a diplomatic residence at Shimoda. Two years later American diplomat Townsend Harris (1804–1878) arrived with his Dutch interpreter, Henry Heusken (1832–1861), to negotiate a commercial treaty on behalf of the United States. The United States–Japan Treaty of Amity and Commerce (Nichi-Bei Shūkō Tsūshō Jōyaku), concluded in 1858, provided for the opening in July 1859 of the treaty ports Nagasaki and Kanagawa, the functions of which were relocated by Japanese officials, without notice to Harris and other diplomats, to nearby Yokohama.

By the autumn of 1858 four European nations—England, France, Russia, and the Netherlands—had followed the young United States in concluding similar commercial treaties with Japan, collectively referred to as the Ansei Treaties. The Five Nations, as they were known, became the focus of intense interest throughout the country. Through broadsides and Japanese translations of the treaty texts, news of the abrupt reversal of official policy was disseminated from Edo, the site of the shogun's castle. Francis Hall, an American merchant who had arrived in Yokohama in November 1859, wrote in his journal the following May:

> Sadajirō [a merchant friend] brought me today copies in Japanese of the treaties with the Americans, English, French, Russians and Dutch. They are in five books, were originally sold for one

ichibu for the whole five, but the sale of them has been so large that the lot are sold for the insignificant price of half an ichibu. They are scattered all over the kingdom and generally used. The same treaties, it is safe to say, are not half so well known at home.[2]

In 1860, less than one year after the opening of Yokohama, the Tokugawa shogunate sent its first embassy to the United States. The embassy's principal mission was to present the treaty of 1858 for ratification to President James Buchanan (1791–1868). On their tour of the vast and unknown nation referred to in Japan as Amerika, the men selected for that historic journey became the first Japanese to travel abroad with official endorsement in more than two centuries.[3] In America the ambassadors were greeted with parades, receptions, and demonstrations of American technology.

Despite such diplomatic achievements abroad, the Tokugawa government was ill-prepared for the domestic political and economic consequences of its change of policy regarding foreign relations. Perry's departure from Japan in 1853 with a declaration that he would return one year later with an extended naval force provoked intense debate within Japan and consolidated political opponents of the weakening shogunate over the issue of foreign policy. Clearly, the shogun and his advisers had recognized the implicit threat posed by the superior naval forces of the United States and major powers of Europe, many of which had been exerting intermittent pressure for landing rights in Japan since the early nineteenth century. After two-and-one-half centuries of peace the Tokugawa government was neither militarily nor financially prepared to risk combat against Western warships.

Inflation and economic duress caused in part by the increased demand by foreign merchants for commodities with a significant domestic market, such as raw silk and tea, aggravated the economic hardship and unrest among Japanese commoners that had already begun to threaten the stability of Tokugawa rule; internal political conflict over the end of national seclusion intensified and was exacerbated after the first commercial treaties were concluded in 1858. It was not until the last shogun, Tokugawa Keiki (Yoshinobu, 1837–1913), resigned in 1867 that tensions abated. The officials of the shogunate had not clearly understood the long-term implications of certain provisions of the Western treaties, such as extraterritorial jurisdiction and extremely low fixed-rate tariffs that had no limitations on their duration. Both extraterritoriality and the tariffs, which remained at 5 percent for most imports, proved to be politically sensitive issues not only for the weakening shogunate but also for the new government of the Meiji emperor after 1868.[4]

The shogunate also faced conflicts with the foreign diplomats and residents of the new treaty ports, especially in Yokohama. The shift of the harbor facilities from Kanagawa, the site stipulated in the commercial treaties, to Yokohama around 1858–59 was a decision the shogunate made without the approval of the official representatives of the Five Nations; it inevitably provoked friction between Western diplomats and the officials of the shogunate. For the Western merchants the site of Yokohama was more favorable than Kanagawa, however, and their acceptance of the relocation presented their diplomatic representatives with a fait accompli. Despite early problems, including more than one destructive fire, Yokohama grew steadily in population and commercial prominence. As the principal point

Figure 4 *Procession of the Dutch to Edo*, Edo period, early nineteenth century. Woodblock print; ink and color on paper. Collection of William and Florence Leonhart. Like the Japanese daimyo, lords of provincial domains throughout Japan, the Dutch merchants who were permitted to reside on the island of Deshima in Nagasaki harbor were required to journey to Edo to pay homage to the shogun. Initially an annual requirement, the Dutch processions to Edo became less frequent during the eighteenth century.

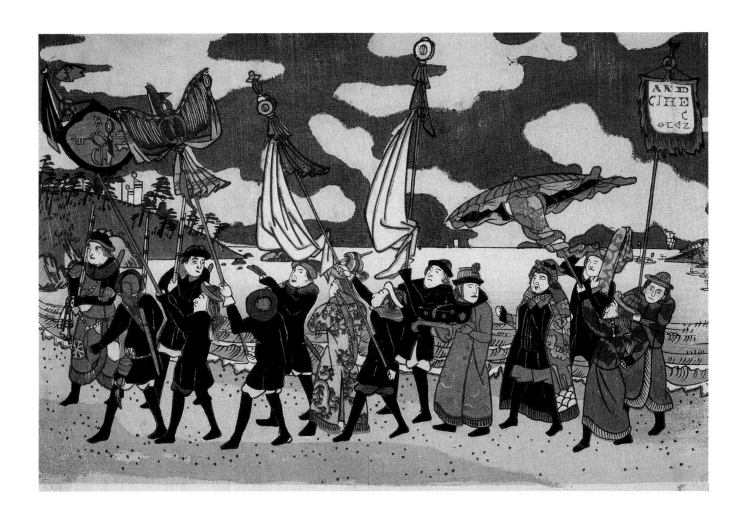

of entry for Western technology, which became increasingly important after the fall of the Tokugawa shogunate in 1867, and with its strategic location near Edo (renamed Tokyo in 1868), Yokohama had a critical role in the diffusion of Western technology and culture beginning in the 1860s.[5]

It is difficult today to appreciate fully the problems that beset both Japanese and Western merchants in the period immediately following the opening of Yokohama, which owing to its favorable location near the shogun's castle quickly overtook Nagasaki as Japan's major port of international trade. That status is maintained today. Neither the foreigners nor the Japanese were prepared for the vast differences of languages and customs that confronted them upon the port's opening. In 1859 the only Western language in use in Japan was Dutch, and that was chiefly for diplomatic and limited scholarly purposes. Negotiations for the United States–Japan commercial treaty of 1858 and the earlier Treaty of Kanagawa (1854), which provided for a diplomatic residence at Shimoda, were conducted in Dutch by interpreters for each side. Competent Dutch interpreters were in such demand that United States Consul General Townsend Harris, as a gesture of goodwill, offered the services of his Dutch interpreter, Henry Heusken, to Sir Rutherford Alcock (1809–1897), who arrived in June 1859 as the British consul general and soon became the British minister. The merchants who rushed to Yokohama on news of the opening of the port initially depended on Chinese employees who could read and write characters intel-

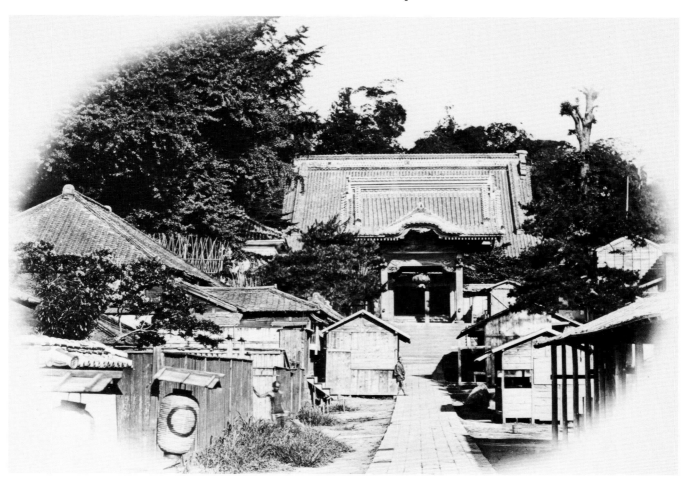

Figure 5 Entrance to the United States legation at the Zempukuji temple in Edo. Photograph by Felice Beato (ca. 1825–ca. 1908). Yokohama Archives of History. The official legations of the United States and other treaty nations were initially housed in Buddhist temples, which provided relatively spacious rooms suitable for Western furniture and walled compounds for better security. Townsend Harris and his Dutch interpreter, Henry Heusken, resided at the Zempukuji temple after journeying by palanquin from distant Shimoda, their first place of residence in Japan.

ligible to the Japanese, on sign language, and eventually on a crude form of pidgin Japanese that evolved within the treaty ports for the conduct of business transactions. The first Japanese-English dictionary was completed in 1867 by James Curtis Hepburn (1815–1911), an American missionary.

The Western residents of Yokohama were at first forbidden to travel more than twenty-five miles from the town, except in the direction of Edo, where they could proceed only with a diplomatic passport.[6] Officials of the shogunate, aware of the intense opposition among some daimyo and samurai to their decision to relax their prohibitions against foreign residents, feared confrontation between the foreigners and hostile members of the armed warrior class: for Japanese of the upper classes, particularly the ruling military class of samurai and daimyo, the decision of the shogunate to encourage commerce by allowing foreigners to reside in Japan was viewed with ambivalence and by some factions with extreme animosity.

Although many early visitors and residents of Yokohama relate stories of the Japanese commoners' friendly curiosity and interest in the novel appearance, mode of dress, and customs of foreigners, the fears of the Japanese officials for the foreigners' safety were not unfounded. Even the Japanese residents of Edo felt uneasy about the unpredictable behavior of the large numbers of sword-bearing samurai who resided in the city. Antiforeign incidents, ranging from rock throwing and harassment to

Figure 6 *Reception of the Japanese Ambassadors by the President of the United States, in the East Room of the White House, at Washington, on Thursday, May 17.* Illustration from *Frank Leslie's Illustrated Newspaper*, 1860. *Frank Leslie's* illustrated in detail the embassy of 1860, the first Japanese diplomatic envoy to the United States. The newspaper's illustrations were studied and copied by Japanese print artists.

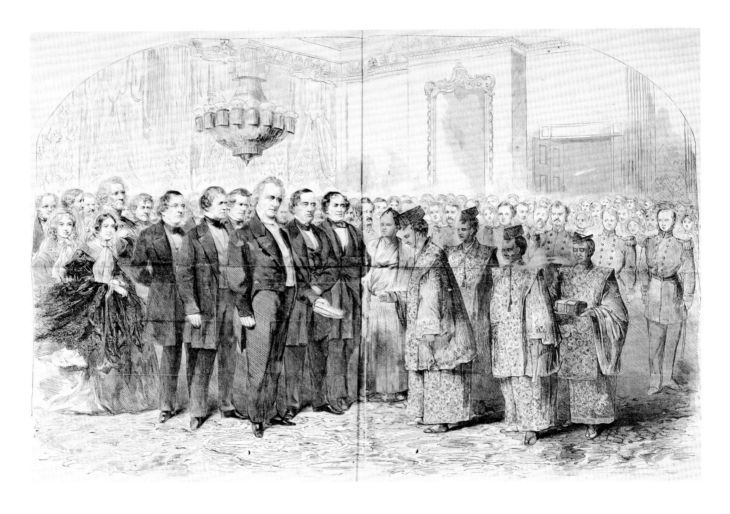

attacks and even murder by samurai, spread tension in the foreign community of Japan and complicated internal and external politics and diplomacy.

The victims of antiforeign attacks were not limited to foreigners but included prominent opponents of the seclusion policy, such as Ii Naosuke (1815–1860), who played an important role in concluding the United States–Japan Treaty of Amity and Commerce of 1858. Daimyo of the Hikone domain, and serving in the influential national office of regent (*tairō*), Ii was assassinated in Edo by samurai from the Mito and Satsuma domains in 1860, just as the first Japanese ambassadors to the United States were voyaging across the Pacific toward California.

The Namamugi Incident (Namamugi Jiken) of September 1862, that is, the murder of British merchant Charles Richardson at a site along the Tōkaidō across the bay from Yokohama, was apparently precipitated when Richardson and two companions rode their horses into the procession of the powerful daimyo of the Satsuma domain in Kyushu. More than any previous antiforeign incident, the fatal attack of Richardson, a merchant who had no official status, inflamed the foreign community of Yokohama and precipitated a British naval attack the following year against the Satsuma fleet in Kagoshima Bay. After resolution of the incident, relations between Satsuma and Britain became close, however, and the two

sides allied themselves against the shogunate during the struggles that culminated in the Meiji Restoration of 1868.

The political, economic, and social repercussions that followed the decision of the Tokugawa shogunate to open Japan to international trade created conditions that accelerated the changes that were already affecting many aspects of Japanese society, technology, and institutions. In previous periods of rapid technological and institutional change, Japan's neighbors, China and Korea, had provided structures to emulate, and even technical expertise. For the first time in Japanese history the models associated with the broad quest for modernization lay outside East Asia. With the coming of the Five Nations to Japan, the United States and Europe offered archetypes for modernization that extended far beyond the obvious benefits of commercial expansion.

Transformation of the whole social and political order of Japan followed within less than a decade after the opening of Yokohama. The restoration of direct imperial rule brought to an end more than six centuries of civil government by the warrior class. Policy under the Emperor Meiji (1852–1912; r. 1867–1912) gave official sanction to modernization of Japanese institutions, industry, education, and com-

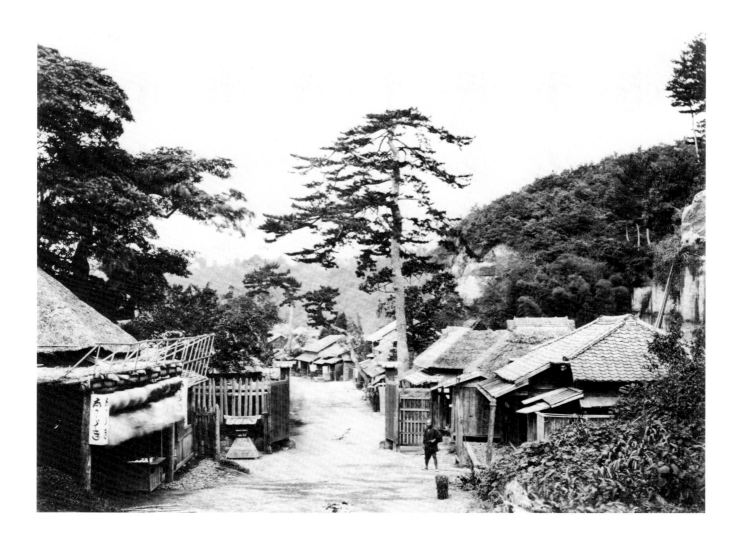

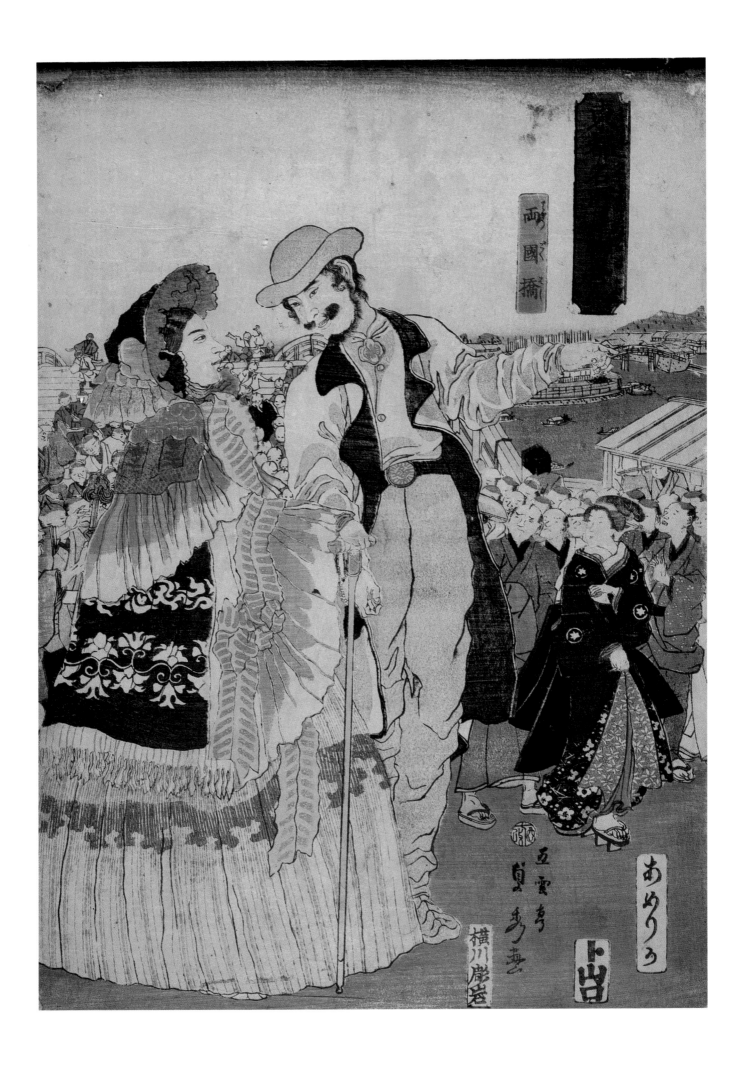

merce along Western forms. Yokohama and Tokyo (formerly Edo), where the emperor moved his residence from Kyoto in 1869, played crucial roles in Japan's astonishingly swift metamorphosis from a feudal state to a modern industrial nation.

1. M. Paske-Smith, *Western Barbarians in Japan and Formosa in Tokugawa Days, 1603–1868* (Kobe: J. L. Thompson, 1930), 135.

2. Francis Hall, "Journal," 2 May 1860, quotation from Fred G. Notehelfer, "Before the Restoration: Francis Hall's Description of Bakumatsu Japan," *Zinbun: Memoirs of the Research Institute for Humanistic Studies, Kyoto University*, no. 21 (1986): 9.

3. See Masao Miyoshi, *As We Saw Them: The First Japanese Embassy to the United States (1860)* (Berkeley: University of California Press, 1979).

4. Negotiations for revision of the commercial treaties (*jōyaku kaisei*) succeeded in abolishing extraterritoriality in 1899 and establishing tariff autonomy in 1911.

5. H. D. Smith II, "Edo-Tokyo Transition: In Search of a Common Ground," in Marius B. Jansen and Gilbert Rozman, eds., *Japan in Transition: From Tokugawa to Meiji* (Princeton: Princeton University Press, 1986), 354.

6. See this book's endleaves for a map showing the treaty limits.

Figure 8 *Foreigners Viewing the Famous Sites of Edo: Americans at Ryōgoku*, 1861, by Sadahide (1807–ca. 1878). Woodblock print; ink and color on paper. Collection of William and Florence Leonhart. In comparison to Yokohama, Edo, a metropolis with a population of approximately one million, had few foreign residents. Ryōgoku, the location of a heavily traveled bridge across the Sumida River, was the site of popular entertainments, including sideshows and fireworks.

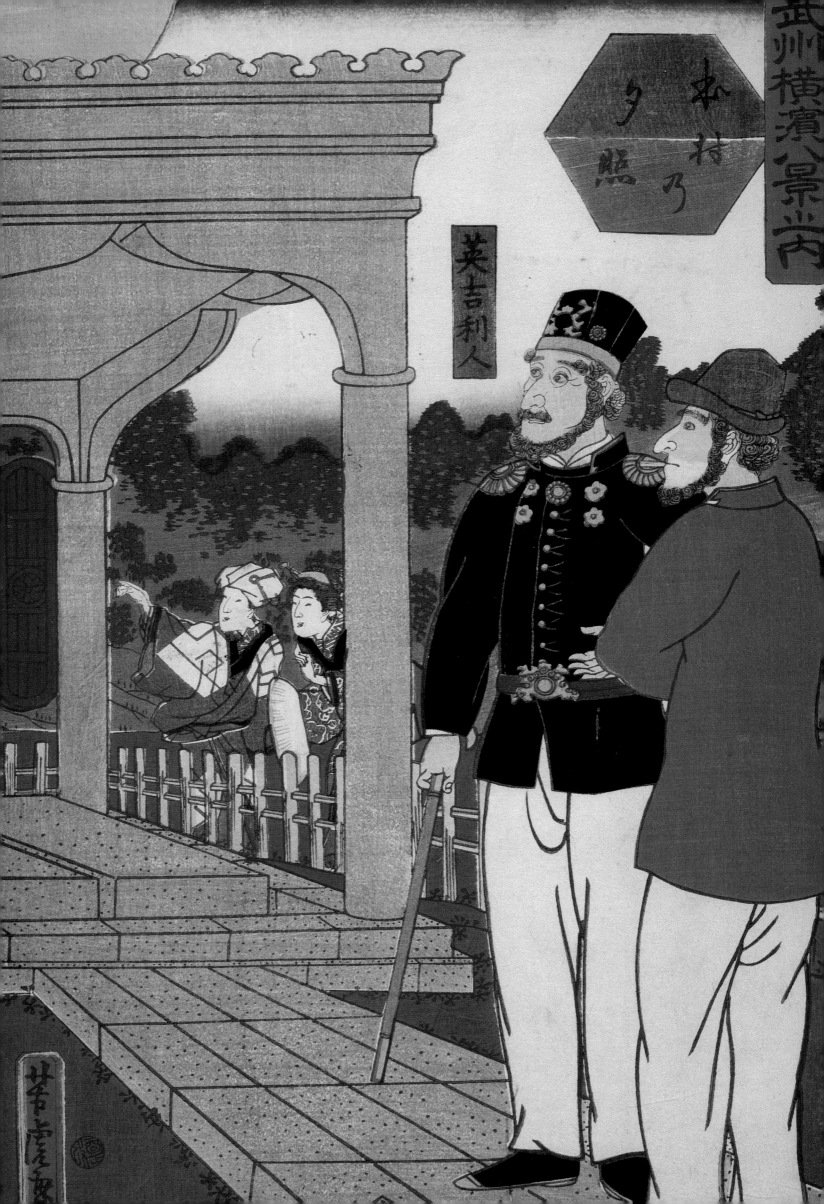

YOKOHAMA PRINTS

THE OPENING of Yokohama to trade through the treaties negotiated between Japan and the United States, Great Britain, France, Russia, and the Netherlands was an event of great interest to the publishers of popular woodblock prints in the nearby metropolis of Edo (modern Tokyo). The term *Yokohama prints* refers broadly to prints depicting Yokohama and its first foreign residents from 1859 to the 1870s, when Japan's first railway was built to link Yokohama with Tokyo. By extension a few additional themes inspired by the foreign settlement at Yokohama, such as imaginary views of foreign countries, are encompassed by the same term, even though such prints do not specifically depict Yokohama. Having perfected their techniques of multicolor printing by 1765, Japanese print publishers continuously competed to employ talented artists and present themes that were novel and current. Their prints were sold in bookstalls and even by itinerant vendors for nominal prices.

The technical production of the woodblock print was relatively efficient for a hand-printing process. Block carvers and printers worked under the supervision of a publisher who coordinated all aspects of the production of an edition of prints from an artist's sketch. Working quickly by placing dampened paper facedown on a carved block brushed with water-soluble ink or color, the printer would firmly rub the back of the paper with a smooth and slightly resilient tool known as the *baren*. The process would be repeated in succession for the key-block (outline) design and for each color. A workshop could produce two hundred or more single-sheet prints in a day.

By the mid-nineteenth century, prints were frequently issued in series of up to one hundred images based on themes such as "Fifty-Three Stations of the Tōkaidō" or views of Mount Fuji, perennial favorites of Japanese and later of Western collectors of Japanese prints. Formats could be enlarged by designing an image for two or more approximately standard-size sheets (*ōban*), which were printed separately, usually without blank borders, and arranged to overlap slightly at one edge to form a single image. That method of producing diptychs, triptychs, pentaptychs, and occasional larger compositions was more efficient than carving the entire design on a larger set of blocks, since it minimized problems of warpage, uniform inking of the blocks, moisture control, and registration.

To complement the theme of the people of the Five Nations, Yokohama prints were frequently published in sets of five, one for each of the treaty nations, or occasionally of six with the addition of China. Although China had no official treaty with Japan, Chinese merchants formed a prominent and indispensable community within Yokohama. The opening of Yokohama seems to have inspired some artists and publishers to produce works of novel dimensions that would draw attention to the uncommon subject matter.

The evidence provided by the prints themselves indicates that Yokohama prints must have been extremely popular, particularly during the first two years after the port's opening: more than five hundred separate designs by thirty-one artists were issued by fifty or more publishers from 1859 to 1862.[1] Moreover, many of the surviving works show signs of having been printed from excessively worn blocks or of hasty printing and coloring that must have resulted from the rush by publishers to meet the high

Figure 9 (page 30) *Eight Views of Yokohama in Bushū (Modern Musashi Province): Evening Glow at Honmura,* 1861, by Yoshitora (fl. ca. 1850–80). Woodblock print; ink and color on paper. Collection of William and Florence Leonhart. From the same series as catalogue numbers 39 to 43, this print depicts a British officer and merchant at a scenic site in Yokohama.

demand for prints of the new foreign community.

The majority of designs for Yokohama prints were supplied by a few artists who specialized in the novel subject. To meet the sudden clamor for prints, the artists frequently resorted to modifying existing compositions and themes. A popular subject with an established audience, such as portraits of beautiful courtesans (*bijinga*), would thus be "translated" into a foreign theme by the simple substitution of foreign women. Since few foreign women lived in early Yokohama, the models for the stylish Western beauties of Yokohama prints were adapted from the fashion plates that appeared in imported Western newspapers and magazines—though Japanese artists generally misunderstood the fit and cut of Western garments for both men and women. Contemporary sources included the *Illustrated London News*, for example, which published monthly fashion plates of the latest Paris styles. An American publication, *Frank Leslie's Illustrated Newspaper*, especially the issues depicting the visit of the Japanese embassy to the United States in 1860 (see fig. 6), also served as an important source of pictorial motifs. Other fashion plates antedated the prints; Japanese artists consulted Western magazines that dated as early as the 1820s.[2] Nagasaki prints (such as fig. 11), produced in the only Japanese port open to trade with a Western nation during most of the Edo period (1615–1868), also provided compositional models, particularly for costume and interior design.

The same sources provided prototypes for the artists' portrayals of Western ships, machinery, and buildings. The artists copied ships and the like, usually without regard for captions, which neither they nor their publishers understood. Hence, buildings in India, for example, appear out of context in a print of Washington, D.C. (see cat. no. 65), and naval vessels appear repeatedly under the flags of different nations. Even interior scenes can often be traced to sources unrelated to actual buildings in Yokohama. A few prints, however, reflect a more objective portrayal of daily life in the city, and some of the most accurate provide important information concerning the early appearance of Yokohama, which can be confirmed from written accounts of the period.

The works of Sadahide (1807–ca. 1878), exceptional among the artists specializing in prints of Yokohama, encompass some of the most memorable designs among Yokohama prints. His monumental landscape map of Yokohama and its surroundings (cat. no. 1), published within less than a year after the opening of Yokohama, reflects meticulous research of the topography of the region from a specific vantage point along the Kanagawa shoreline. His portrayals of life in Yokohama, more so than those of contemporary print artists, appear to be based on direct observation.

Sadahide brought to the new subject of Yokohama extensive experience in mapmaking and topography as well as illustration. In 1855 he had produced illustrations for *Kita Ezo zusetsu* (Illustrated Notes on Northern Ezo), a book written by Mamiya Tomomune describing his explorations of the remote northern territory known today as Hokkaido. In addition to varied and memorable prints of Yokohama, Sadahide also produced illustrated books. One of the most famous, *Yokohama kaikō kembunshi* (Record of Things Seen and Heard in the Open Port of Yokohama), contains vivid illustrations and detailed anecdotes concerning the customs of the foreigners in Yokohama. Sadahide was selected in 1866 as one of the artists to represent Japan in the international exposition to be held in 1867 in Paris. His work

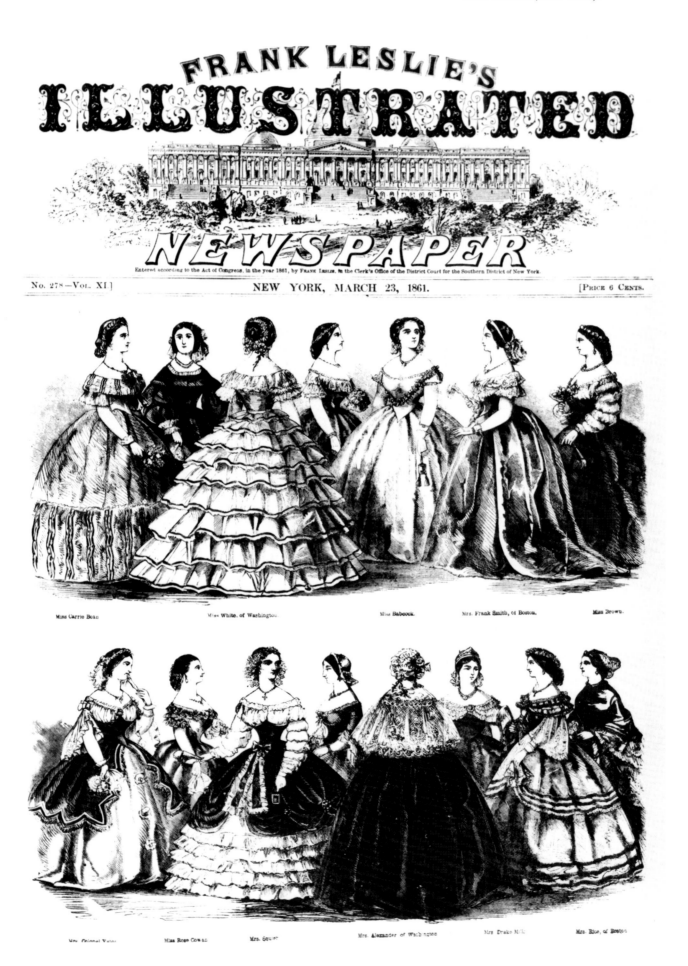

FRANK LESLIE'S
ILLUSTRATED
NEWSPAPER

Entered according to the Act of Congress, in the year 1861, by FRANK LESLIE, in the Clerk's Office of the District Court for the Southern District of New York.

No. 278—Vol. XI.] NEW YORK, MARCH 23, 1861. [PRICE 6 CENTS.

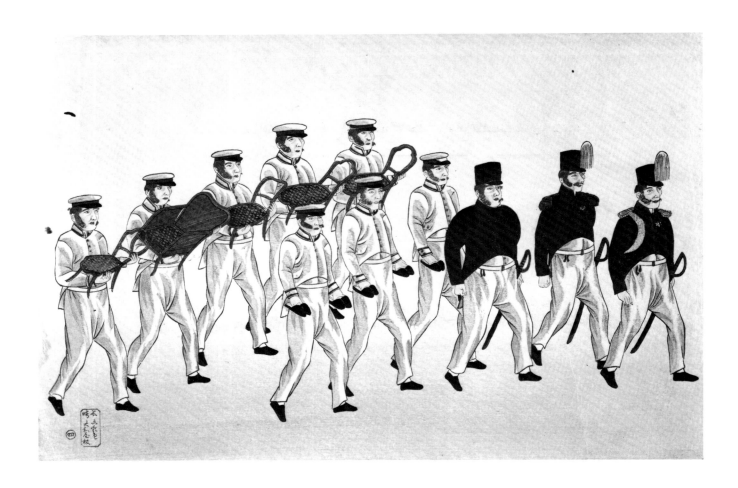

was thus displayed in one of the Five Nations whose coming to Japan had stirred his imagination and inspired his most devoted artistic efforts.

The vogue for Yokohama prints was intense but brief, and publication dropped precipitously in 1862. Diminished public interest owing to the vast production of the prints, which may have exceeded 250,000 images, together with intensified antiforeign activity, may have contributed to the waning of Yokohama as a subject for prints.

After the Meiji Restoration of 1868, Japan under the leadership of the Emperor Meiji entered an era of rapid modernization. The exuberant spirit of the new era was expressed in the phrase *bunmei kaika* (civilization and enlightenment). Print publishers and artists turned to the theme of modernization, which, because it generally depended upon Western models, again focused on Japan and its relationship to the West. In the popular prints of the Meiji period (1868–1912) the artists achieved, however, a more objective attitude toward their subjects. Although fiction, imagination, and the depiction of mechanical wonders are still aspects of prints of the period, many artists were drawn to current events, and reportage became increasingly prominent in the medium of popular prints.

In prints from the 1870s and later, Japan's successful adoption of Western technology, architecture, transportation, and even clothing is recorded. With the selective integration of many aspects of Western culture into Japanese life, the foreigners themselves were no longer a subject of curiosity as they

Figure 11 *Auspicious Ceremony of the Russian Mission,* Edo period, ca. 1854, by Kawahara Keiga (ca. 1786–ca. 1860). Woodblock print; ink and color on paper. Published by Yamatoya in Nagasaki. Collection of William and Florence Leonhart. From a set of seven prints that depict the landing of Russian warships under Admiral Euphimius Putiatin at Nagasaki in 1854, these prints represent a parade of military personnel. The artist and publisher cooperated to represent light and shadow, which Keiga had studied from Western art.

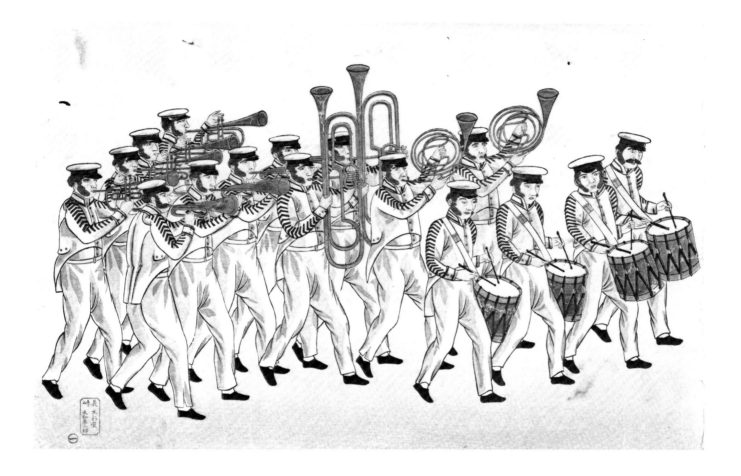

had been in the years immediately following the advent of international trade. The early Yokohama prints had an important function in informing a broad segment of the Japanese public about the coming of the people of Five Nations to Japan; as a popular art form they expressed a widespread interest within Japan in an event of great immediate and lasting importance for the nation. Prints of the Meiji period celebrate the achievement of modernity and Japan's new and important role in international relations.

1. Kanagawa Kenritsu Hakubutsukan (Kanagawa Prefectural Museum), *Shūtaisei Yokohama ukiyo-e* (Compilation of Yokohama prints) (Yokohama: Yūrindō, 1979), 520–23.

2. Claudia Brush Kidwell, curator, Division of Costume, National Museum of American History, Smithsonian Institution, Washington, D.C., provided valuable information and observations regarding costumes shown in Yokohama prints.

The prints in this catalogue are arranged thematically. Each section begins with an essay discussing the historical setting and context of the prints.

Catalogue entries provide the year of a print's publication followed by the month (e.g., 1860:3). Because the Japanese lunar calendar in use until 1 January 1873 corresponds imprecisely with the Gregorian calendar, however, two systems are used: the year cited is the conversion of the Japanese era date to the Gregorian calendar, but the month refers to the lunar month. Relative chronology of publication is thus maintained. Dates of publication after 1873, if known, are fully converted to the Western calendar.

The term *ōban* denotes a roughly standard paper size preferred by Japanese print publishers. Triptychs and larger compositions generally comprise more than one *ōban* sheet. For images composed of more than one sheet, overall dimensions are provided. Dimensions are in centimeters followed by inches in parentheses; height precedes width.

Diacriticals (macrons) are omitted in modern Japanese place-names. The traditional Japanese sequence of family name followed by personal name is observed in the text. The citations of Japanese authors in the notes and Bibliography follow conventions parallel to those used for Western names.

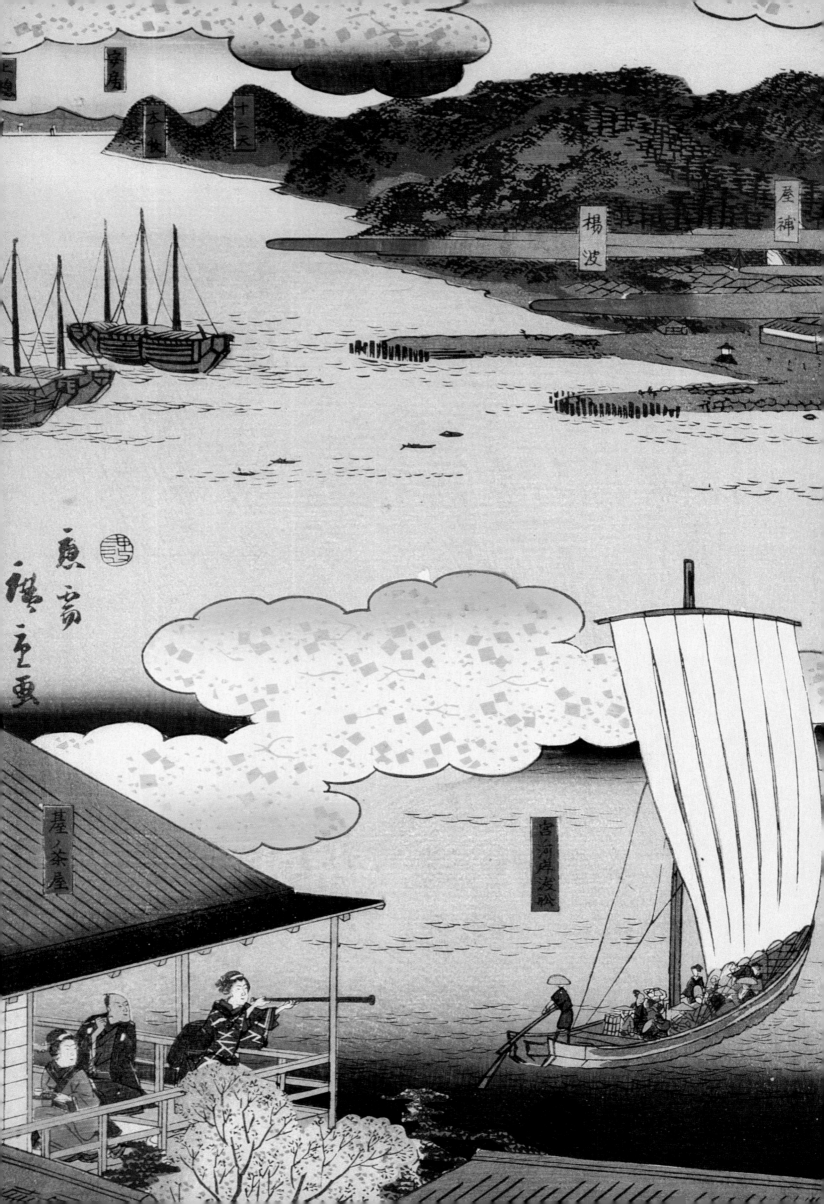

YOKOHAMA: NEW TOWN ON EDO BAY

T HE FIRST Japanese ports to be opened to American ships and their crews after Commodore Matthew Calbraith Perry (1794–1858) initiated negotiations in 1853 were Hakodate on the northern island of Hokkaido, and Shimoda on the Izu Peninsula southwest of Edo (modern Tokyo). In addition, the Treaty of Kanagawa—officially the Treaty of Peace and Amity between the United States and the Empire of Japan—signed at Kanagawa on 31 March 1854, provided for establishment of a United States consular office at Shimoda.

The United States–Japan Treaty of Amity and Commerce (Harris Treaty), signed on 29 July 1858 aboard the USS *Powhatan* in Edo Bay, provided for the opening of four additional Japanese harbors to trade with the United States: Kanagawa and Nagasaki on the fourth of July 1859, and Niigata and Hyogo (modern Kobe) on the first of January 1860.[1] Within six months of its opening, Kanagawa was to replace Shimoda as a domicile for Americans. Similar commercial treaties were concluded in October 1858 with Great Britain, France, Russia, and the Netherlands.

Less than one year remained after the treaties were signed for the Japanese to prepare for foreign settlement at Kanagawa, a post town located on the Tōkaidō (fig. 13), the great eastern highway linking Edo, the seat of the Tokugawa shogunate, and Kyoto, the imperial capital. Unexpectedly, the officials of the Tokugawa shogunate decided unilaterally to relocate the foreign settlement from Kanagawa to Yokohama, a fishing village three-miles distant on the opposite shore of a bay. In shifting the foreign settlement to its new location, officials in Edo had clearly recognized that foreign residents at Kanagawa held the potential for disrupting vital traffic along the Tōkaidō. Moreover, they feared conflict between the foreigners and the samurai and daimyo, lords of provincial domains who were required to travel regularly between their home provinces and Edo.

To ensure a favorable response to the new site, the Japanese government expended considerable effort and expense to prepare for immediate occupation when the treaties came into force in early July 1859. The building of Yokohama proceeded remarkably rapidly, to the amazement of all who observed the transformation. Contemporary accounts repeatedly express astonishment at the remarkable emergence from the swampland of a town with well-organized streets, habitable buildings, shops, and other amenities, all in the space of a few months. As British Minister Sir Rutherford Alcock (1809–1897) later recalled, "Here, out of a marsh by the edge of a deserted bay, a wave of the conjurer's wand had created a considerable and bustling settlement of Japanese merchants."[2] When Alcock arrived as British consul general in June 1859 to oversee the opening of Kanagawa, he discovered that across the bay at Yokohama

[t]hey had gone to vast expense in building a causeway across the lagunes [*sic*] and marshy ground for nearly two miles, to shorten the distance—and afford a certain and direct means of communication with the high road at Kanagawa. I found solid granite piers and landing-places had already been built: and an extemporised town for Japanese traders, with a number of small houses and go-

Figure 12 *Detailed Map of the Newly Opened Port for Foreign Trade at Kanagawa, Showing Official Buildings, Temples, Shrines, and Houses*, 1859, by Ichi-gyokusai. Woodblock print; ink and color on paper. Kanagawa Prefectural Museum, Yokohama. One of the earliest map prints of Yokohama, this design shows the orderly grid of the new town of Yokohama across the bay from Kanagawa. The Tōkaidō is in the foreground (north).

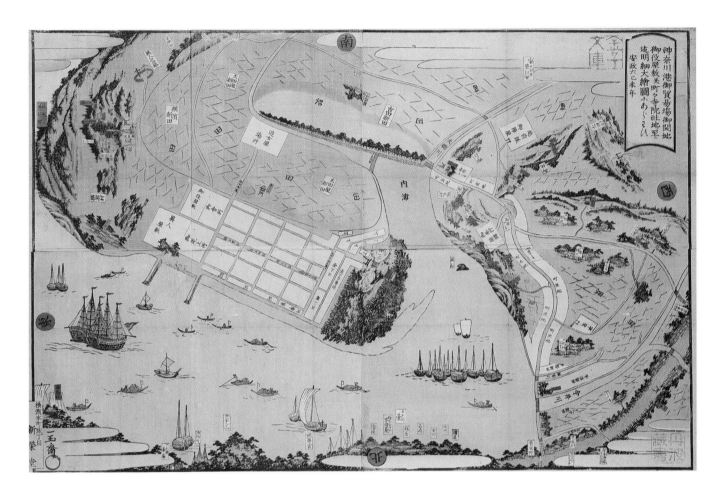

downs for the foreign merchants . . . together with a large range of official quarters, in which a custom-house was already established.[3]

With several ships already in the harbor, prepared to establish their commercial interests the instant the treaties come into force, both Alcock and United States Consul General Townsend Harris (1804–1878) realized the likely futility of their actions but urged their countrymen to insist upon fulfillment of the terms of the treaties, which had stipulated a settlement at Kanagawa. The merchants, however, were in need of immediate accommodations and quickly began to accept quarters in Yokohama. Moreover, they regarded Yokohama's harbor as a more favorable anchorage for their ships than Kanagawa, where the vessels would have to remain farther from shore.

The establishment of an entirely planned new town in time to receive foreign residents by the opening date set by the commercial treaties of 1858 relied upon precedents established during more than two centuries of extremely limited foreign relations that had been governed by the policy of national seclusion. The main commercial and residential section of Yokohama was completely circumscribed by the shoreline of the bay and wide canals, forming, in effect, an island. Guard stations were placed at the bridges crossing the canals to the mainland. Although Yokohama developed rapidly, ex-

Figure 13 The Tōkaidō. Photograph by Felice Beato (ca. 1825–ca. 1908). Yokohama Archives of History. The heavily traveled eastern highway (Tōkaidō) between Kyoto and Edo was as wide as forty feet and passed through many scenic regions portrayed in prints by Hiroshige I (1797–1858) and other Japanese artists.

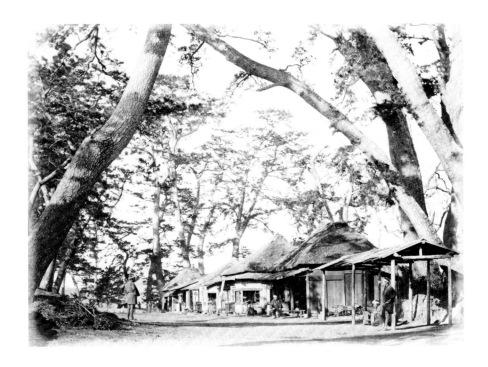

Figure 14 View of Deshima in Nagasaki harbor, 1864. Photograph by Felice Beato (ca. 1825–ca. 1908). Yokohama Archives of History. The Dutch, the only European merchants permitted to trade in Japan from 1639 until 1859, were confined to Deshima, a man-made island in the harbor of Nagasaki.

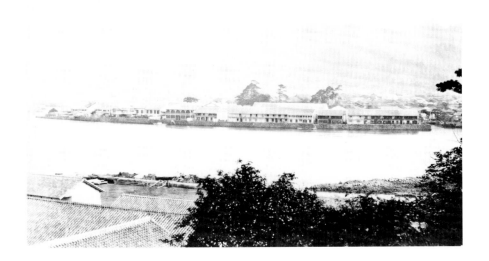

panding beyond the original perimeter, the initial plan reflected the continuing Tokugawa policy of restraining the foreign merchants from direct contact with the Japanese populace.

The plan for Yokohama was similar to that already established at Nagasaki, where Dutch traders had been confined since 1641 to Deshima (fig. 14), a man-made island in the harbor. Yokohama's resemblance to Deshima was apparent to many of the foreign envoys, who were concerned that the Japanese

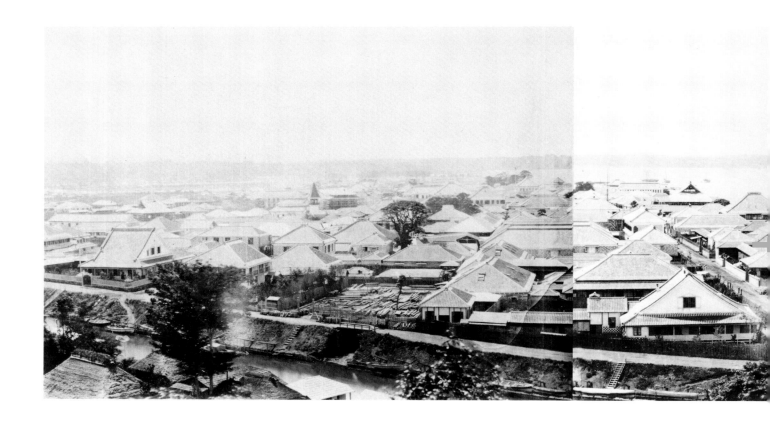

government would restrict their activities and obstruct their access to Edo if they complied with the relocation from Kanagawa. Diplomatic representatives of the treaty nations, refusing to move to Yokohama, initially maintained quarters in Buddhist temples on the Kanagawa side of the bay. Meanwhile, merchants in Yokohama had rushed to stake their claims to suitable quarters in the new city.

As a planned city, Yokohama's layout was orderly. Two piers were available for loading and unloading goods brought by small boats from the larger vessels anchored in the deeper part of the bay. A customhouse, staffed and ready for business, was situated on the waterfront, and foreign trading firms were established on land parallel to the shore, the area that came to be known as the Bund, from a Hindi term for an embankment. Across a narrow canal, in the swampland slightly removed from the commercial center of Yokohama, was Miyozaki-chō, Yokohama's entertainment district.

Foreign ships bearing passengers and provisions were prepared to land in early July 1859, and Yokohama grew rapidly after the arrival of the first settlers. Citizens of those foreign nations not covered by a treaty relationship with Japan were permitted to reside in Yokohama through sponsorship by a treaty nation.

Residential areas for Europeans and Americans were limited to the eastern part of the city; the Japanese residences and business district were in the western section. The Chinese also lived in a segregated residential quarter. From 1864, Europeans and Americans were permitted to build homes on the Bluff of Yokohama, located across the canal to the east of the city. With its cooler climate and commanding views of the harbor, the Bluff became a favored location for foreign residences. Although

Figure 15 Yokohama from the Bluff, 1864. Photograph by Felice Beato (ca. 1825–ca. 1908). Yokohama Archives of History. The large compounds of the foreign settlement are in the foreground. In the harbor are the combined naval forces of Great Britain and three allied nations that gathered at Yokohama before sailing to Shimonoseki in southwestern Japan. There they bombarded the city to retaliate against the forces of the daimyo of the Chōshū domain, who were intermittently shelling foreign ships that passed through the Strait of Shimonoseki.

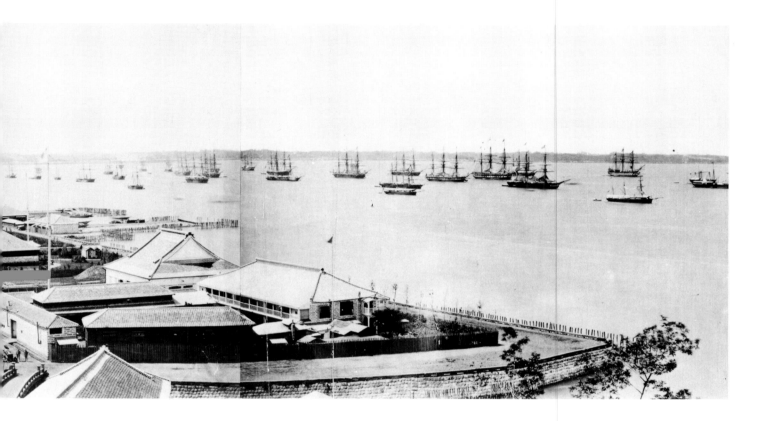

little remains from the original settlement, the Bluff maintains today a distinct character that reflects its early history.

The remarkable new city of Yokohama quickly became a subject of interest to print publishers in Edo, which was only seventeen miles to the northeast along the Tōkaidō. Among the first types of Yokohama prints to be published were landscapes and maps featuring the new city as seen from the hills behind it or from across the bay. Many of the artists relied heavily on compositional conventions developed by prominent masters such as Hiroshige I (1797–1858), who specialized in landscapes of famous sites along the Tōkaidō and in the city of Edo. Others, such as Sadahide (see cat. no. 1), studied the city and its environs in detail to produce striking topographic landscapes that portrayed Yokohama on a grand and memorable scale.

1. The opening of Niigata and Hyogo were delayed owing to political opposition within Japan.

2. Sir Rutherford Alcock, *The Capital of the Tycoon: A Narrative of a Three Years' Residence in Japan*, vol. 1 (London: Longman, Green, Longman, Roberts, & Green, 1863), 145.

3. Ibid., 137.

A magnificent topographical view of the new town of Yokohama is presented by this large landscape map. Published within the year after Yokohama opened, the print represents an impressive technical achievement. Assembled from eight oversize sheets of paper, each separately printed in several colors, it is one of the largest prints ever published in the traditional Japanese technique of woodblock printing.

A lengthy inscription by a writer who signed with the nom de plume Setsuryū Sanjin is printed in the upper left corner:

Once I wandered around the border area and asked where the trading firms were. No one knew where they were, nor was there a map to show the location. Therefore, I silently lamented. Now the opening of the port has been settled and the Five Nations have gathered here. If the conditions of the past had to be investigated to determine whether they had been profitable to our country, there would be no means to verify it. I could do nothing but regret this situation. Later, the publisher Hōzendō made a map of Yokohama. It was shown to me, and I saw the landscape, public buildings, Western-style houses, and urban buildings expanding in all directions. Now we see a map very clearly, so we can imagine the past phenomena of this area. A landscape painting is only for poets. Therefore, I encourage people to publish maps. If people want to see the scenery of this area, they can see them by means of this map, and they will still be able to see them one hundred years from now.

The artist, Sadahide, who signs with an artistic name, Gyokuransai Hashimoto of Edo, declares in his inscription: "I have painted this picture en route to the capital [Kyoto]: a true view of the outlook from Koyasumura [Koyasu Village]." From his vantage point in a village located to the northeast of Kanagawa, the artist looks toward the new town of Yokohama, on the southwest shore of the bay. The Tōkaidō, the busy highway linking Edo and Kyoto, runs along the

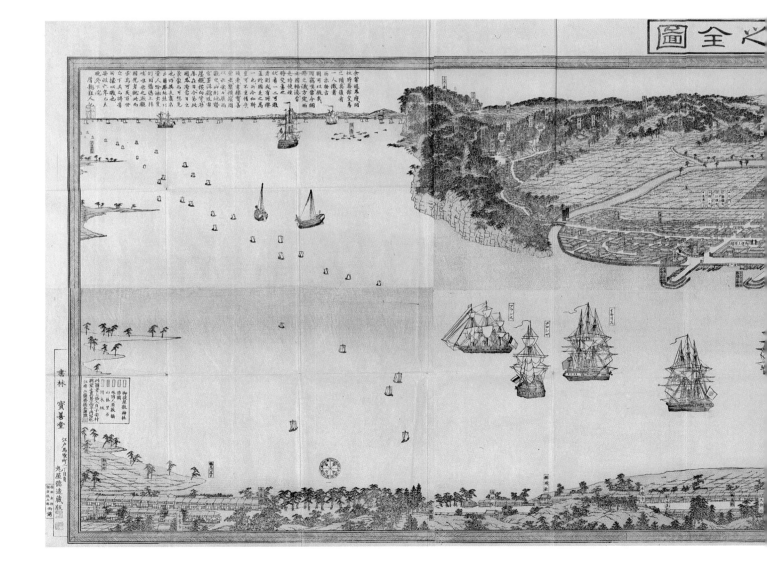

cat. no. 1
Gokaikō Yokohama no zenzu
Edo period, winter 1859/60
by Sadahide (1807–ca. 1878)
publisher: Maruya Tokuzō
woodblock print
ink and color on paper
eight sheets joined and folded:
69.5 × 191.1 cm (27⅜ × 75¼ in.)

near shoreline. Toward the right, the road passes through Kanagawa, the post town that was specified by the treaties of 1858 as the site for foreign commerce and residence.

In creating this expansive yet minutely detailed landscape map of Yokohama and its environs, Sadahide employed techniques of observation and artistic visualization that had been an important force in Japanese painting since the second half of the eighteenth century. Topographic features such as mountains and rivers, and sites such as temples, bridges, buildings, and roads, are labeled individually as was customary in earlier Japanese paintings of *meisho-e*, pictures of famous places. Telescopes were already featured in eighteenth-century teahouses endowed with scenic views,[1] and it is possible that Sadahide made use of such an instrument to enhance his observations. The artist's elaborate visualization of the general and specific aspects of an extensive landscape depended upon principles Kuwagata Keisai (1764–1824) successfully employed in his panoramic view of famous places of Edo, the first print of its kind, published in 1803.[2] Sadahide's choice of that model for his earliest large landscape of Yokohama possibly reflects his ambition to produce a similarly important and influential image of the new city.

Whatever his methods, the *Complete Picture of the Newly Opened Port of Yokohama* was a significant achievement, magnificent in scale and successful as both a landscape and guide to the rapidly developing region. The importance and popularity of the impressive print in the years following its publication are confirmed by the existence of several versions, all fundamentally identical but differing from each other in particulars, such as the number and types of ships in the harbor or in the configuration and extent of

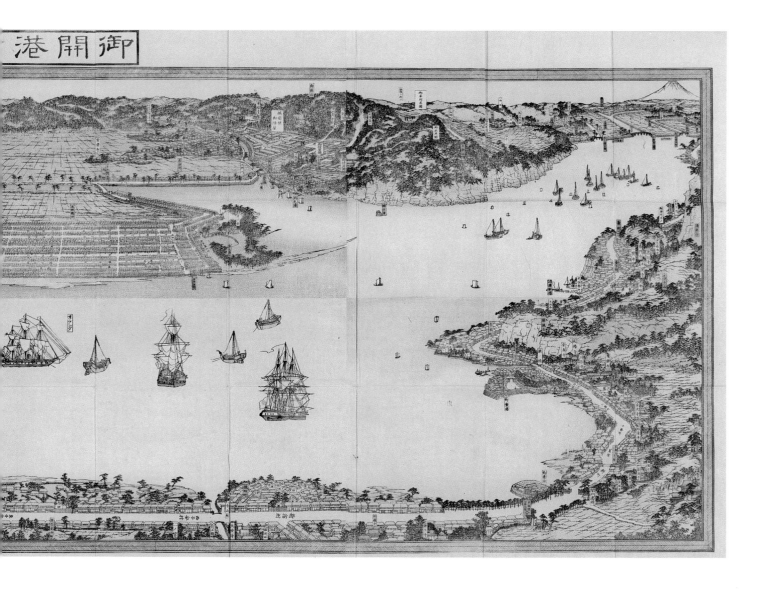

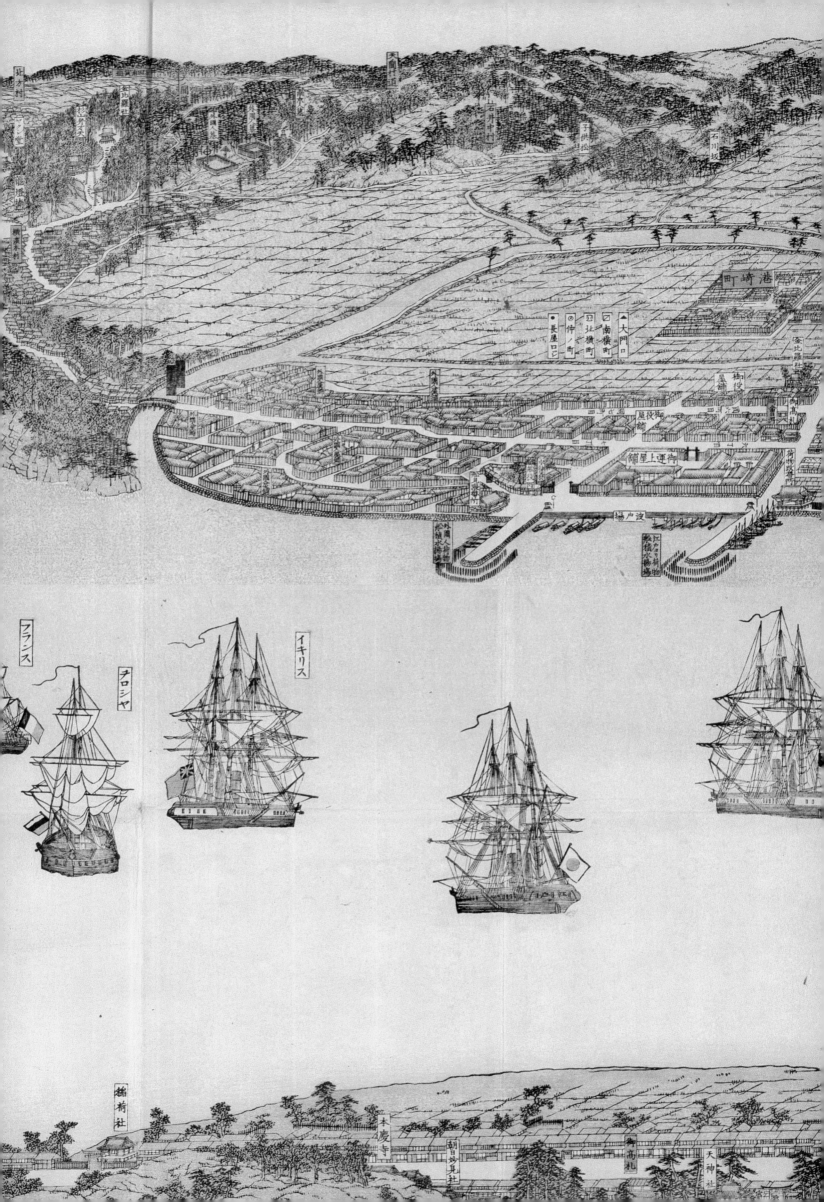

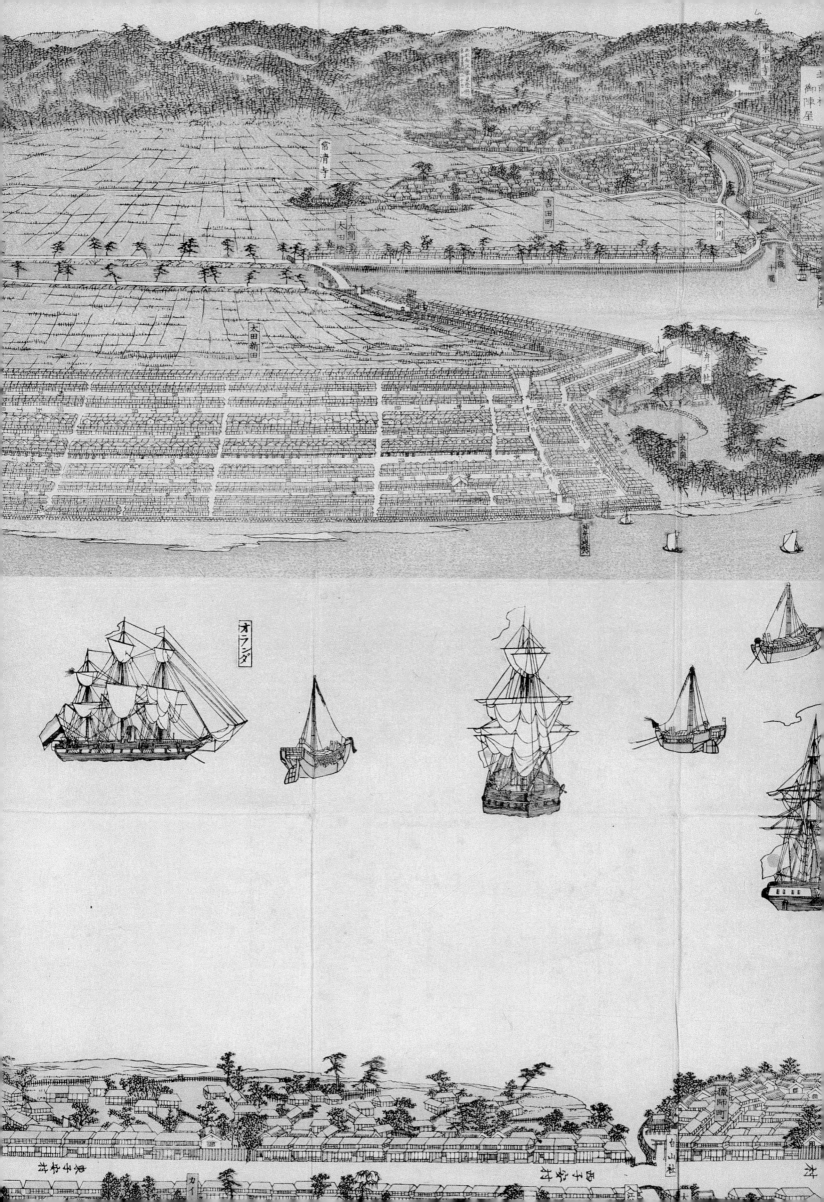

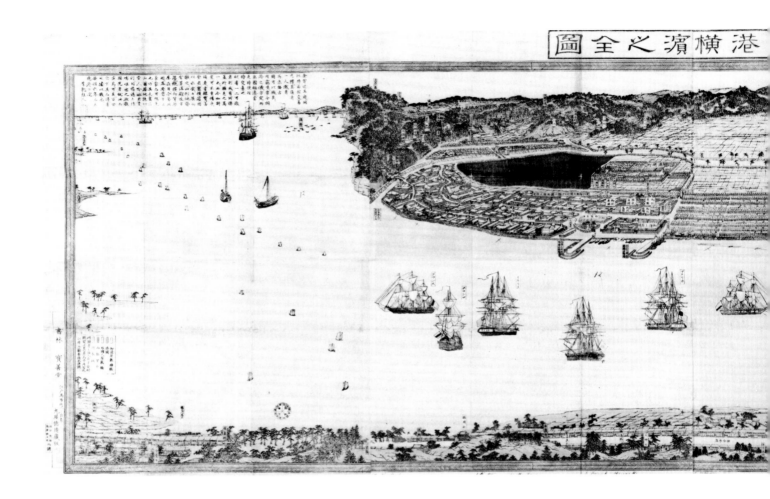

the town of Yokohama.³ Sadahide depicted in detail the large ocean-going Western ships, Japanese coastal trading vessels, and the smaller ferries and fishing boats that filled the harbor of Yokohama and Edo Bay, which extends toward the right in this print. British horticulturalist Robert Fortune, upon reaching Yokohama at the end of October 1860, described the scene in terms remarkably parallel to Sadahide's nearly contemporary print: "On our right, in the direction of Yedo [Edo], we observed a cloud of boats under sail, composed chiefly of fishing-boats which supply the markets of the capital and the surrounding towns with fish."⁴

Comparison of the variant examples of Sadahide's *Complete Picture* suggests that the publisher revised the grand view of Yoko-

hama several times without changing the date, "winter, the sixth year of the Ansei era [1854–59]," which appears in the inscription at the upper left. According to the inscription, the print must initially have been planned for publication at the end of 1859 or in early 1860.⁵

As the city expanded during the intervals between printings of revised versions, the carver was able to adjust details of the print by recarving or replacing portions of certain blocks while leaving other sections, including the original inscription, intact. For such a large composition, repeatedly using the same set of blocks after modifying specific sections avoided the necessity of recarving the entire set of blocks for each revision.

The Leonhart collection contains two examples of this print.

Whereas catalogue number 1 depicts Yokohama shortly after its opening in 1859, the other version (fig. 16) represents Yokohama at a later stage of development, when the city and its entertainment district, Miyozaki-chō, had grown. Evidence of wear from repeated printings can be discerned in areas where the later print and original are identical.

Complete Picture of the Newly Opened Port at Yokohama expresses in its imposing scale and meticulous detail the artist's devotion to what must have been a demanding project. The continued popularity of the image during the years following the port's opening reflects its utility as a guide to the region and the brilliance of Sadahide's first great landscape of Yokohama.

Figure 16 Variant of cat. no. 1

1. Henry D. Smith II, "World without Walls: Kuwagata Keisai's Panoramic Vision of Japan," in Gail Lee Bernstein and Haruhiro Fukui, eds., *Japan and the World: Essays on Japanese History and Politics in Honour of Ishida Takeshi* (London: Macmillan Press in association with St. Anthony's College, Oxford, 1988), 16.

2. Ibid., 13.

3. Slightly altered reprints were published in the Genji (1864) and Keiō (1865–67) eras. See Kanagawa, *Yokohama ukiyo-e*, 494.

4. Robert Fortune, *Yedo and Peking: A Narrative of a Journey to the Capitals of Japan and China* (London: John Murray, 1863), 28.

5. Kanagawa, *Yokohama ukiyo-e*, 494. The appearance of the bridge, Yatohashi, indicates that despite the inscription dated 1859, the print could not have been published until 1860.

2 Picture of the Coast of Yokohama

cat. no. 2
Yokohama kaigan zue
Edo period, 1860:3
by Hiroshige II (1826–1869)
publisher: Daikokuya Kinnosuke,
Kinjirō
woodblock print
ink and color on paper
ōban triptych: 36.5 × 75 cm
(14⅜ × 29¹⁷⁄₃₂ in.)

A festive ambience is imparted by stylized clouds embellished with golden flecks that resemble the gold-leafed clouds of Japanese screens. This triptych, together with one titled *True View of the Harbor of Kanagawa and Yokohama*, forms a continuous scene of six sheets, reflecting the six-panel format common to large-scale Japanese folding screen paintings.[1] The artist, Hiroshige II, has relied extensively on the striking pictorial conventions, such as pronounced contrast between near and distant scenes, developed by his teacher and father-in-law, Hiroshige I (1797–1858). A forest of masts of Japanese junks links the foreground shore to the city on the opposite coast. At the extreme lower left, from a site along the Tōkaidō, a Japanese woman peers through a telescope from the veranda of the Go Teahouse, named for a Japanese board game. Boatloads of passengers sail across the bay toward Yokohama.

No evidence of Yokohama's special status as a new settlement for foreigners is revealed in this print. The ships in the harbor and the people are exclusively Japanese, and the view of the city overlooks the Japanese town, with the distant foreign quarter barely visible beneath stylized clouds. The city and its surrounding hills are depicted in simplified, general terms, and only a few sites, principally the blocks along the main road of the Japanese district, are named. Miyozaki, Yokohama's isolated entertainment quarter, is incorrectly labeled Yoshiwara, the name of its prototype in Edo.

In contrast to Sadahide's meticulously detailed *Complete Picture of the Newly Opened Port of Yokohama* (cat. no. 1), this triptych and its companion triptych emphasize the familiar Japanese scenes of travelers and teahouses along the Tōkaidō. Yokohama as depicted in this print could be any Japanese harbor town; the city is portrayed as if the foreign ships have not yet come to Japan or have miraculously vanished.

The artist's dependence upon pictorial convention and generalization suggests that he was not intimately familiar with Yokohama but was relying upon his knowledge of the region to meet a sudden demand for prints of the new city. He might, in fact, have created the print by consulting sketches or travelers' accounts without having ever visited Yokohama.

1. Kanagawa, *Yokohama ukiyo-e*, 512. An example of the companion triptych, in the Kanagawa Prefectural Museum, is illustrated in *Yokohama ukiyo-e*, p. 352.

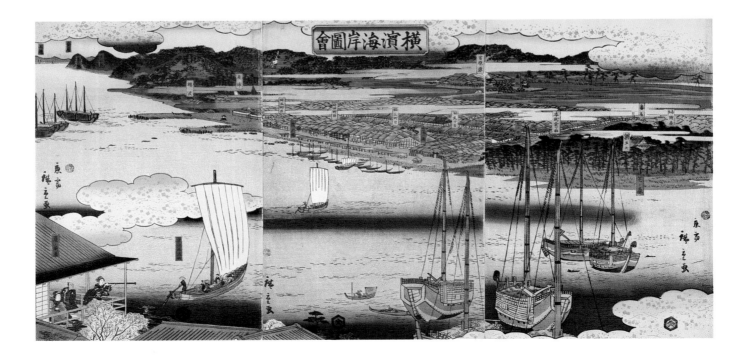

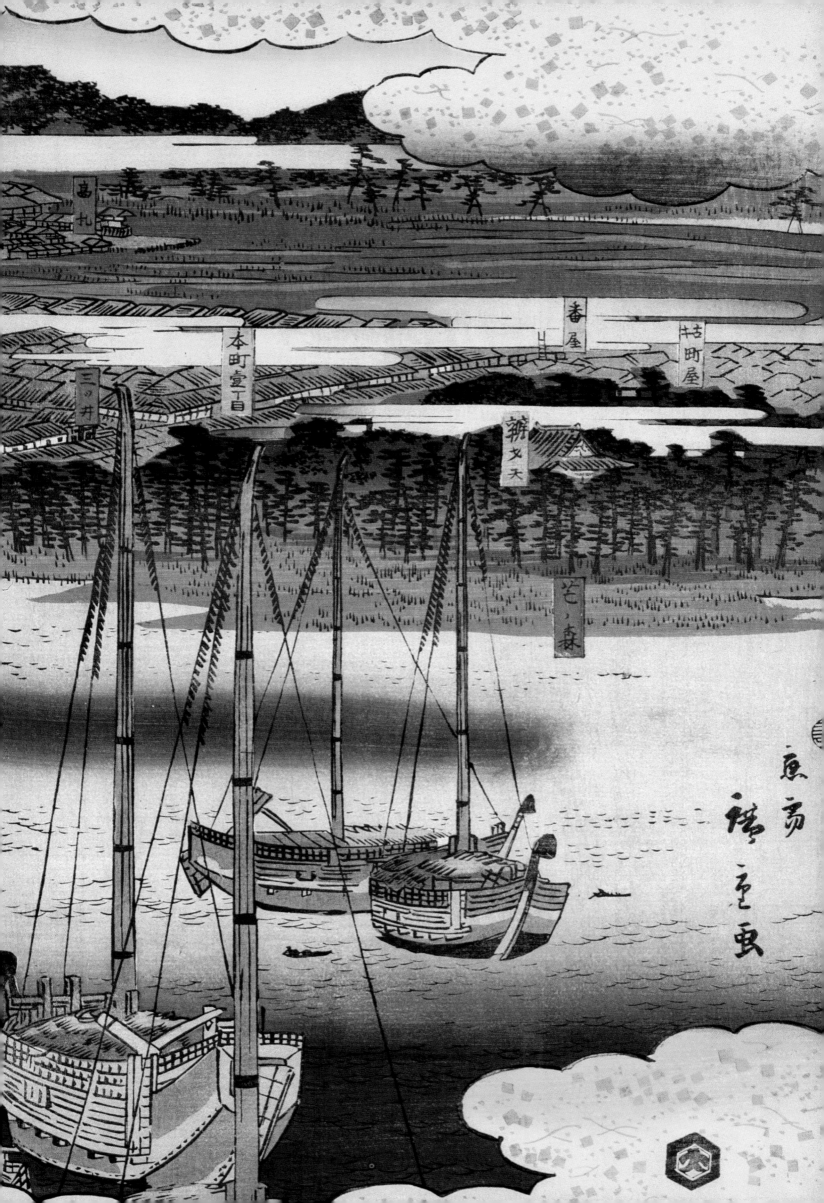

From a vantage point in the hills behind Yokohama facing the bay, this triptych by Sadahide depicts the east-west (right-left) plan of the town. Despite the small scale of the buildings and figures, Sadahide has provided an accurate portrayal of Yokohama in its first year as an international port. The walled compounds where foreigners resided and established their businesses extend toward the east, where an American flag flies prominently at the upper right. Honchō-dōri, the broad main avenue of the Japanese commercial district to the west, is filled with activity, including carts transporting goods near the waterfront.

A road through the empty fields behind the town leads, at the far right, to Miyozaki, Yokohama's equivalent of the famous Yoshiwara entertainment district of the great city of Edo. Like Yokohama, which was surrounded by water and accessible by land only by passing over sentry-guarded bridges—such as Yoshidabashi shown in the foreground—Miyozaki was encircled by a moat and had to be entered over a bridge through a single gate. The plan of the city and its surroundings provided Japanese officials a means of monitoring movement to and from the city and its pleasure quarter.

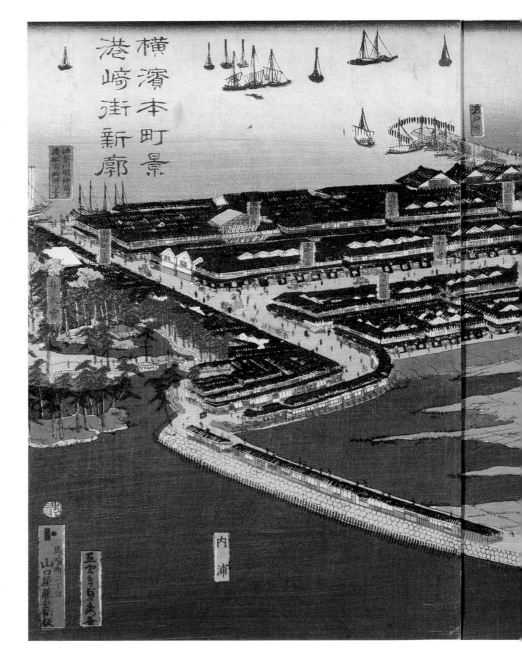

cat. no. 3
Yokohama Honchō kei Miyozaki-gai shinkaku
Edo period, 1860: intercalary
3d month
by Sadahide (1807–ca. 1878)
publisher: Yamaguchiya Tōbei
woodblock print
ink and color on paper
ōban triptych: 36.7 × 75.6 cm
(14 7/16 × 29¾ in.)

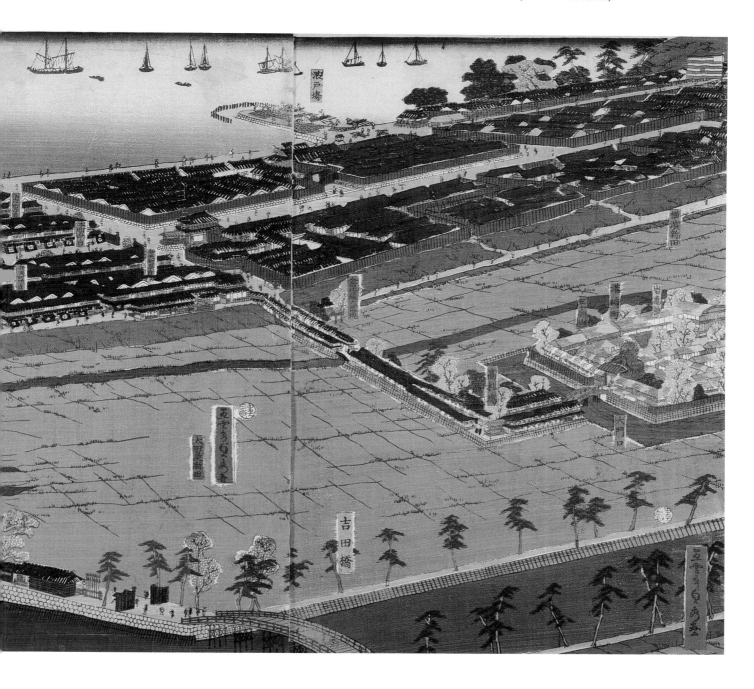

4 Complete Detailed View of Yokohama Honchō and the Miyozaki Quarter

cat. no. 4
Yokohama Honchō narabi ni Miyozaki-chō saiken zenzu
Edo period, 1860:4
by Sadahide (1807–ca. 1878)
publisher: Yamamoto Heikichi
woodblock print
ink and color on paper
ōban triptych: 37.5 × 76.8 cm
(14¾ × 30³⁄₁₆ in.)

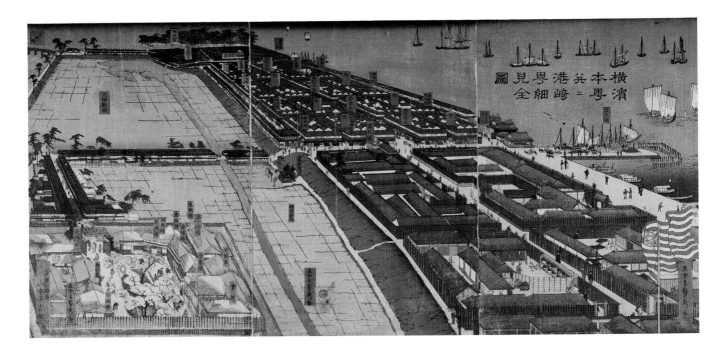

In a view of Yokohama from east to west Sadahide has filled his print with observant details of daily life in the new city. An American flag, visible only in the distance in the previous print (cat. no. 3), flies prominently in the lower right corner of the triptych.

Miyozaki, Yokohama's pleasure quarter, occupies the lower left of the scene. The great gate stands open, and a few of the women residents stroll in the gardens outside the establishments where they live and work. Labels identify each of the houses. Gankirō, with its notable gabled roof, is located in the lower right corner. In contrast to many of the businesses in Miyozaki, Gankirō catered to both foreign and Japanese clientele, and its gaudily decorated rooms were a popular subject of Yokohama prints (see cat. nos. 57–59).

To the right, adjacent to the harbor, are the walled compounds occupied by Europeans and Americans. Within, servants of various nationalities including Japanese attend to their work; ducks and goats kept for food are seen in the yards. Warehouses, sheds, and residential buildings can all be distinguished.

Small boats sail to and from the stone pier, which is piled high with commercial goods. In the distance the smaller buildings along the Japanese district's main thoroughfare, Honchō-dōri, can be seen. The Japanese settlement extends toward the Benten (Benzaiten, or Sarasvatī) Shrine, located among the trees at the far left.

5 Detailed Picture of the Great Harbor of Yokohama

cat. no. 5
Yokohama taisō saiken no zu
Edo period, 1860:6
by Sadahide (1807–ca. 1878)
publisher: Tsujiokaya Bunsuke
woodblock print
ink and color on paper
ōban hexatych: 71 × 74 cm
(27¹⁵⁄₁₆ × 29³⁄₁₆ in.)

A portrayal of the Japanese settlement of Yokohama, this large image comprising two rows of three *ōban* prints encompasses the scenic grounds of the Benten Shrine to the left and the Miyozaki entertainment district to the lower right. Hovering in the upper register, as if floating in the sky, are the Japanese junks and Western steam and sailing vessels in the harbor.

The unusual format of *Detailed* *Picture of the Great Harbor* provided for a more spacious composition than those of the common triptych or double triptych. During the first year after the opening of Yokohama, Sadahide concentrated his efforts on depicting the new city; he produced more than forty designs of Yokohama within the year. Many, like this one, were large in scale. Their special size must have drawn attention to their novelty among customers in nearby Edo and throughout Japan.

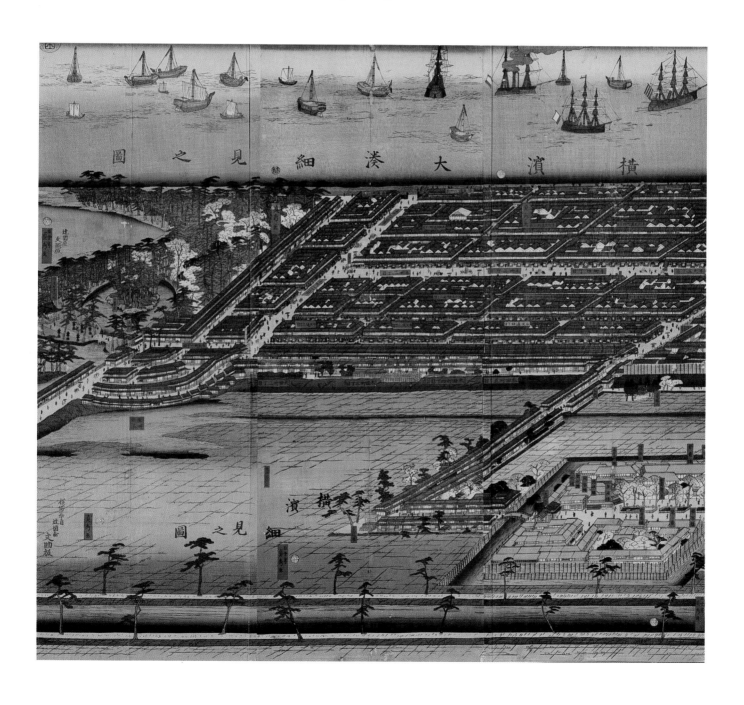

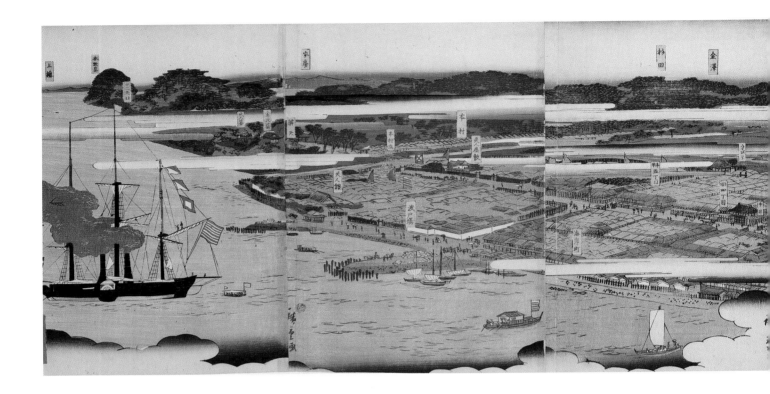

Published four months apart in 1861 as independent triptychs under different titles, these six prints together present an aerial view of Yokohama as seen from the bay. The full extent of the city as it appeared in 1861 occupies the center of the composition. Across the plain, at the far right, Mount Fuji rises above distant hills.

From the vantage point of the bay the new city of Yokohama is represented in a context already made familiar by numerous series of Japanese landscape prints, a form made popular through the works of Hokusai (1760–1849) and Hiroshige I (1797–1858), the latter the teacher and father-in-law of Hiroshige II. Although Hiroshige II was less innovative than his teacher as a designer of prints, this composition reveals his proficient grasp of the principles of graphically depicting an extensive scene as reconstructed from an imaginary point of view.

Despite the somewhat sketchy and abbreviated rendering of the scene, Hiroshige II has clearly portrayed the overall scheme of the city of Yokohama and its suburbs. The commercial district of the city at Honchō Itchōme appears in the lower part of the sheet third from the right. Trade goods, possibly bales of raw silk, the principal export commodity of Yokohama, are heaped on the main pier to the left. A large ship flying a striped flag—the artist's impression of an American flag—approaches the harbor from the far left.

Publishing a landscape of six *ōban* prints as two triptychs provided for selling the triptychs as independent images, each complete within itself. Together they form an elongated horizontal composition similar in scale to Japanese handscroll paintings, which are unrolled from right to left.

cat. no. 6
(a) *Kanagawa Noge Yokohama*
Edo period, 1861:2
ōban triptych: 34.9 × 72.2 cm
(13¾ × 28 7/16 in.)
(b) *Yokohama fūkei ban*
Edo period, 1861:6
ōban triptych: 35 × 74 cm
(13¹³/₁₆ × 29½ in.)

by Hiroshige II (1826–1869)
publisher: Sanoki
woodblock print
ink and color on paper

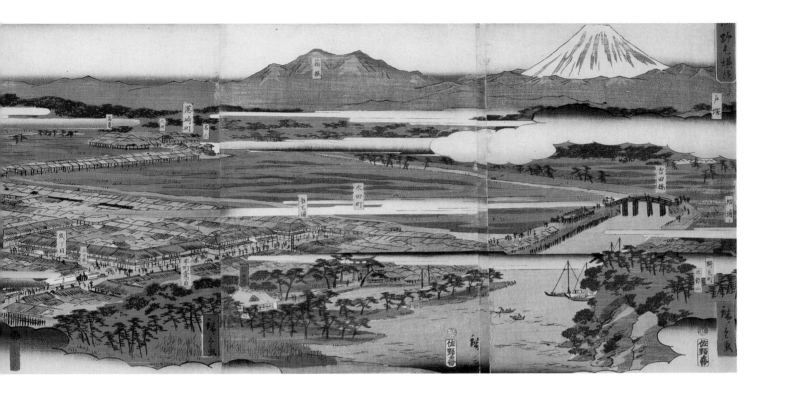

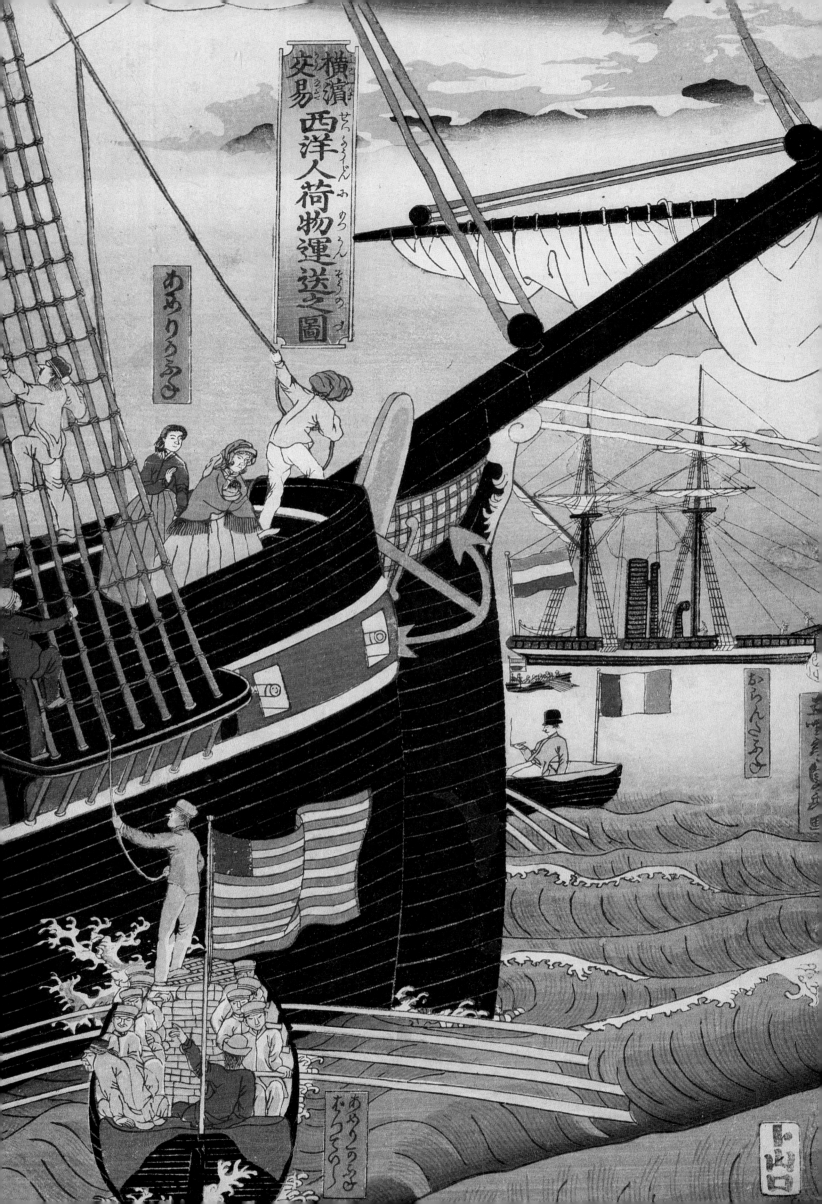

横濱交易西洋人荷物運送之圖

THE GREAT SHIPS

REGULATIONS OF the Tokugawa shogunate had initially forbidden the building of ships exceeding five hundred *koku*[1] in cargo capacity. The restriction was intended to prevent provincial daimyo from owning vessels large enough to support military action against the Tokugawa shogunate and to limit their ability to profit from independent foreign trade. Coastal shipping was vital, however, to the economic interests of the shogunate, and larger ships were eventually permitted. By the nineteenth century, Japanese coastal trading vessels had reached fifteen hundred to two thousand *koku* (147 to 196 gross tons) in capacity.[2]

The shogunate's policy of national seclusion, in force since 1639, had terminated experiments in building ships based on European models, which had depended on the expertise of such resident foreigners as William Adams (1564–1620) of England. Repeated contact with European vessels during the nineteenth century and the sudden incursion of the armed American steamships of Commodore Matthew Perry into Edo Bay in 1853 revived Japanese interest in European shipbuilding technology.

In 1855, Japanese carpenters assisted the Russian crew of the shipwrecked *Diana* in building a schooner based on salvaged drawings.[3] Although of modest size, the *Heda*, named for the harbor on the Izu Peninsula where the *Diana* had sunk, provided valuable experience to the Japanese builders who assisted in her construction.

Until after the Meiji Restoration of 1868, however, most of the Western-style ships sailing under the Japanese flag had been built abroad and brought to Japan for sale or as diplomatic gifts. The *Emperor*, a British steam-powered yacht, was presented in 1858 to the shogun (who was thought to be the Japanese emperor) as a gift from Queen Victoria upon conclusion of the British commercial treaty. A festive ceremony celebrated its presentation:

> Lord Elgin now formally addressed the Commissioners, handing over to them, on behalf of her Majesty, the yacht which she had presented to the Tycoon [shogun] as a token of friendship and good-will. Then down came the English ensign, and up went the red ball on the white ground, the signal for the forts to salute; and the puff curling over the blue waters of the bay, and followed by a dull roar, proved how well the Japanese signal man had kept his watch.
>
> With perfect precision the native gunner fired twenty-one guns with an interval of ten seconds between each. The weather was lovely, the bay was alive with pleasure-boats—the wonderstruck Japanese listening to their own forts conducting themselves in this totally unprecedented manner. Then came the sharp ringing response from the 68 pounders of the Retribution and Furious, and the yacht got slowly under weigh, commanded by a Japanese captain, manned by Japanese sailors, and her machinery worked by Japanese engineers. Notwithstanding the horizontal cylinders and other latest improvements with which her engines were fitted, the men had learnt their lesson well, and were confident in their powers. We steamed gallantly through the fleets, the admiration of all beholders, whether British or Japanese. A brilliant sunset added its glories to this lively and attractive scene. The shores of the bay were lined with people. . . . Many-coloured flags fluttered

in the breeze, hundreds of boats flitted to and fro on the still waters of the bay; while, rearing its conical summit far into the blue sky, old Fusi-yama [Mount Fuji] formed a picture such as had never before been witnessed in the course of all the many centuries during which this majestic peak has presided over the capital of Dai Nipon [Great Japan].[4]

A Japanese crew made its first transpacific voyage in 1860, when they carried as passengers members of the first Japanese diplomatic mission to the United States. One of their two ships, under the command of Kimura Yoshitake, was the *Kanrin Maru*, built in Holland in 1857 for the shogun. American adviser Captain John Mercer Brooke (1826–1906) and ten others from the crew of the USS *Fenimore Cooper*, which had been unsalvageable after running aground during a storm in the harbor of Yokohama, were invited by the shogun to accompany the official mission.[5] The other vessel was the USS *Powhatan*, on which the Harris Treaty had been concluded in 1858.

The Japanese appear to have assimilated the techniques for navigating Western steamships more quickly than they did Western concepts of the proper maintenance of wooden hulls. When Sir Rutherford Alcock (1809–1897), then British consul general to Japan, had occasion to inspect the *Emperor* following his arrival in 1859, he observed:

> The painted woodwork looked shabby, because the Japanese abhor paint about their ships, and had consequently been steadily engaged in scrubbing it off ever since the boat had come into their possession, and by dint of labour and perseverance had nearly succeeded. How they dispense with paint, and oil, and varnish, on all their boats and junks, and still preserve them in a seaworthy state, I have never been able to learn. . . . They char the keels, and more than once, I believe, but beyond this, they seem to do nothing to guard the wood from decay, under a hot sun, and the alternate processes of soaking and drying. This, too, in the land of lacquer and varnish! . . . But the engines, and all the brass-work, would have done no discredit to the best kept man-of-war in our service. I afterwards found, that they frequently got up her steam and proceeded with her to different points, when any high official had to be sent on the Tycoon's [shogun's] service, and the vessel was worked entirely by Japanese.[6]

The foreign ships that rushed to Yokohama when the treaties took effect in 1859 provided a challenging and colorful subject for the artists of Japanese prints. The opening of Yokohama coincided with a period of rapid progress in naval technology, and the ships that came there presented a picturesque variety of types and materials. Both wood and iron were used for shipbuilding in the West. Although introduction of steam engines had vastly reduced the time necessary to travel long distances, ocean-going vessels at the time of Yokohama's opening were still traveling under a combination of steam and sail.

Depicting the unfamiliar vessels was somewhat problematic for the Japanese artists. Consequently, they consulted illustrations published in foreign newspapers such as the *Illustrated London News* for

Figure 17 A Japanese junk near the Nagasaki customhouse. Photograph by Felice Beato (ca. 1825–ca. 1908). Yokohama Archives of History. Single-masted wooden vessels carried cargo for Japanese coastal trade during the Edo period (1615–1868).

pictorial models from which they could study the shapes, decor, and complex rigging of European and American ships. The captions of the news illustrations were, of course, completely indecipherable to Japanese artists, and different prints based on the same illustration are thus labeled arbitrarily as American, British, Dutch, or Russian.[7] Nevertheless, the availability of detailed illustrations to the artists of Yokohama prints improved their ability to depict the foreign vessels with some accuracy. Although the Japanese print designers incompletely understood foreshortening and other Western techniques, those methods provided new inspiration for some of the most striking designs among Yokohama prints. Even the internal details of the ships supplied intriguing subject matter. Like the prints of daily life in the foreign community of Yokohama, prints of ships focused on details that struck the Japanese as obviously different from their own customs.

Western ships are among the most captivating subjects of Yokohama prints. The artists employed familiar Japanese artistic conventions for describing natural features such as waves, sky, and clouds to enhance their portrayals of the great ships. In contrast to the Dutch ships in the earlier, Nagasaki prints, which display a naive charm, or to Perry's black ships in the monochrome prints of the mid-1850s, ships in the prints of Yokohama achieve a new level of artistic merit.

1. One *koku* is equivalent to 10 cubic feet, or .28 cubic meters. Five hundred *koku* equal 49 gross tons.

2. Torao Mozai, "Ships," *Kodansha Encyclopedia of Japan*, vol. 7 (Tokyo: Kodansha, 1983), 144.

3. George Alexander Lensen, *The Russian Push toward Japan: Russo-Japanese Relations, 1697–1875* (New York: Octagon Books, 1971), 334–40.

4. Laurence Oliphant, *Narrative of the Earl of Elgin's Mission to China and Japan in the Years 1857, '58, '59*, vol. 2 (Edinburgh: William Blackwood, 1859), 240–42.

5. George M. Brooke, Jr., ed., *John M. Brooke's Pacific Cruise and Japanese Adventure, 1858–1860* (Honolulu: University of Hawaii Press, 1986), 156–57.

6. Alcock, *Capital of the Tycoon*, vol. 1, 94–95.

7. Kanagawa, *Yokohama ukiyo-e*, 428–34.

7 American Steamship: Length Forty *Ken*, Width Six *Ken*

The oceangoing ships that came to Yokohama from Europe and America were much grander in scale than the traditional Japanese coastal vessels. Perhaps to impress the intended purchaser, the publisher of this print included in its title the length and width of the steamship. In traditional Japanese architecture the *ken* is the distance between two pillars, a unit determined by the length, approximately six feet, of the standard tatami mat. Although the dimensions of tatami varied slightly from region to region, the *ken* as a unit of measurement was universally understood. The length of the ship, expressed in Japanese terms as that of forty tatami placed end to end, or roughly 240 feet, would have seemed palatial to the Japanese.

This print, a triptych of three

cat. no. 7
*Amerika jōkisen: nagasa yonjukken
haba rokken*
Edo period, 1861:4
by Yoshikazu (fl. ca. 1850–70)
publisher: Maruya Jinpachi
woodblock print
ink and color on paper
ōban triptych: 36.5 × 75.1 cm
(14 × 29⁹⁄₁₆ in.)

standard sheets, provides an overall wide format for the profile view of a ship with billowing sails and a plume of black smoke. Graded color printing of the sky, smoke, water, and evening glow on the horizon is beautifully executed in techniques that had become well established in the landscape prints of Hokusai (1760–1849) and Hiroshige I (1797–1858). The artist clearly devoted considerable effort to depicting the ship as accurately as possible and providing it with a suitably beautiful setting.

Yoshikazu's familiarity with European conventions of draftsmanship is apparent in the sharp, linear patterns in the sky. The image's peculiarly abstract quality contrasts markedly to the effect produced by the subtle graded washes typical of Japanese landscape prints.

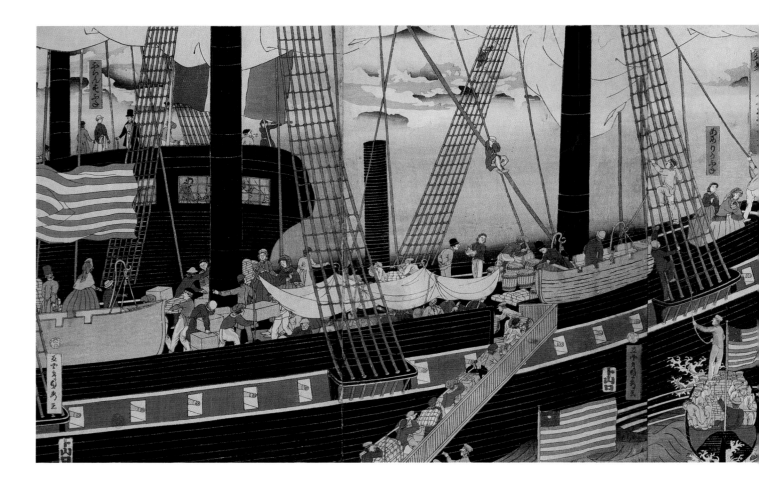

Sadahide's *Picture of Western Traders at Yokohama Transporting Merchandise* is a masterpiece among his many prints of Yokohama. The great black hulls of three Western ships dominate the foreground, looming so close and massive that even the space of five standard prints encompasses them only partially. In contrast to the high and distant viewpoint in Sadahide's panoramic landscapes of Yokohama, the scene here is depicted as if the viewer is looking steeply upward toward a network of masts, rope ladders, rigging, and furled white sails. From such perspective the ships in the foreground have a monumental effect.

Ships large and small visually dominate the dramatic and unprecedented design, but *Picture of Western Traders at Yokohama* is rich in observant detail that in-

vites close examination. The American ship in the foreground loads cargo from smaller boats that are rowed to its anchorage in the bay. The gangplank has a continuous procession of workers of various nationalities who bring cargo aboard in barrels and crates, while a clerk makes notes from the deck and sailors climb the rigging. Women observe the activity through the glass windows of the nearby French ship. Details of the lavish interior furnishings of the Russian ship at the far right are visible through its windows. In the distance are a Dutch steamer and a British sailing ship, the latter with its rigging full of sailors who look like acrobats.

Although Sadahide may have developed ideas for this unusual composition from having seen il-

lustrations such as that of the ships *Emperor* and *Melazzo* in the port of Naples published in the *Illustrated London News* (fig. 18),[1] his passion for incorporating personal observations of Yokohama communicates a vivid immediacy. It is said that Sadahide accidentally dropped his brush into the bay while he was aboard a small ship making preliminary sketches for this print, and so completed his sketches with a pencil donated by a foreigner.[2]

In contrast to many of the Japanese prints showing ships in Yokohama, which might well have been based entirely upon secondary sources, Sadahide's prints convey a colorful impression of firsthand experiences in the lively new city. The opening of Yokohama had provided him a fresh and welcome source of new subject matter and

cat. no. 8
Yokohama kōeki seiyōjin nimotsu unsō no zu
Edo period, 1861:4
by Sadahide (1807–ca. 1878)
publisher: Yamaguchiya Tōbei
woodblock print
ink and color on paper
ōban pentaptych: 37.2 × 127 cm
(14⅝ × 50 in.)

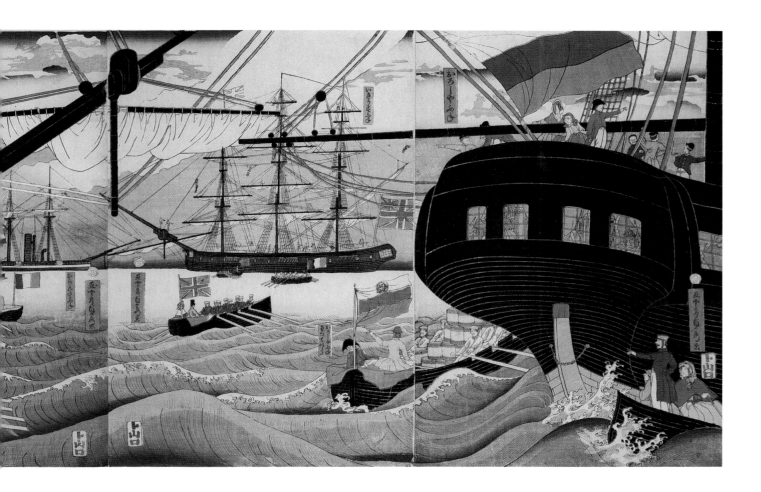

a means for expressing his versatility and artistic vision. The dense, crowded spatial organization of the print is the antithesis of Sadahide's expansive landscapes of Yokohama, such as his masterpiece of 1860, *Complete Picture of the Newly Opened Port of Yokohama* (cat. no. 1).

1. Kanagawa, *Yokohama ukiyo-e*, 432, fig. 26; Julia Meech-Pekarik, *The World of the Meiji Print: Impressions of a New Civilization* (New York: John Weatherhill, 1986), 20–21.

2. Kanagawa, *Yokohama ukiyo-e*, 495.

Figure 18 *Arrival at the Military Port, Naples, of the "Emperor" and the "Melazzo."* Illustration from the *Illustrated London News*, 3 November 1860.

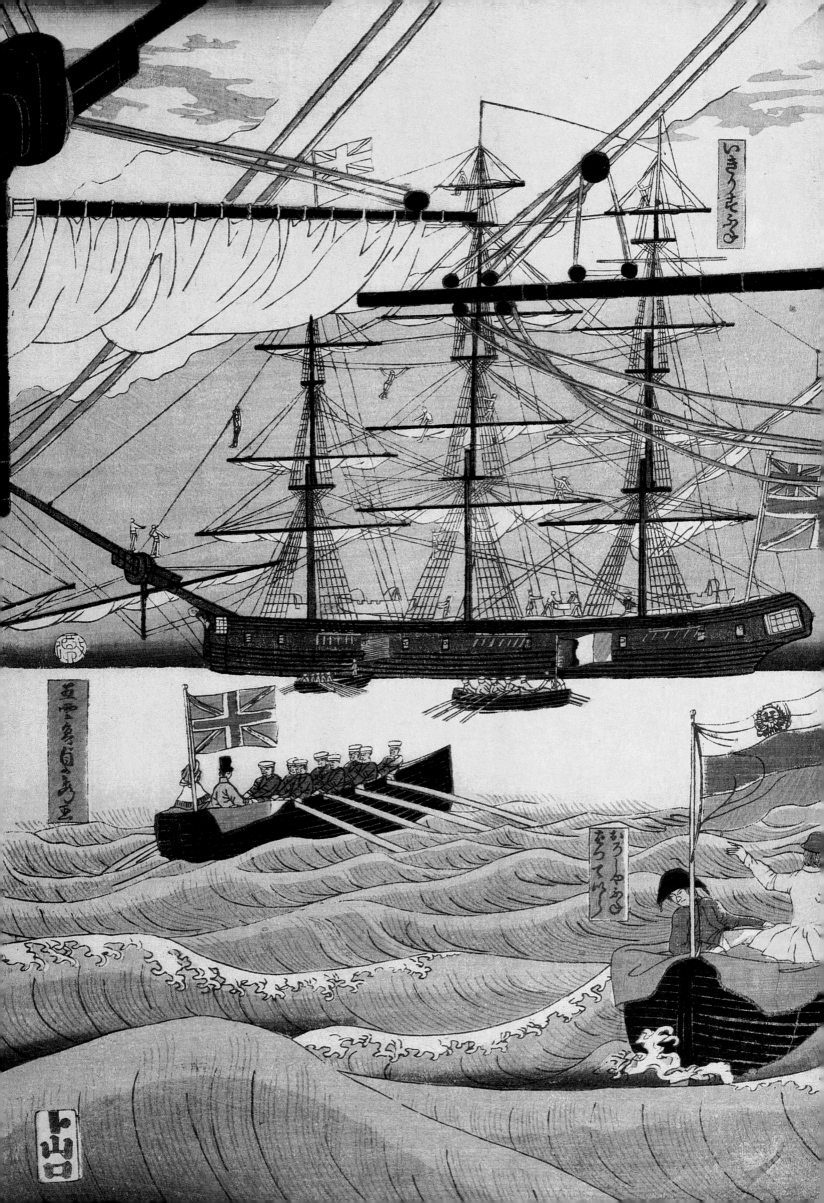

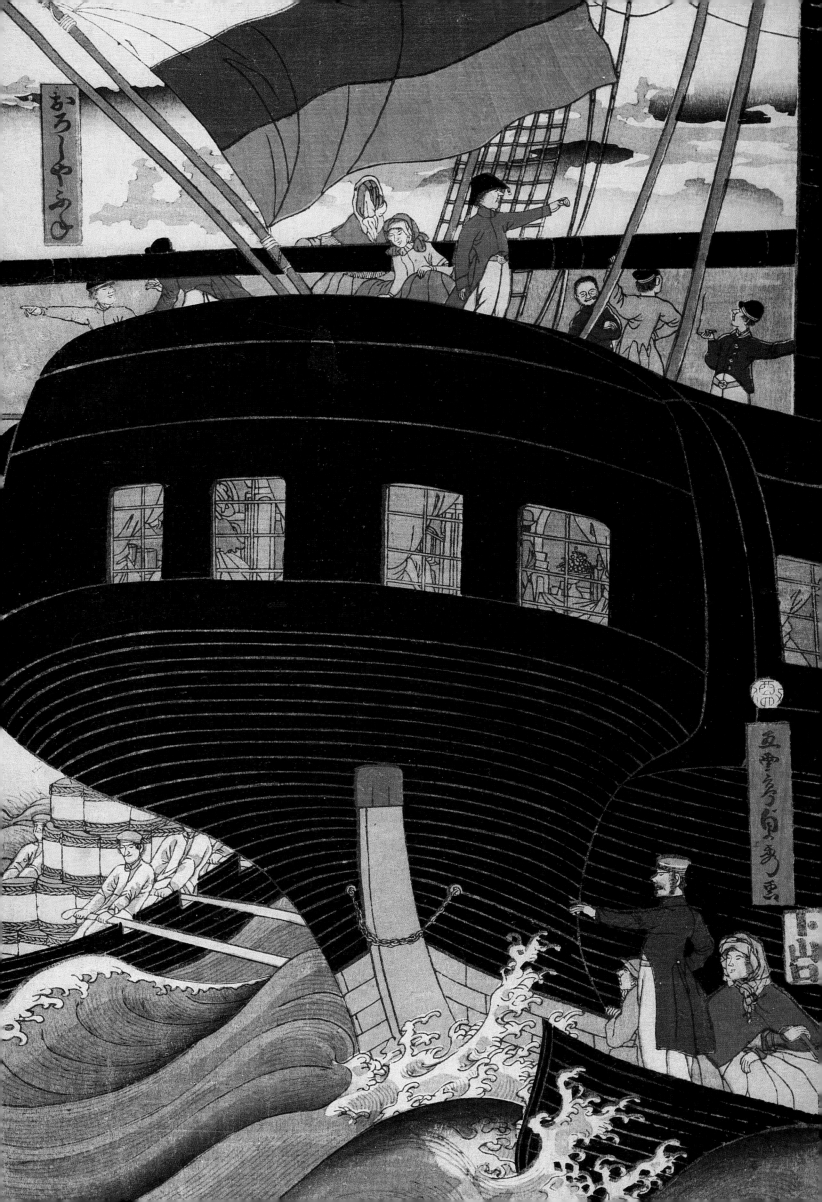

9 Picture of a Great Ship from America: In the Distance, Exact Copies of Great Ships of the Five Nations

cat. no. 9
Amerikakoku taisen no zu: sono hoka gokakoku taisen no shasei enkei
Edo period, 1861:3
by Yoshiiku (1833–1904)
publisher: Kobayashi Tetsujirō
woodblock print
ink and color on paper
ōban triptych: 37.1 × 72.6 cm
(14⅝ × 28⁹⁄₁₆ in.)

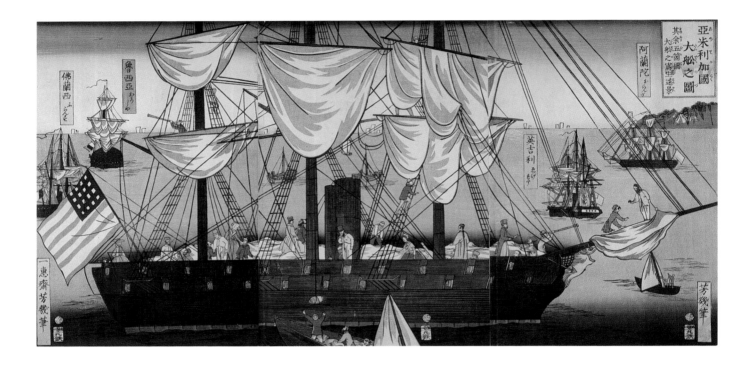

Yoshiiku was a young artist when the port of Yokohama opened in 1859. This print, showing an American ship in the foreground with the ships of the other four treaty nations—identified from left to right as France, Russia, England, and the Netherlands—in the background, was published in early 1861. Like other artists of Yokohama prints, Yoshiiku had seen illustrations published in the *Illustrated London News:* the "American" and "Russian" ships are both based on an illustration of the British hospital ship *Maritime* from the periodical's 21 January 1860 edition.[1]

1. Kanagawa, *Yokohama ukiyo-e*, 428–29.

10 Picture of the Interior of an American Steamship

cat. no. 10
Amerikakoku jōkisen no naka no zu
Edo period, 1861:4
by Yoshikazu (fl. ca. 1850–70)
publisher: Maruya Jinpachi
woodblock print
ink and color on paper
ōban triptych: 36.5 × 73.4 cm
(14⅜ × 28⅞ in.)

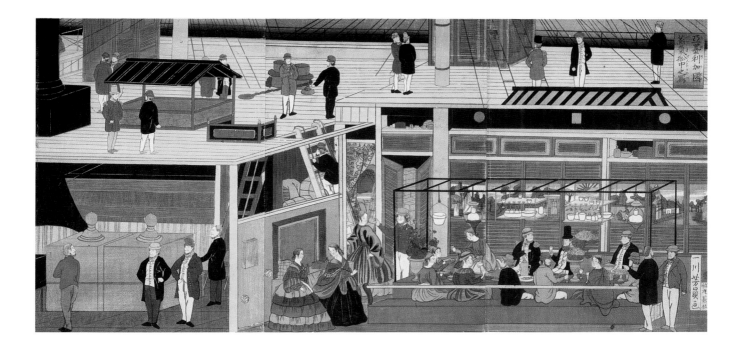

For this "interior view" of an American ship, the artist has adapted artistic conventions that had been employed in Japanese painting since at least the twelfth century. Architectural interiors, particularly in narrative handscroll paintings, were depicted from a high viewpoint as if the building's roof had been removed. The Japanese term for this compositional convention is *fukinuki yatai*, often translated as "blown-away roof." The unnatural, in fact impossible, perspective of *fukinuki yatai* allows the artist to portray activities more completely than would be possible from a level standpoint, since foreground figures do not fully obstruct those in the distance.

The upper deck of the ship is only partially shown, while in the foreground, below the deck, a dinner party is arranged as if the side and deck of the ship have been removed. In some of the women's dresses, the artist has made an effort to duplicate the impression of light and shadow that he had studied from the wood engravings in *Frank Leslie's Illustrated Newspaper.*[1] The artist's dependence on Western pictorial models for the figures and their clothing results in a somewhat unnatural, theatrical scene that is in effect a pastiche from more than one source. To the left several men stand in a room that houses equipment used in sugar manufacture.[2]

The artist, Yoshikazu, has rendered in detail the interior furnishings and tableware that fascinated Japanese observers of foreign residences in Yokohama. Stemmed glassware, urns holding sprays of flowers, footed serving dishes, hanging lamps, and framed pictures on the walls were remarkably different from their Japanese counterparts. Even the concept of a large group seated at a single table was unusual, since formal meals in Japan were customarily served on individual trays or low tables.

1. Kanagawa, *Yokohama ukiyo-e*, 504.

2. Ibid.

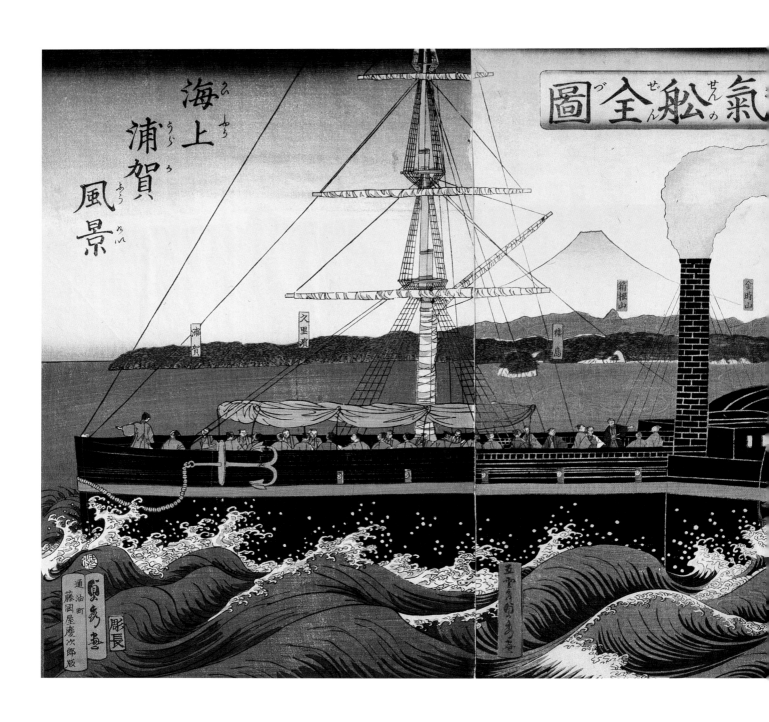

cat. no. 11
Jōkisen no zenzu: kaijō Uraga no fūkei
Edo period, 1863:2
by Sadahide (1807–ca. 1878)
publisher: Fujioka Keijirō
woodblock print
ink and color on paper
ōban triptych: 37 × 74.1 cm
(14⁹⁄₁₆ × 29³⁄₁₆ in.)

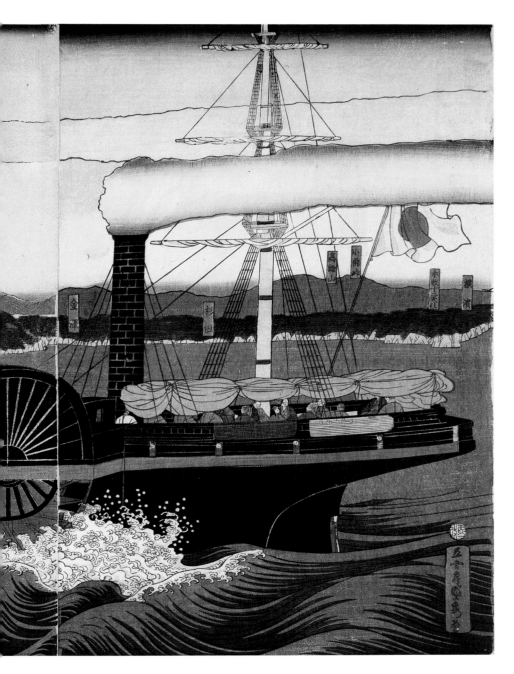

With manifest pride Sadahide created this triptych print showing a modern paddle-wheel steamer flying the Japanese flag. On deck is an entirely Japanese crew, dressed in traditional Japanese kimono and armed with the swords of samurai. Uraga, site of Commodore Perry's landing in 1853 on the Miura Peninsula, appears at the extreme left of the distant landscape.

By 1863, when *Complete Picture of a Steamship* was published, several large Western-built ships were sailing under the Japanese flag. The successful official voyage in 1860 of the Japanese crew of the *Kanrin Maru* to the United States had become a source of national self-esteem. This print by Sadahide, who had devoted so much enthusiasm toward studying Western customs in Yokohama, seems to express his veneration for Japan's mastery of the new naval technology. Ten years after Commodore Perry's black ships made their abrupt entrance into Japanese history, a Japanese ship glides loftily past Uraga, momentarily framing Mount Fuji between its mast and smokestack.

Technological innovation and the interiors of Western naval vessels continued to interest the artists of Yokohama prints even after Japan established its Navy Ministry in 1872. Unsen, an artist who specialized in depicting Western ships, portrays in this triptych of 1874 the interior rooms of a new battleship from Germany. Prussia and the North German Confederation had negotiated a commercial treaty with Japan in 1861, and the first Prussian consulate in Japan was established the following year.

The battleship's hull nearly fills the picture, so that only a portion of the rigging can be discerned. The deck teems with activity, including men working in the ropes. Below the deck, living quarters (those for officers to the right, and those for men of lower rank to the left and below) and rooms housing guns, ammunition, ropes, anchors, horses, and provisions are labeled with captions.[1]

1. Meech-Pekarik, *World of the Meiji Print*, pl. 16, illustrates another state of this print in the Metropolitan Museum of Art, New York.

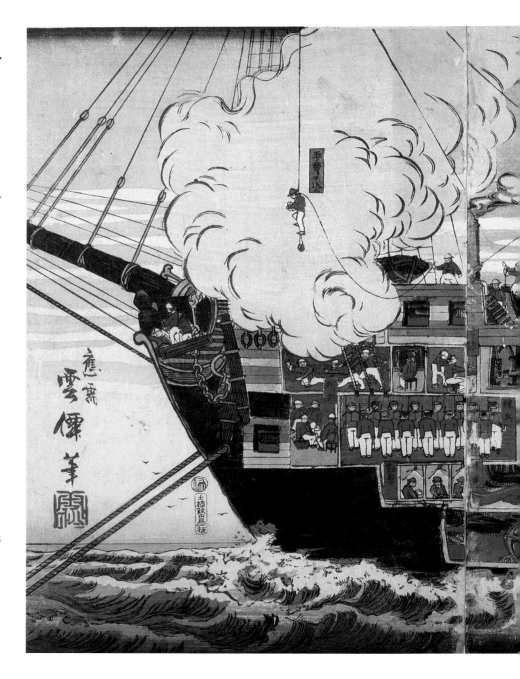

cat. no. 12
*Shinhatsumei: Doitsukoku gunkan
naikaku kikai no zu*
Meiji period, 1874
by Unsen (fl. ca. 1875)
publisher: Masadaya Heikichi
woodblock print
ink and color on paper
ōban triptych: 35.5 × 70.3 cm
(14 × 27¾ in.)

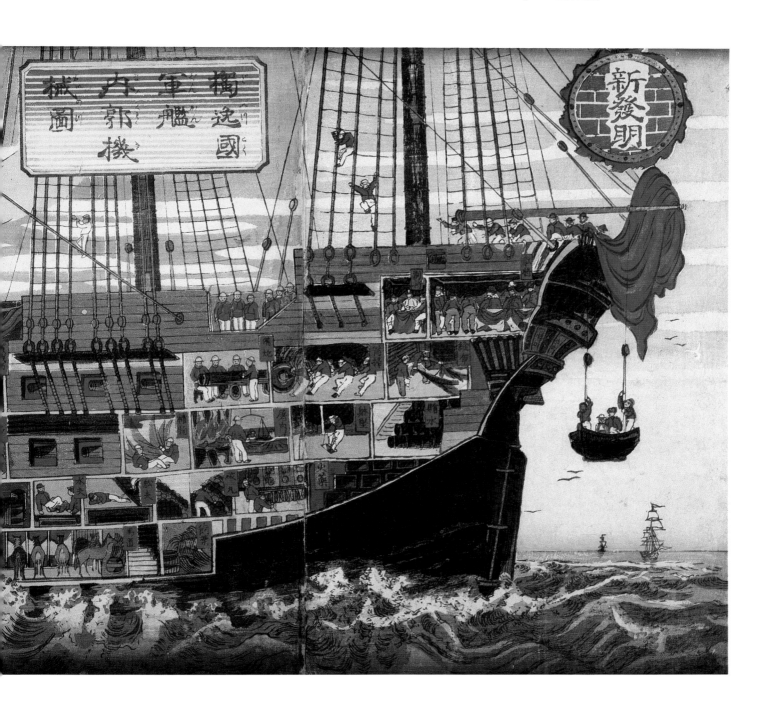

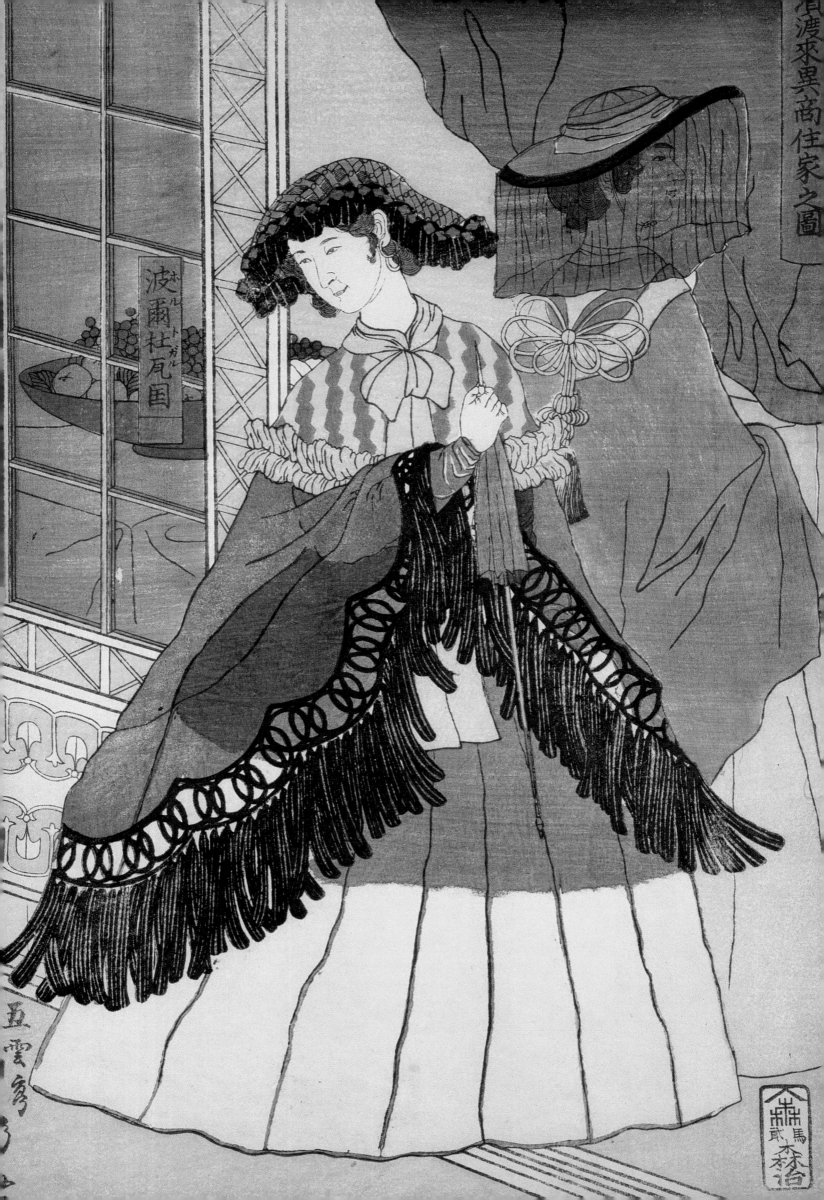

PEOPLE OF THE FIVE TREATY NATIONS IN YOKOHAMA

O N THE FIRST of July 1859, Yokohama opened in accordance with the commercial treaties that had been negotiated the previous year by the United States, Great Britain, France, Russia, and the Netherlands—the Five Nations of Yokohama prints. Other European nations such as Portugal, which had been officially excluded from Japan since 1639, and Prussia, whose commercial treaty came into force in 1863, initiated trade in Yokohama by joining with the officially recognized Dutch, French, or American firms. In addition to residents from the treaty nations, international trade also brought to Yokohama a large number of Chinese, who as money changers and compradors performed functions vital to the economy despite their lack of official status. Immigrants of other nationalities, especially those from the East Indies, India, and Southeast Asia, came as servants to the European and American merchants and speculators; they were followed in time by missionaries, physicians, and nearly every foreign visitor to Japan in the second half of the nineteenth century as Yokohama grew to become the major port of entry to Japan.

Considering the rapidity of Yokohama's development from swampland only a year before, the town was reasonably prepared for the arrival of foreign residents. On opening day the customhouse was staffed with interpreters and officials "with scales and weights and a glittering heap of new coins . . . ready to be exchanged, 'according to treaty,' for dollars."[1]

Despite the appearance of preparation for foreign commerce, many initial problems arose; not the least among them was establishing a rational method for managing international transactions paid in currency. Although its magnitude has been exaggerated in later historical accounts,[2] currency speculation was stimulated by the disparity between the Japanese five-to-one ratio of silver to gold and the international ratio of fifteen to one. By exchanging their coinage for Japanese silver and converting the Japanese silver to gold at the internal rate of exchange, the foreigners could export and reexchange the gold abroad at a significant profit. Exportation of Japanese gold was short-lived, however, since in early 1860 the Japanese government adjusted its internal rate of exchange to the international standard. It was not until 1863 that Yokohama's first bank, the Chartered Mercantile Bank of India, London & China, was established.

For the first three months after Yokohama's opening, trade was somewhat slow and even disappointing to the eager Western merchants. Silk and tea, the commodities the merchants anticipated from districts in close proximity to Yokohama, were not initially available in commercially profitable quantities. As news of the new market spread to the rural areas of Japan, however, the supply of agricultural goods transported to Yokohama from near and distant regions gradually increased.

Silk, tea, fish and vegetable oils, copper, and other products of Japan became the staples of trade in Yokohama. Yet demand for export commodities continued for some time to outpace supply, and the result was inflation in the domestic prices of products associated with international trade. Conditions abroad, such as epidemic disease in European silkworms, had a profound effect on the demand for Japanese silk. The Civil War's disruption of the cotton supply within the United States unexpectedly increased the exportation of Japanese cotton. Foreign merchants were also troubled by fluctuation in

Figure 19 *View of the Waterfront Street (Kaigan-dōri) in Yokohama,* 1870, by Hiroshige III (1842–1894). Woodblock print triptych; ink and color on paper. Kanagawa Prefectural Museum, Yokohama. The customhouse of Yokohama, flanked by the pair of stone piers constructed for the opening of the city in 1859, is the focus of this print, which depicts bales of raw silk and other commodities. The large buildings of the foreign settlement, rebuilt after the fire of 1866, are shown to the left.

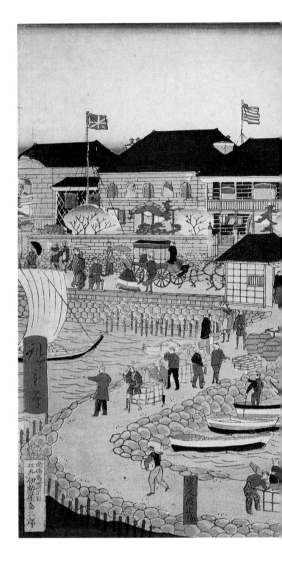

the quantity and quality of important commodities such as raw silk, especially during the first decade after Yokohama's opening. A report of the Yokohama Chamber of Commerce in 1868 cited such manufacturing problems as the poor quality and reeling of silk, and the excessive weight of paper ties used to bind the hanks.[3]

Comparative trade figures from British consular reports indicate that by 1860, only a year after its opening, Yokohama had overtaken Nagasaki in valuation of imports and led substantially in valuation of exports. Over the following years, Yokohama continued to increase its primacy as Japan's leading center of foreign commerce. By 1868, the year of the Meiji Restoration, trade at Yokohama was estimated at more than $34 million.[4]

The Japanese business district in the town of Yokohama consisted of numerous shops along the main street, Honchō-dōri, which were established by merchants who had moved hastily from Edo to set up their businesses in time for the opening of international trade. As Yokohama grew and prospered, the Japanese merchant community increased and vastly outnumbered the small but highly con-

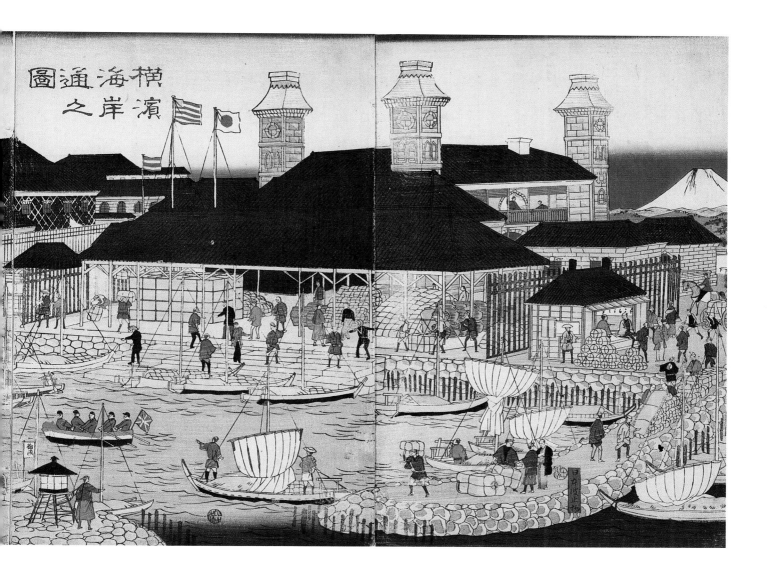

spicuous foreign community. The shops in the Japanese district provided food and other basic necessities of daily life for the Japanese and foreign residents of the area. Moreover, a bookstore and dealers in handcrafts, curios, and antiques were patronized by residents and visitors seeking souvenirs. Western accounts express the foreigners' admiration for the lacquerware and miniature ivory carvings (netsuke) that they purchased as memorabilia.

The resident community of Europeans and Americans was small, perhaps about twenty members, in 1859, and the consular residences were initially located across the bay in Kanagawa, the site stipulated for the foreign settlement by the American and European treaties. But according to the Reverend George Smith, bishop of Hong Kong, on a visit in May 1860, the "majority of foreign merchants, amounting to above one hundred persons, all classes included, find it more convenient to reside at Yokuhama [sic]."[5] Smith landed at Yokohama

between two piers protected by deep palisades of wooden piles . . . at the scene of Commodore

Perry's negotiation of the American treaty, the temporary struction [*sic*] raised for that purpose on a previously uninhabited point of the shore having been recently converted into the spacious offices of the Japanese custom house. Here on a level sandy spot extending a few hundred yards in each direction a foreign settlement of single-storied wooden houses and warehouses had speedily arisen, and all the busy scenes of European and Japanese traffic were visible. Japanese coolies, European and American sailors, native officials, and foreign mercantile agents, gave an air of business and animation to the place; and every variety of costume from the oriental garb of the country to the light and easy vestments of every hue, pattern and device, which Europeans feel themselves at liberty to adopt in these remote settlements, was conspicuous among the moving crowd in the newly-formed road lining the shore.[6]

The lively and picturesque scenes described by Western travelers to Yokohama proved equally captivating to the artists and publishers of Japanese prints, who were constantly seeking to illustrate the most current and fashionable subjects. Some of the more enterprising artists, such as Sadahide, must have made their way to Yokohama from Edo, about seventeen miles away, to record their observations. Others relied less on their own experiences than on secondary sources such as sketches, prints, and illustrations by both Japanese and Western artists.

The allure of the foreign community to Japanese artists is apparent in their prints, which are full of images that emphasize the details that caught the artists' attention as unfamiliar or unusual. In that respect the prints provide a Japanese counterpart in visual terms to the numerous Western writings from the period that describe Japanese dress, food, customs, language, and even the conventional mode of sitting or sleeping without what was regarded by foreigners as the minimal requisite furniture.

Both Western travelers and Japanese artists were forced by circumstance to rely chiefly upon their immediate observations and impressions, since initially they had no common language other than the diplomatic language, Dutch, which was known among the Japanese only to a handful of official interpreters. With the passage of a few years a language peculiar to Yokohama, consisting of an ungrammatical mixture of words from Japanese, Western languages, and even Malay, had evolved. Sir Ernest Satow (1843–1929), who was sent to Japan in 1862 for language training to become a professional interpreter in the diplomatic service of Great Britain, later recalled, "A sort of bastard language had been invented for the uses of trade, in which the Malay words *peggi* and *sarampan* played a great part, and with the addition of [the Japanese words] *anata* and *arimasu* every one fancied himself competent to settle the terms of a complicated transaction."[7] Gestures and sign language must also have had a role in the linguistic vacuum of the early 1860s, when a clap of the hands customarily signified agreement to the terms of a transaction.

The exceptional popularity of Japanese prints depicting the foreign settlement in Yokohama is confirmed by evidence that a large number of impressions were printed for many of the designs. Since many of the extant prints were unclearly printed from extremely worn blocks, it can be surmised that hundreds of impressions were printed of some of the most popular designs.

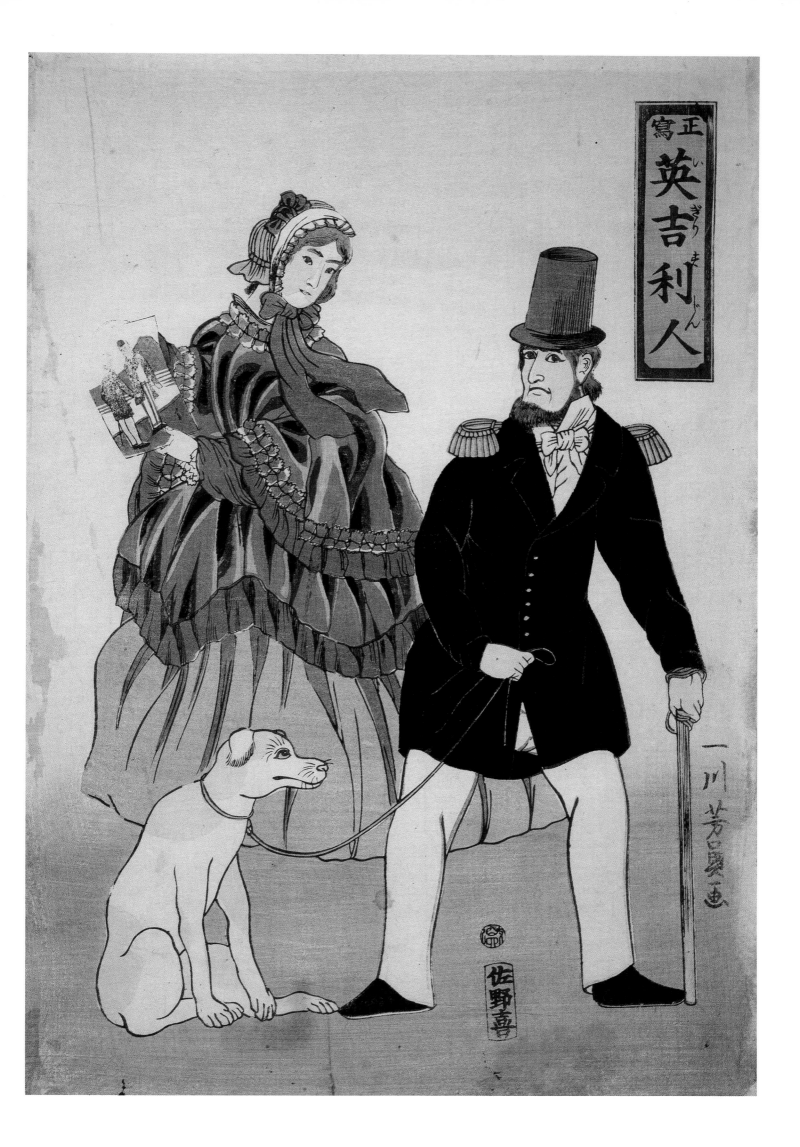

正寫 英吉利人

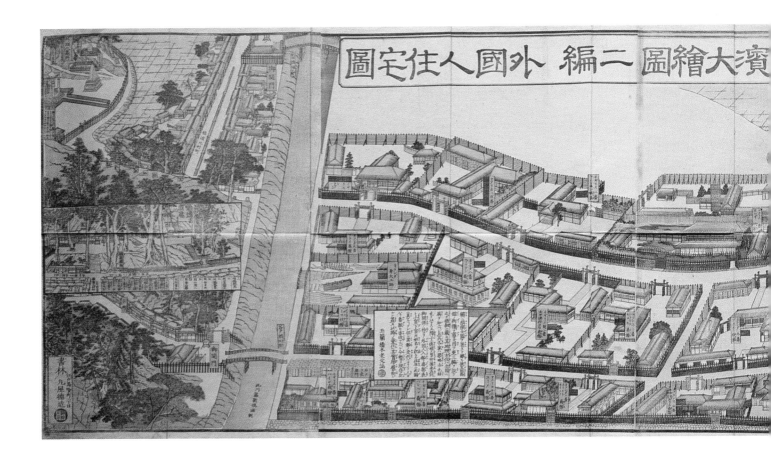

The demand for prints of the foreigners may be assumed to have been concentrated in the nearby metropolis of Edo, which had an estimated population of more than one million; but the many travelers who traversed to and from Edo along the Tōkaidō, which passed through neighboring Kanagawa, might well have taken the prints as souvenirs, testimony to the appearance of the strangers in Japan. Shortly after his arrival in Japan late in 1860, British horticulturalist Robert Fortune described a visit to a bookstore in the Japanese section of Yokohama where maps, illustrated books, and "pictures," probably meaning woodblock prints, could be obtained.

> Although foreigners have been only a short time residing in Yokuhama [*sic*], their appearance, customs, and manners are faithfully represented by Japanese artists. Here are to be found pictures of men and women—rather caricatures it must be confessed—engaged in amusements peculiar to highly civilized nations. Ladies riding on horseback, or walking—duly encompassed with a wonderful amount of crinoline—are fairly represented. . . . Altogether, some very curious and instructive works of Japanese art may be picked up in shops of this description.[8]

Possibly the foreigners, too, found these pictures of themselves amusing and novel enough to purchase as keepsakes.

Without recourse to verbal communication, the Japanese artists captured in their prints whatever

Figure 21 *Large Panorama of Yokohama Port Showing the Foreign Residences*, ca. 1862, by Sadahide (1807–ca. 1878). Woodblock print pentaptych; ink and color on paper. Kanagawa Prefectural Museum, Yokohama. Details of the buildings of the foreign settlement are faithfully depicted in this print, one of the most accurate portrayals of Yokohama. Lot number one on the Bund, the Western term for the Yokohama waterfront, housed the two-story headquarters of the British firm Jardine Matheson, popularly known in Japanese as Ei-Ichiban-kan (British Number One Building). Lot number two, directly to the left, was the compound of the American firm Walsh & Company (later Walsh, Hall, & Company).

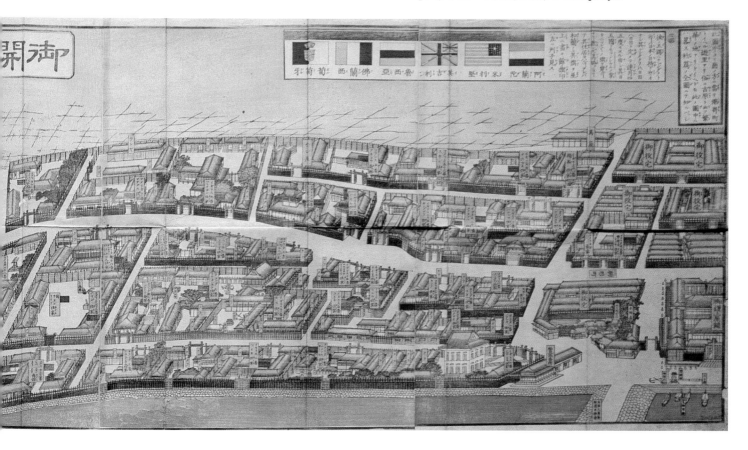

aspects of foreign life seemed to them most striking, noteworthy, and perhaps most colorful and artistically effective. Western clothing, from military uniforms with shiny buttons and epaulets to women's full skirts, was so remarkably different from Japanese dress that it excited curiosity and at times close examination wherever the foreigners ventured. Conversely, Western travelers to Japan, habituated to the heavy clothing of the Victorian era, were struck by how little clothing the Japanese laborers and peasants wore. Although the artists of prints of the foreigners of the Five Nations made a sincere attempt to portray the "true" appearance of their subjects, their lack of familiarity with details of Western costume and customs is often apparent. Epaulets slightly askew, misshapen musical instruments, and other odd misunderstandings appear frequently in the prints.

Japanese artists also described in detail the furnishings of Western residences, many typical adornments of which they clearly regarded as extraordinarily luxurious. Before the opening of Yokohama few Japanese had seen carpets covering the floors, lamps and chandeliers, framed pictures on the walls, or ornamental glassware. They considered carpets such a luxury that Fukuzawa Yukichi (1835–1901), a member of Japan's first diplomatic mission to the United States, recalled in his autobiography his arrival at a hotel in San Francisco in March 1860:

> There we noticed, covering the interior, the valuable carpets which in Japan only the more wealthy could buy from importers' shops at so much a square inch to make purses and tobacco pouches

with. Here the carpet was laid over an entire room—something quite astounding—and upon this costly fabric walked our hosts wearing the shoes with which they had come in from the streets! We followed them in our hemp sandals.[9]

Suddenly, thousands of prints dispersed throughout Japan by travelers to Kanagawa, Yokohama, and Edo communicated the newfound wonders to commoners nationwide with an immediacy probably comparable in its time to that of television today.

Yokohama prints reveal a wide variety of approaches to the subject of the people of the Five Nations. Sadahide, more so than other artists, generally took the most documentary approach in producing prints that reflect a personal study of life in Yokohama (see fig. 20). Some seem to have composed their designs after studying pictorial sources such as Western newspaper and magazine illustrations; others adapted conventional artistic themes, such as beautiful women, women and children, lovers, or views of famous sites. Series of five prints, one representing each of the Five Nations, are common, and China is occasionally incorporated or added as a sixth print.

Western women appear in Japanese prints in numbers disproportionate to their actual presence in early Yokohama, where the foreign community was predominantly male. Prints of fashionably dressed Japanese women, especially the courtesans of Edo's Yoshiwara, who were the popular celebrities of their day, had been an important subject of Japanese popular prints since the efflorescence of the medium in the eighteenth century. Accustomed as they were to depicting beautiful women, Japanese artists were naturally inclined to favor the subject of foreign women, even in the absence of opportunities for direct observation. Those artists who had never seen a Western woman, perhaps the majority in the early 1860s, relied upon secondary sources such as the *Illustrated London News* and the American publication *Frank Leslie's Illustrated Newspaper*, both of which were available in Yokohama.

Prints were the first popular medium to disseminate basic information about the languages of the five treaty nations. A number of "dictionary" prints depicting foreigners and accompanied by texts consisting of Japanese words and the transliterations of equivalent foreign words were published. The titles of a few of these prints even attempt to reproduce selected letters of the roman alphabet. Although some of the translations—such as those reflecting arbitrary responses to the question "What do you call this?"—are amusing, they are often reasonably accurate for an era in which no true bilingual dictionaries existed for the French, Russian, or English languages.

Apart from the dictionary prints, a few Yokohama prints have brief texts presenting statements about each of the Five Nations and occasionally China. The texts are written in simple prose with phonetic transliterations of all Chinese characters, thereby to facilitate comprehension by the many Japanese whose reading ability was limited. The texts represent the first facts about Western nations to be widely circulated in Japan.

To the artists and publishers of Japanese prints the people of the Five Nations seemed novel and intriguing, an ingenuous response shared among many of the common people of Japan who had little previous contact with foreigners. What the prints do not reflect is the dark undercurrent of fear and

insecurity that had haunted the foreign settlement almost from the outset and had caused the merchants and diplomats to arm themselves, post guards, and build stockades around their businesses and residences.

Among the governing classes of Japan the attitude toward foreigners during the 1860s ranged from ambivalence to open hostility. The foreign residents and even the Japanese who were employed by them experienced within the first years after the opening of Yokohama a series of murders and appalling injuries at the hands of sword-bearing samurai. Fire was a constant threat to the houses and warehouses made of wood, and even copper siding did not protect the structures from the great fire of 1866, which left homeless more than one hundred residents, or one-quarter of the Western settlement. Having the resilient spirit of pioneers, however, the residents of Yokohama rebuilt after each disaster, making improvements along the way. Wider avenues, for example, intended to serve as firebreaks, also alleviated traffic conditions.

The popularity of prints describing foreigners in Yokohama was relatively short-lived, with the majority of them, amounting to more than five hundred designs, having been published between 1860 and 1862. At the level of popular culture they express, together and individually, a brief but widespread fascination, even infatuation, with the new foreign community. Political and diplomatic problems within Japan may have had as great a role in the precipitous decline of Yokohama prints as the waning of their novelty. Yet, following a temporary lapse, Yokohama became once again, just after the Meiji Restoration of 1868, a focal subject of Japanese prints. By then, the full significance of the coming of the people of the Five Nations had been realized, and Yokohama came to be identified with modernity and progress in a time of great transition.

1. Alcock, *Capital of the Tycoon*, vol. 1, 144.

2. John McMaster, "The Japanese Gold Rush of 1859," *Journal of Asian Studies* 19, no. 3 (1960): 273–87.

3. F. O. Adams, *Report on the Silk Districts of Japan* (London: Silk Supply Association, 1869), 32.

4. Paske-Smith, *Western Barbarians*, appendix 1, 303.

5. George Smith, *Ten Weeks in Japan* (London: Longman, Green, Longman & Roberts, 1861), 247.

6. Ibid., 249–50.

7. Sir Ernest Satow, *A Diplomat in Japan* (London: Seeley, Service, 1921), 23.

8. Fortune, *Yedo and Peking*, 37.

9. Fukuzawa Yukichi, *The Autobiography of Yukichi Fukuzawa*, trans. Eiichi Kiyooka (New York: Columbia University Press, 1966), 113.

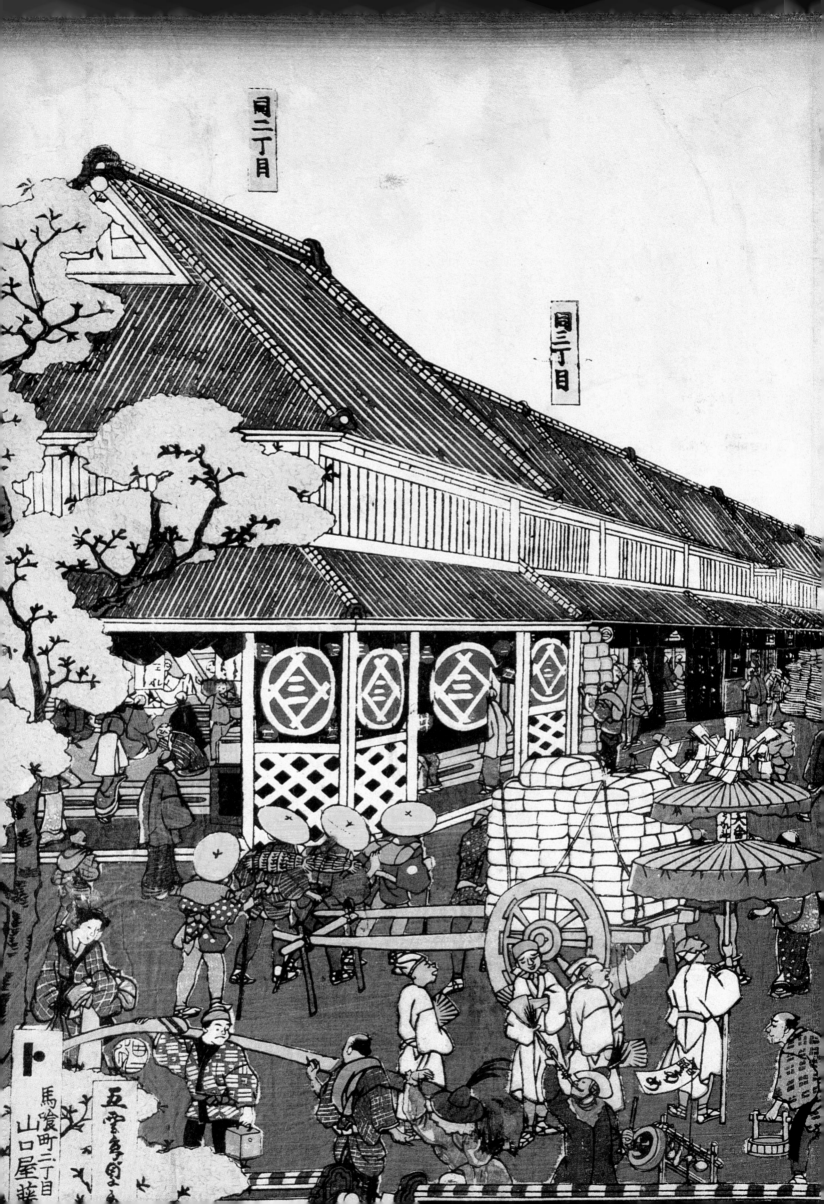

13 Picture of the Newly Opened Port of Yokohama in Kanagawa

cat. no. 13
Kanagawa Yokohama shin kaikō zu
Edo period, 1860:2
by Sadahide (1807–ca. 1878)
publisher: Yamaguchiya Tōbei
woodblock print
ink and color on paper
ōban triptych: 36.6 × 75 cm
(14⅜ × 29½ in.)

Using principles of perspective that had been introduced from European art into Japanese prints of the eighteenth century, Sadahide depicted in this triptych the lively main street of Yokohama's Japanese business district. One of the earliest prints of Yokohama, this view of Honchō-dōri, the wide boulevard of the Japanese quarter, reveals no evidence of the presence of the foreign settlers from the Five Nations, who in 1860 formed, in fact, only a small community of fewer than fifty residents. Among the few distinctly foreign costumes are those worn by the candy vendors shown in the left foreground; their garments recall those displayed in Korean diplomatic processions. [1]

Filling the wide street are heavily laden peddler's carts pushed by laborers, and packhorses, travelers, vendors, and a few women and children. The comfortable, practical, indigo-dyed clothing of the working men parallels the description of Japanese boatmen and dockworkers written by American painter John La Farge (1835–

1910) upon his arrival at Yokohama on 3 July 1886. He observed "rowers standing in robes flapping about them, or tucked in above their waists. There were so many that the crowd looked blue and white—the color of their dresses repeating the sky in prose." [2] Dogs and even a tame boar run loose in the busy streets.

The Japanese shops, unshuttered for the day, are full of a variety of merchandise, including the "curios" described in detail by Western travelers who seemed never to fail to spend some of their time shopping on Honchō-dōri. The Japanese commercial district as depicted by Sadahide resembles the scene encountered by British horticulturalist Robert Fortune in 1860:

The native town is remarkable for one fine wide street which runs down its centre. Here are exposed for sale the various productions of the country in very large quantities. Bronzes, carvings in ivory, lacquer-ware, and porcelain, are all duly represented. [3]

The shop in the left foreground is marked with the distinctive

trademark of Mitsui, Japan's wealthiest merchant house during the Edo period (1615–1868). Specializing in dry goods, and money lending and exchange, members of that family also served the Tokugawa shogunate as chartered merchants (*goyō shōnin*) who transmitted tax receipts from Osaka to Edo. [4] Mitsui's establishment of a shop in Yokohama foreshadowed its future involvement with international trade, shipping, and finance. Having successfully adapted to rapidly changing political and economic conditions during the nineteenth and twentieth centuries, Mitsui is now Japan's second-largest general trading company (*sōgō shōsha*).

1. Ronald P. Toby, "Carnival of the Aliens: Korean Embassies in Edo-Period Popular Art and Culture," *Monumenta Nipponica* 41, no. 4 (Winter 1986): 415–56.

2. John La Farge, *An Artist's Letters from Japan* (1897; reprint, London: Waterstone; New York: Hippocrene Books, 1986), 1–2.

3. Fortune, *Yedo and Peking*, 33.

4. Eleanor M. Hadley, "Mitsui," *Kodansha Encyclopedia of Japan*, vol. 5 (Tokyo: Kodansha, 1983), 209–10.

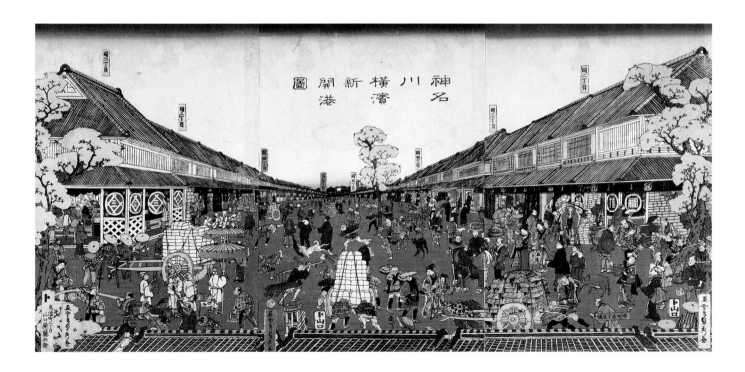

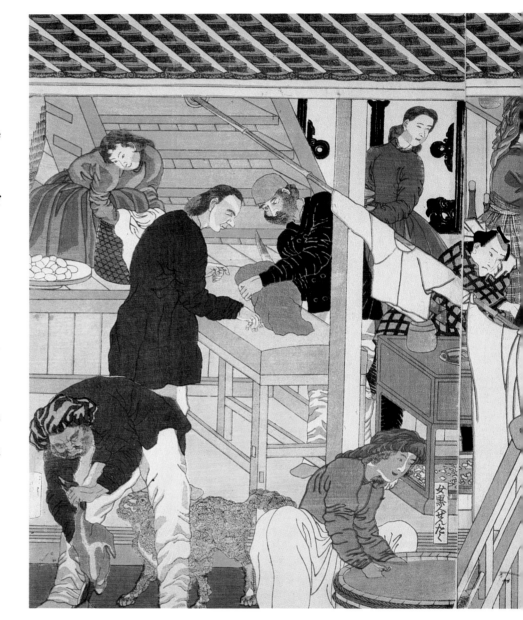

In a crowded but typically observant composition, Sadahide has depicted activities in a Western mercantile office. At right Western merchants bargain over merchandise with Japanese tradesmen; hand gestures supplement their extremely limited knowledge of each others' native languages. Also to the right, wearing a long robe and queue, is a Chinese merchant, one of a large community of Chinese men who performed essential functions in Yokohama's economy as compradors and money changers. Toward the back of the room a Japanese merchant of higher status oversees another transaction.

Sadahide has depicted the furnishings and activities remarkably accurately, even capturing such details as the left-to-right horizontal writing of the man in the foreground; by contrast, Japanese was customarily written with a brush in vertical columns beginning from the upper right corner of a page. On the shelf are large bound volumes of books with embossed leather covers, numerous containers and boxes, and a huge picture of an elephant.

At left, in the back room, a stairway leads to a second floor, a rarity in early Yokohama. As Sir Ernest Satow (1843–1929) observed, "Architectural ambition at first was contented with simple wooden bungalows, and in the latter part of 1862 there were not more than half a dozen two-storied buildings in the foreign portion of the town."[1] Servants, including a black laundress in the foreground, attend to the household tasks, while the cooks prepare a large piece of meat and a duck.

1. Satow, *Diplomat in Japan*, 22.

cat. no. 14
Yokohama ijin shōkan uriba no zu
Edo period, 1861:9
by Sadahide (1807–ca. 1878)
publisher: Sanoki
woodblock print
ink and color on paper
ōban triptych: 34.8 × 72.8 cm
(13¾ × 28⅝ in.)

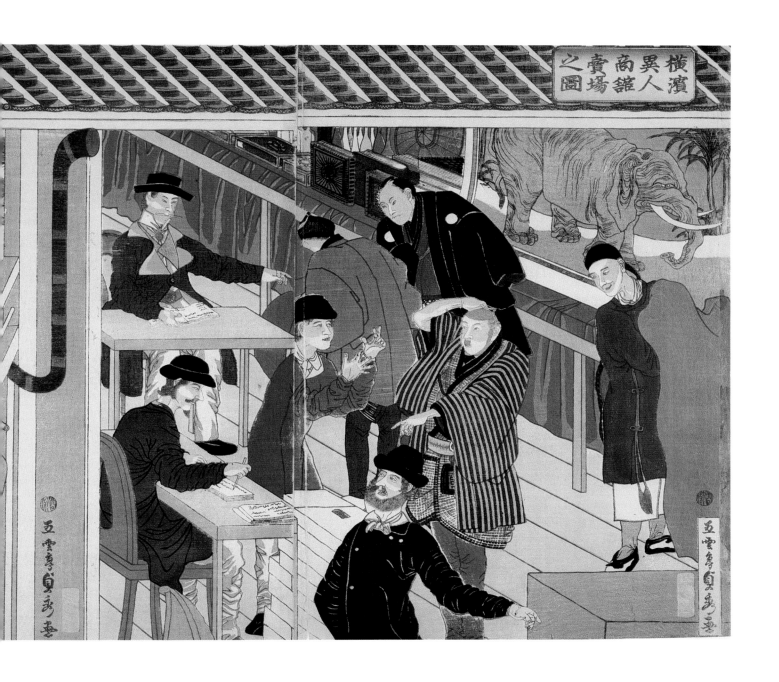

15 Picture of a Foreign Building in Yokohama

In contrast to the many prints of Yokohama based on secondary sources, this print, like those of Sadahide, is full of particular details that correspond closely to contemporary descriptions. The location and configuration of the enclosed compound, for example, parallel the accounts of Walsh & Company (later Walsh, Hall & Company), the first American firm to reach Yokohama in 1859.[1] An important map print by Sadahide published around 1862 (fig. 21) shows an aerial view of Walsh & Company's compound, located at lot number two on the Bund, the Westerner's term for the embankment along the harbor's edge. Sadahide's print shows the L-shaped configuration of the main building, the spacious courtyard, the surrounding palisade, and the gate in positions identical to Hiroshige II's composition. The company's early arrival in Yokohama secured its highly desirable location near the customhouse and one of the two stone piers.

Picture of a Foreign Building in Yokohama is replete with unusual details that provide an exceptionally faithful visual record of Walsh & Company's Yokohama compound. The American and Chinese wings of the main building, here labeled "American room" and "Nanking room," reflect what was known in 1861 about the firm's rented quarters. The buildings are depicted as typical Japanese structures—rooms supported by narrow pillars, with the floors built aboveground as platforms—but the walls are modified by the novel glass windows preferred by Western settlers.

Of particular interest is the garden in the large courtyard, where Japanese, Chinese, and Western visitors stroll. Plants grow in an orderly plot, and a magnificent *bonsai* pine, or miniature potted tree, can be seen in the distance.

Dr. George R. Hall of Walsh & Company, a pioneer resident of Yokohama, assembled an important collection of Japanese plants, which he transported to the United States in 1862.[2] This print suggests that his garden may have attracted visitors from Yokohama's small international community.

In the "American room," opened in the fine weather to a view of the harbor, two Japanese male visitors clad in kimono sit stiffly in chairs, enjoying refreshments with their American hosts; the

"Nanking room" near the gate of the compound has an open structure typical of a Chinese shop. Chinese compradors, employed by the European and American mercantile firms, provided invaluable assistance to merchants of the five treaty nations, who depended upon the compradors' ability to communicate in writing with the Japanese. To the left, Chinese and a Japanese make computations with abacuses, the remarkably efficient calculators used in many parts of Asia. On the walls are inscriptions in cursive Chinese

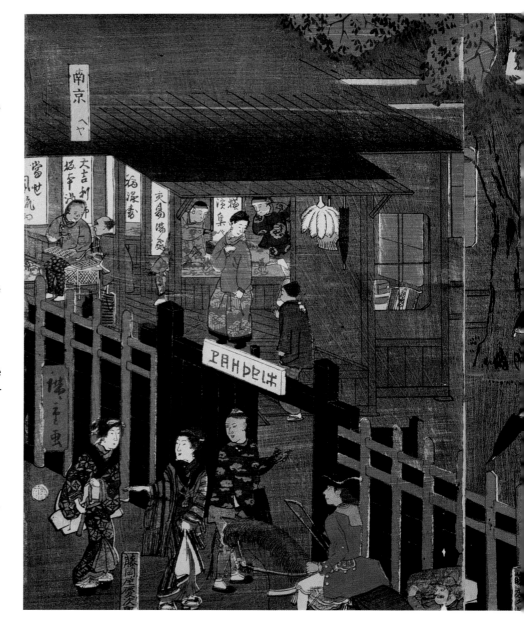

cat. no. 15
Yokohama ijinkan no zu
Edo period, 1861:10
by Hiroshige II (1826–1869)
publisher: Fujiokaya Keijirō
woodblock print
ink and color on paper
ōban triptych: 34.9 × 73.4 cm
(13¹¹⁄₁₆ × 28⅞ in.)

script that resemble the signs in Chinese shops that describe merchandise. Reading from right to left, the inscriptions provide random phrases such as, "Yokohama collection, whole place for trade, Fukurokuju [God of Long Life], Ōkichi print publisher bath . . . contemporary fashion."[3] Across the courtyard to the right hang rows of ducks to be used for meat. Over the gate, the artist has copied letters of the Cyrillic alphabet, possibly because he thought he was writing English. Hiroshige II's rendition is sufficiently accurate to

indicate that he had actually seen Russian writing in some form.

In contrast to many of the Yokohama prints that present the generalized features of foreign mercantile establishments, *Picture of a Foreign Building in Yokohama* provides an unusually accurate portrayal of a specific site that can be identified from contemporary records. Like Sadahide, Hiroshige II must have had an opportunity to visit Yokohama and record his impressions. Perhaps he once had joined the visitors to Dr. Hall's garden in the Walsh compound.

1. This suggestion was made by Fred G. Notehelfer of the University of California, Los Angeles. See also his article, "Visions of Early Yokohama: Francis Hall in Treaty Port Japan," in *Asian Art* 3, no. 3 (Summer 1990): 9–35.

2. Ibid., 21–22.

3. This partial inscription behind the Chinese man holding an abacus seems to name the publisher of eighteenth-century prints of beautiful women, including bathhouse attendants (*Genshoku ukiyo-e dai hyakka jiten* [Great encyclopedia of ukiyo-e in color], vol. 3 [Tokyo: Daishūkan shoten, 1982], 136).

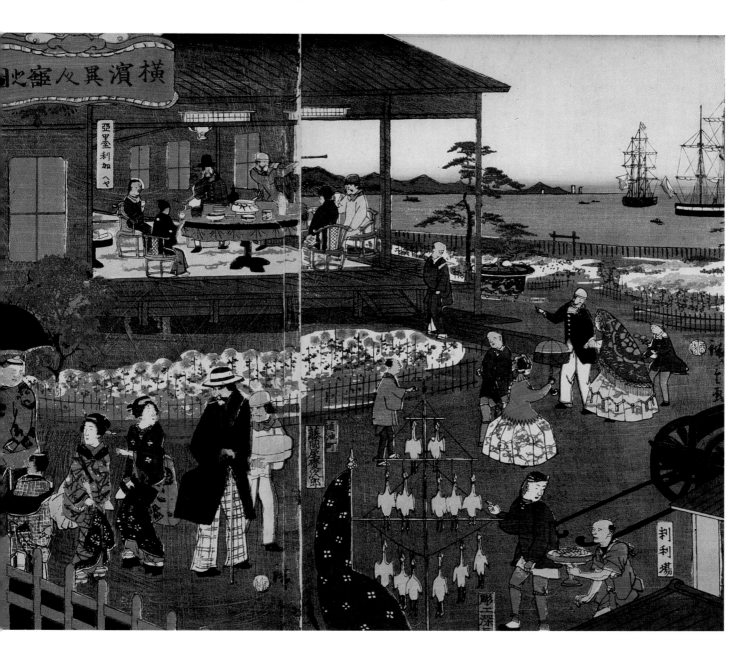

Sir Ernest Satow (1843–1929) recalled that upon his arrival in Yokohama in 1862:

Streets were laid out with but little thought of the general convenience, and slight provision for the future. The day of wheeled carriages had not dawned upon Japan. It was sufficient if space were left for handcarts, and the most important Japanese commercial town of the future was thus condemned in perpetuity to inconveniences of traffic, the like of which can best be appreciated by those who knew the central parts of business London fifty years ago, or the successive capitals of the Italian kingdom when they were raised to that rank.[1]

The disastrous fire of 16 November 1866 consumed one-third of the Japanese town of Yokohama and one-fourth of its foreign settlement, including Satow's residence and his precious library of books collected in China. In the aftermath of the fire Yokohama was rebuilt, however, and the city that emerged from the ashes was clearly more comfortable and orderly.

This print of 1870 depicts the mercantile establishments along Nakadōri, a broad avenue that was among the civic improvements following the great fire. The inconveniences Satow noted have disappeared, together with the flimsy wood palisades that had been erected around the early foreign compounds. Stone walls enclose substantial, two-story buildings, streetlamps stand along the wall, and carriages carry passengers toward the gate. Japanese and foreign men, women, and children mingle in the busy scene in the foreground while the wealthy foreign merchants look out from

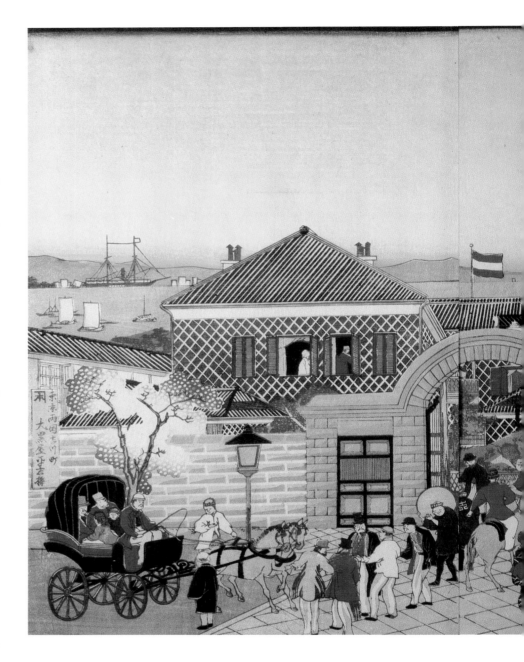

the windows and porches of their large buildings. Kuniteru's print represents Yokohama in a much-improved state just over ten years past its opening.

1. Satow, *Diplomat in Japan*, 24.

cat. no. 16
Yokohama kaigan Nakadōri shōkan han'ei no zu
Meiji period, 1870
by Kuniteru II (1830–1874)
publisher: Daikokuya Heikichi
woodblock print
ink and color on paper
ōban triptych: 37.2 × 76.3 cm
(14⅝ × 30 1/16 in.)

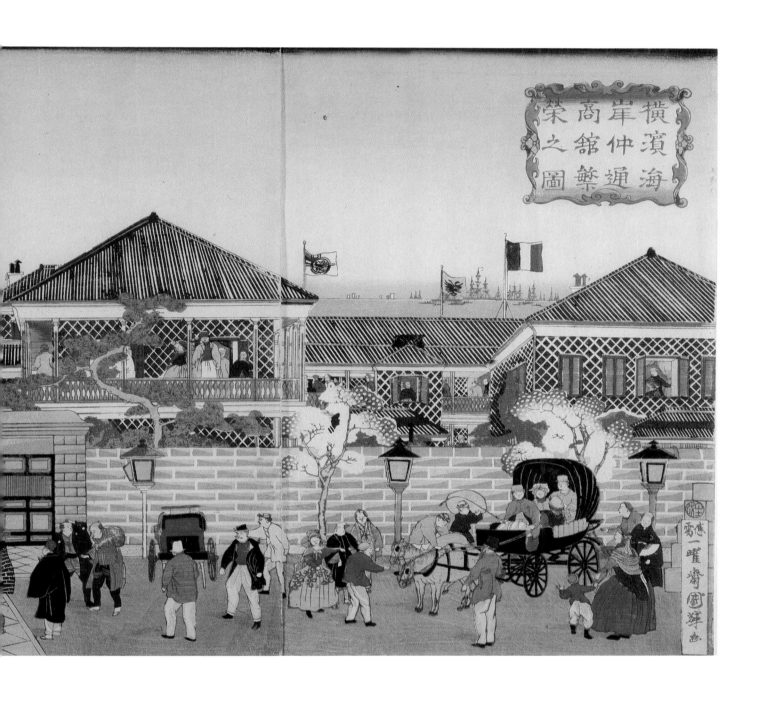

17 Picture of the Landing of Foreigners of the Five Nations in Yokohama

cat. no. 17
Gokakoku ijin Yokohama jōriku no zu
Edo period, 1861:11
by Yoshikazu (fl. ca. 1850–70)
publisher: Enshūya Hikobei
woodblock print
ink and color on paper
ōban triptych: 37 × 75 cm
(14%⁄16 × 29%⁄16 in.)

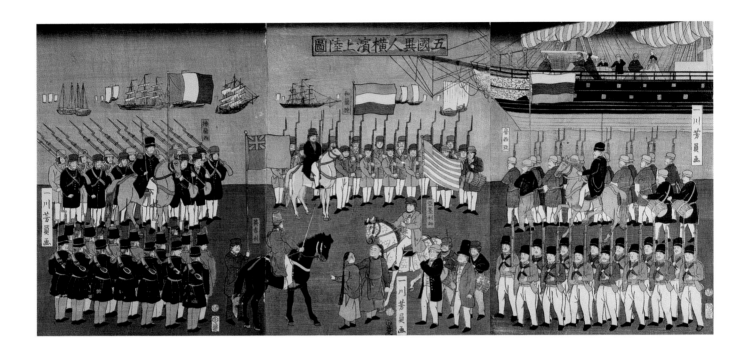

Along the Yokohama waterfront, known to the Western residents as the Bund, are soldiers and civilians of the five treaty nations. Each group is marked with a flag and a label identifying the country in Japanese; reading counterclockwise from the lower left are England, France, the Netherlands (or Oranda, for Holland), Russia, and America. Two Chinese, whose presence as compradors was vital to commerce in Yokohama, appear in the foreground. Several Western ships and single-masted Japanese coastal vessels fill the harbor. The largest, to the right, has furled sails striped like American flags, a sure indication that the artist had little firsthand knowledge of Western ships.

Yoshikazu's print is one of the earliest to depict military troops of the Five Nations in Yokohama. This scene is clearly an imaginative fabrication since in 1861 no occasion would have arisen for a friendly assembly of military units from the Western treaty nations.[1] Mutual suspicion and competitive interests in Tsushima, the islands lying strategically between Japan and the nearest point on the Asian continent, had led to hostility between the Russians, who had landed the warships *Posadnik* and *Oprichnik* at Tsushima, and the British, who encouraged the Tokugawa government to support British interests in forcing the Russians to withdraw.[2]

1. Kanagawa, *Yokohama ukiyo-e*, 300, 502.

2. Lensen, *Russian Push toward Japan*, 447–53.

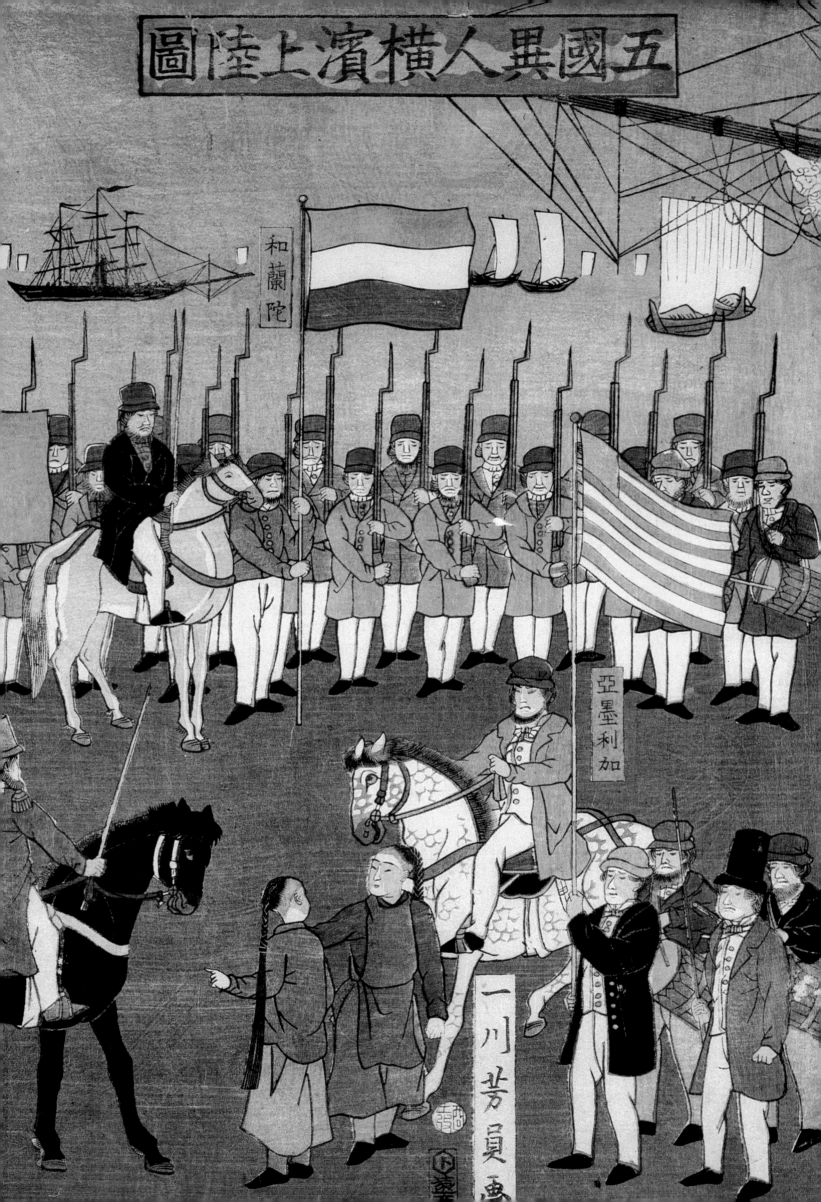

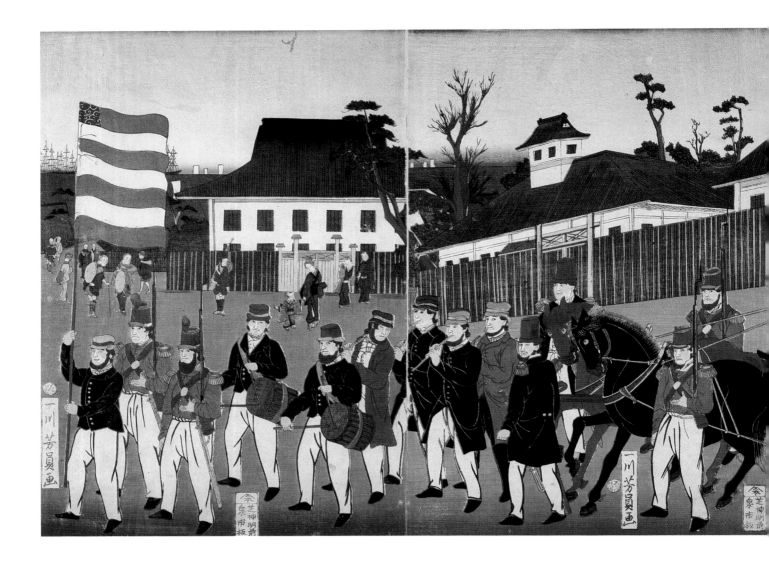

Processions (*gyōretsu*) of high officials and provincial rulers were frequent spectacles during the Edo period (1615–1868). In accordance with the alternate attendance (*sankin kōtai*) system instituted in 1635 by the Tokugawa shogunate, half of more than 260 daimyo would travel to Edo each year for a year's residence there, while the other half would leave Edo for their home territories. With a retinue of at least 150, a procession of a high-ranking daimyo might require in excess of two hours to pass along the road.[1] Colorful and impressive to the common people who lived along the highways of Japan, daimyo processions had become a subject

of Japanese paintings. The infrequent but even more noteworthy processions of Korean embassies to Japan had also become a popular theme of Japanese art of the Edo period.[2]

The title of this print recalls those familiar Japanese parades of dignitaries, both native and foreign. Instead of using a Japanese palanquin, a vehicle borne by men, the foreign couple rides in an open carriage drawn by a pair of horses. At the front of the entourage an American flag is carried aloft, like the tall standards of daimyo processions that warned of the lord's approach. Armed military guards and a fife-and-drum band accompany the retinue,

which has many elements of a typical American parade. Not likely to represent a actual event in Yokohama, the scene depicted here is rather a reprise of a common Japanese theme but with a new cast of characters. Some of the details of the procession, such as the carriage, military uniforms, and top hats, probably were adapted from Western news illustrations of the visit in 1860 of the first Japanese embassy to the United States (see fig. 22).[3]

The buildings in the background, however, appear to depict the compound occupied by the British firm Jardine Matheson & Company, located on lot number one on the Bund, adjacent to the

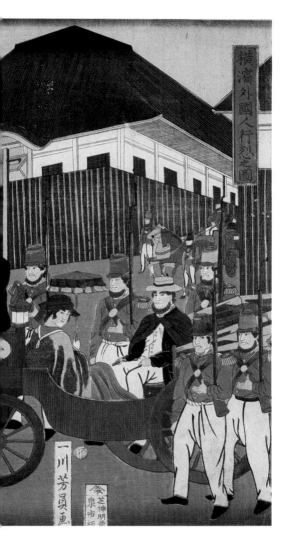

cat. no. 18
Yokohama gaikokujin gyōretsu no zu
Edo period, 1861:2
by Yoshikazu (fl. ca. 1850–70)
publisher: Izumiya Ichibei
woodblock print
ink and color on paper
ōban triptych: 36.4 × 73.7 cm
(14⅝⁄16 × 29¹⁄16 in.)

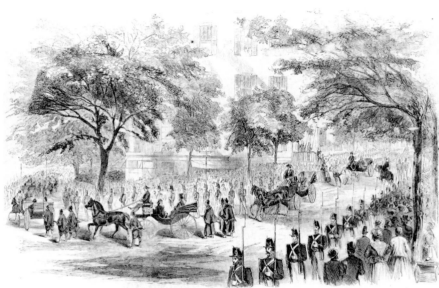

Figure 22 *The Procession of the Japanese Embassy Leaving Willard's Hotel to Visit the President.* Illustration from *Frank Leslie's Illustrated Newspaper*, 6 June 1860.

customhouse on the Yokohama waterfront. Representatives of Jardine Matheson, which had well-established commercial interests in China, arrived in Yokohama immediately upon its opening to foreign trade in 1859 and claimed a large and favorably located address for the firm's headquarters. Before the great fire of 1866, Jardine Matheson's compound had one of the few two-story buildings in the small foreign settlement of Yokohama. It can be seen in the left panel behind the Japanese passersby who gaze at the American parade.

1. G. Smith, *Ten Weeks in Japan*, 246–47.

2. Toby, "Carnival of the Aliens," 415–54, *passim*.

3. Kanagawa, *Yokohama ukiyo-e*, 433–34. Yōichi Yokota cites *Frank Leslie's Illustrated Newspaper* as the pictorial source for Yoshikazu's print.

19 Picture of a Parade of Foreigners Landing at Yokohama

cat. no. 19
Gaikokujin Yokohama jōriku gyōretsu no zu
Edo period, 1860:12
by Yoshikazu (fl. ca. 1850–70)
publisher: Maruya Jinpachi
woodblock print
ink and color on paper
ōban: 37 × 25.6 cm (14 9/16 × 10 1/16 in.)

In a street in the foreign quarter of Yokohama a group of soldiers armed with rifles stands at attention. Although the artist has attempted to copy their uniforms with care, he apparently had difficulty rendering the correct perspective of such ornaments as the men's epaulets, which hang askew. In 1860, when the print was published, relatively few foreign military officers would have been stationed in Yokohama. In Edo, however, where the foreign legations were located, military forces provided security. Count Mouravieff, representing Russia, is said to have "landed with a guard of three hundred men fully armed and equipped."[1] Like those in *Picture of a Procession of Foreigners at Yokohama* (cat. no. 18), the figures in this print might have been based on Western illustrations. The depiction of the buildings of the foreign quarter, enclosed for security behind wood fences, parallels descriptions in contemporary accounts of Yokohama.

1. Alcock, *Capital of the Tycoon*, vol. 1, 240.

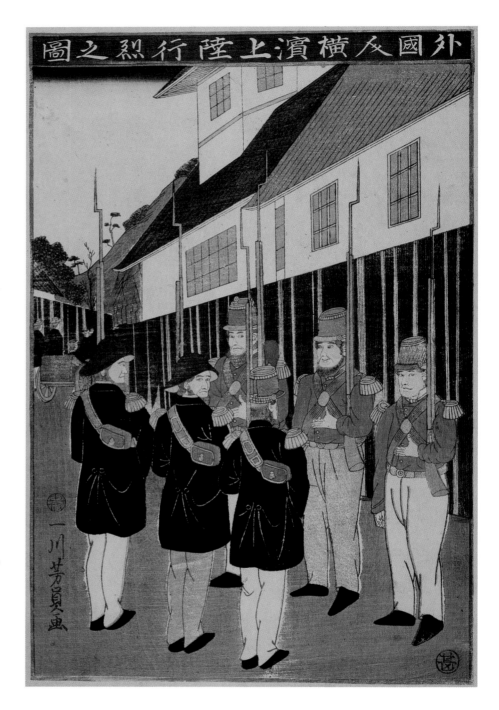

20 Picture of a Foreign Official Traveling

cat. no. 20
Gaikoku kanjin ōrai no zu
Edo period, 1860:11
by Yoshikazu (fl. ca. 1850–70)
publisher: Maruya Jinpachi
woodblock print
ink and color on paper
ōban: 34.5 × 24 cm (13 9/16 × 9 7/16 in.)

By the gateway of a foreign mercantile establishment near the Yokohama harbor, a man rides aboard an open carriage. In reality, probably few if any such vehicles could be found in Yokohama immediately after the port's opening, and the artist likely depended upon Western newspaper illustrations for this picture. Japanese roads were not well adapted to wheeled carriages, and dignitaries both Japanese and foreign were customarily transported in palanquins (*norimono*), enclosed compartments carried by male bearers. Japanese palanquins, which required passengers to sit on the floor, were small and uncomfortable for Western men accustomed to sitting on chairs; the early foreign residents of Yokohama and Edo regarded horseback riding as the preferable mode of transportation.

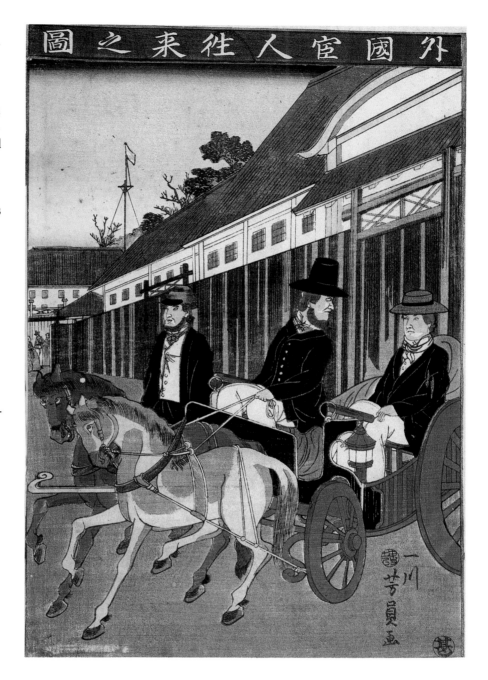

21 Picture of a Parlor in a Foreign Mercantile Firm in Yokohama

cat. no. 21
Yokohama ijin shōkan zashiki no zu
Edo period, 1861:9
by Sadahide (1807–ca. 1878)
publisher: Moriya Jihei
woodblock print
ink and color on paper
ōban: 34.8 × 24 cm (13¹¹⁄₁₆ × 9⁷⁄₁₆ in.)

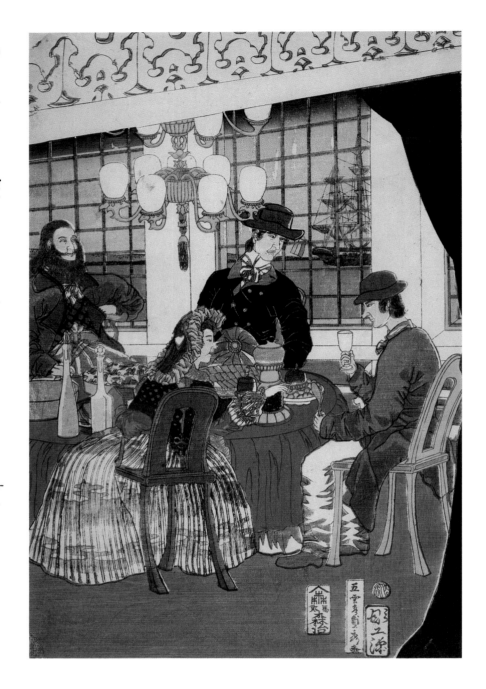

The left panel from an incomplete triptych, this print represents the interior of a Western business establishment in Yokohama; a large ship anchored in the harbor is visible through the glass windows. The details with which Sadahide has depicted the lady's elaborate hat and other accessories of costume reveal that his knowledge of current styles came from study of fashion plates in contemporary Western magazines.[1]

Sadahide demonstrates, moreover, an interest in capturing the postures and gestures of the group, all of which contrast markedly with customary Japanese poses. The bearded merchant leans back in his chair with his elbow propped on the arm. As if to emphasize the variety of novel utensils used for eating, one man is shown holding a stemmed glass and a spoon while his companion opposite holds a fork.

With so many problems to resolve in rendering altogether unfamiliar physiognomy, costume, and furniture, it is not surprising to see the artist's slight awkwardness in handling foreshortening, light and shadow, and miscellaneous details, such as the double rows of buttons on the black jacket. Sadahide's composition, which disposes the figures around the circular table so that they must be portrayed from various angles, is nonetheless daring and remarkably effective. The curtain in the foreground accentuates the viewer's impression of peering into an exotic scene.

1. The bonnet, a type that appears in several of Sadahide's prints of the period, resembles the Helena Bonnet illustrated in *Peterson's Magazine*, July 1861 (Meech-Pekarik, *World of the Meiji Print*, 26, fig. 21).

22 Picture of a Foreign Residence in Yokohama

cat. no. 22
Yokohama ijin yashiki no zu
Edo period, 1861:1
by Yoshikazu (fl. ca. 1850–70)
publisher: Ōmiya Kyūsuke
woodblock print
ink and color on paper
ōban triptych: 36.4 × 73.7 cm
(14 5/16 × 29 1/16 in.)

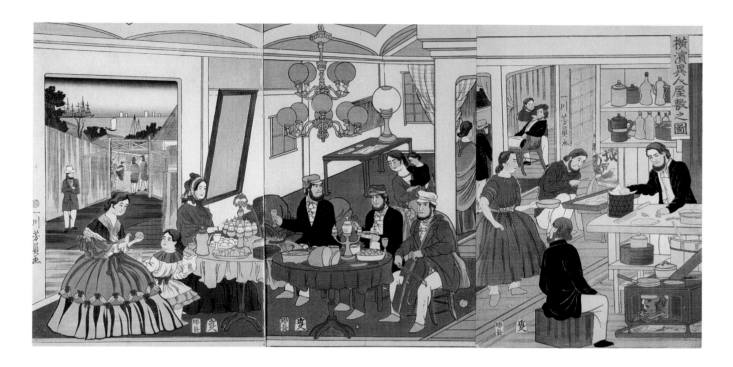

This charming print purports to portray the interior of a foreign *yashiki*, the Japanese term for the residence of a daimyo. Implicit in the choice of terminology is the opulence with which the Japanese associated the large scale of Western rooms and such typical furnishings as chandeliers and carpeted floors. The artist has endeavored to make the print as informative as possible about activities and material details of a Western household: in the kitchen to the right, food is prepared on a wood-burning iron stove; in the distance a bearded man is given a shave; in the parlor the table is laden with food and drink including a large loaf of bread; women of the household dressed in the fashionable full skirts of the period care for their children; the gateway of the residence stands open to a view of the harbor.

Although the print is rich in detail, it is not based on an actual foreign residence of Yokohama. Rather, the artist has created the scene from a number of contemporary sources. Many of the Western figures, such as the man playing the cello in the center print and the woman and child, have been adapted from illustrations published in the *Illustrated London News* and *Frank Leslie's Illustrated Newspaper*.[1]

1. Kanagawa, *Yokohama ukiyo-e*, 501.

23 English Man Sorting Fabric for Trade at Yokohama

cat. no. 23
Igirisujin Yokohama ni orimono irowake kōeki no zu
Edo period, 1861:2
by Sadahide (1807–ca. 1878)
publisher: Moriya Jihei
woodblock print
ink and color on paper
ōban: 35 × 25.1 cm (13¾ × 9⅞ in.)

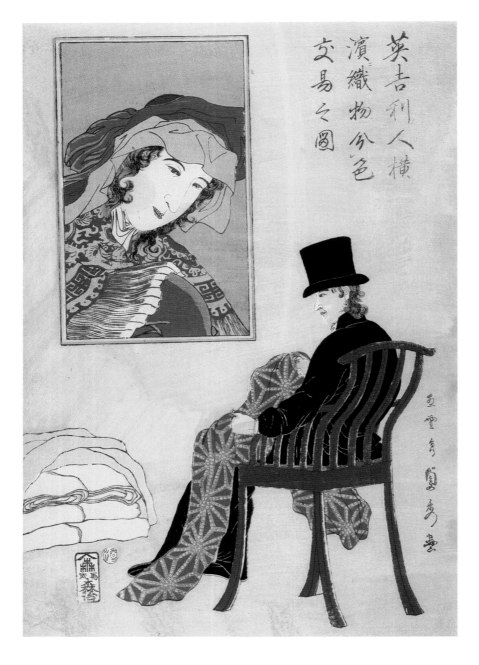

ing, drinking, and attending dinner parties were available in those early years. Lieutenant John Mercer Brooke (1826–1906), commander of the United States schooner *Fenimore Cooper*, which ran aground at Yokohama during a storm, eased his longing for his beloved wife during his unexpectedly prolonged sojourn in Japan by collecting for her beautiful examples of Japanese handcrafts, some his own design.

Yesterday the proprietor of a laquer shop showed me the drawings of shells and sea weeds for a box now making [*sic*] at Yedo [Edo] for me. I suggested the design, furnished plates, shells, etc., to guide the artist. . . . I have directed him to have two or three articles made for me. I intend them for Lizzie. A work box, a writing desk and some card cases.[2]

Sadahide's print belongs to a series that shows Western couples with one of the pair framed and therefore understood to be far away. Through that pictorial convention the theme of mutual affection would have been clearly understood, even to Japanese who had never seen a foreigner.

1. Kanagawa, *Yokohama ukiyo-e,* 494.

2. Lieutenant John M. Brooke, "Journal," 8 December 1859, in Brooke, Jr., ed., *John M. Brooke's Pacific Cruise,* 183–84.

Positioned to suggest that it is hanging on a wall, a large "framed" portrait shows a woman gazing downward toward a merchant who examines a large piece of colorfully dyed textile. The lonely man appears lost in thoughts of his absent wife, whose demeanor also suggests longing for a distant spouse. Framing one partner as a picture is a Japanese artistic convention for representing a couples' yearning for each other.[1]

The society of the Yokohama Western community was predominantly composed of young men, and this print reflects accurately the reality of life in the foreign settlement in the 1860s. Living conditions were far from luxurious and often unsafe, and those who had wives and children had left them in their homelands or in China, where many of the early settlers had previously resided. Loneliness was probably common, as few diversions other than rid-

24 Foreigner Embracing a Child

cat. no. 24
Gaikokujin kodomo chōai no zu
Edo period, 1860:10
by Yoshikazu (fl. ca. 1850–70)
publisher: Maruya Jinpachi
woodblock print
ink and color on paper
ōban: 36.8 × 25.3 cm (14½ × 9 ⁵⁄₁₆ in.)

Women and children are a common subject of Japanese genre paintings and popular prints created during the Edo period (1615–1868); the theme continues in Yokohama prints that depict foreigners' customs. Western visitors to Japan at the time of Yokohama's opening noticed the affectionate regard that Japanese parents held for their children. Sir Rutherford Alcock (1809–1897), the British minister, observed:

It is a very common sight, in the streets and shops of Yeddo [Edo], to see a little nude Cupid in the arms of a stalwart-looking father, . . . who walks about with his small burthen, evidently handling it with all the gentleness and dexterity of a practised hand.[1]

As for many of his other prints, the artist Yoshikazu has probably depended upon Western engravings as models for his picture. A young boy sits barefoot on the floor while his mother carries an infant in the crook of her arm rather than on her back, which is the Japanese practice. The unfamiliar Japanese custom caused Alcock to worry that a "dislocation of the neck must inevitably be the result,"[2] though he finally concluded that the babies did not seem to mind. Yoshikazu's print reveals the difficulty of handling Western perspective and understanding the finer details of costume.[3]

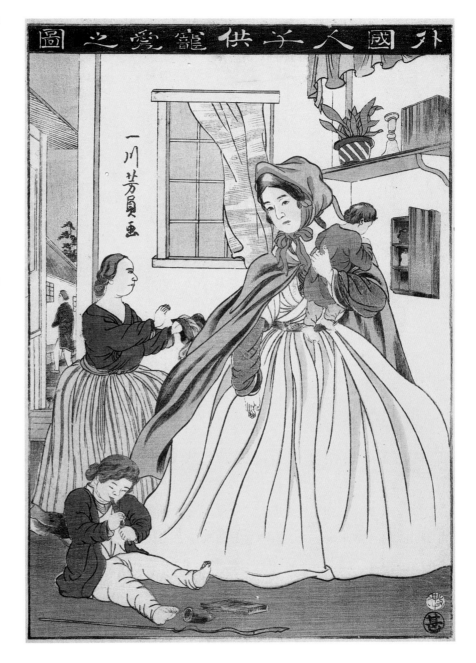

1. Alcock, *Capital of the Tycoon*, vol. 1, 122.

2. Ibid., 121–22.

3. The front of the woman's dress, for example, is wrapped left over right like a Japanese kimono (Meech-Pekarik, *World of the Meiji Print*, 18–20).

25 Picture of Americans

cat. no. 25
Amerikajin no zu
Edo period, 1861:2
by Yoshikazu (fl. ca. 1850–70)
publisher: Maruya Jinpachi
woodblock print
ink and color on paper
ōban: 35.6 × 24.3 cm (14 × 9 9/16 in.)

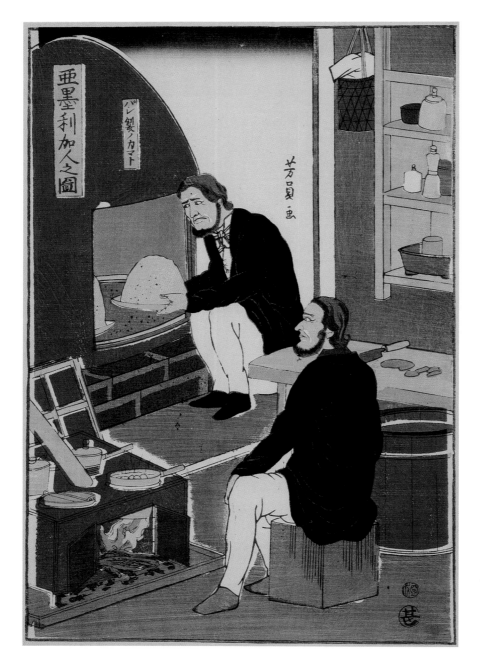

The caption to the right of the title reads, "bread-baking oven." A man places a large loaf into the oven while another tends the food cooking in the skillets and pots on a stove in the foreground. Japanese and Western culinary techniques and ingredients initially had little in common, and many of the first Americans and Europeans to arrive in Japan longed for their familiar staples. United States Consul General Townsend Harris (1804–1878), during his long stay in isolated Shimoda, was frequently presented with fresh boar meat but nevertheless despaired when the provisions he had brought, including cured hams, ran out.[1]

Few Americans and Europeans in Yokohama seem to have acclimated to Japanese foods. Instead, they continued to eat a typical Western diet of meats provided by animals raised for the purpose, or by game that was abundant in the countryside around Yokohama until the shogunate's ban on hunting became routinely violated.

1. Townsend Harris, "Journal," 23 June 1857, in William Elliot Griffis, *Townsend Harris: First American Envoy in Japan* (1895; reprint, Freeport, N.Y.: Books for Libraries Press, 1971), 162.

26 Among the People of All Nations: Americans

cat. no. 26
Bankoku jinbutsu no uchi: Amerikajin
Edo period, 1861:5
by Kuniaki II (1835–1888)
publisher: Tsujiokaya Bunsuke
woodblock print
ink and color on paper
ōban: 33.8 × 23.1 cm
(13 5/16 × 9 3/32 in.)

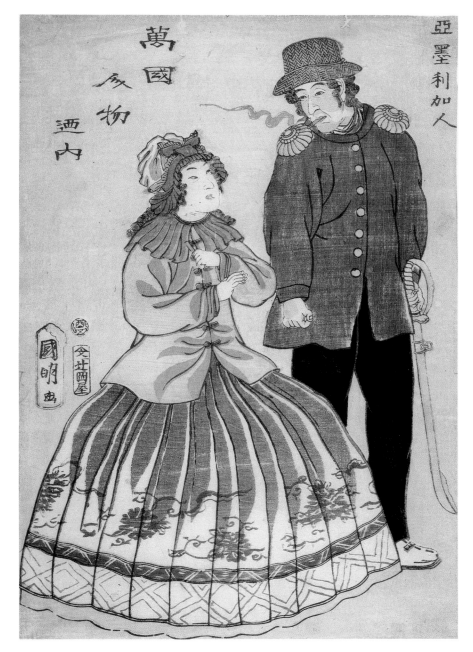

Kuniaki's print is one of many Yo-kohama prints that represent couples of various nations. The costumes reflect the artist's confusion concerning the details of Western attire: the woman is dressed in the fashionable full skirt of the period but wears an oddly designed jacket that fastens in the manner of a Chinese garment; the man carries a saber and wears a jacket with the ornaments of a military uniform, but his informal woven hat and shoes are completely incongruous.

When this print was published in 1861 the cigarette was still a novelty in Japan, although tobacco had been introduced there, probably by Portuguese or Spanish traders, during the late sixteenth century. Records show that it was cultivated in Nagasaki as early as 1605.[1] When Americans arrived in the mid-nineteenth century with cigarettes and cigars, the Japanese custom of smoking tobacco in long-stemmed pipes (*kiseru*) was widespread, despite efforts by the Tokugawa government to restrict its prevalence. Cigarette smoking increased in Japan during the Meiji period (1868–1912), and a to-bacco monopoly was established by the government in 1904, initially to raise revenue for the Russo-Japanese War (1904–05).[2]

1. Ishizaki Jūrō, "Tobacco," in *Kodansha Encyclopedia of Japan*, vol. 8 (Tokyo: Ko-dansha, 1983), 31.

2. Ibid.

**27 Picture of the Residence of a Foreign Merchant from Overseas: Portugal and South America (*a*, *b*);
Yokohama Merchant from Overseas: Picture of a Prussian Couple (*d*); America: Van Reed (*e*)**

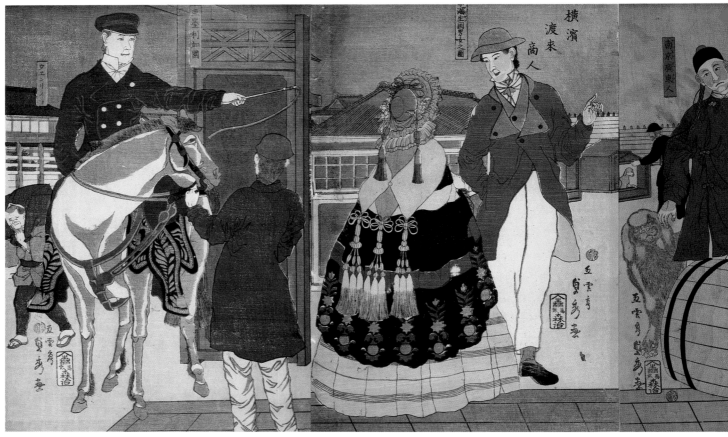

e d

The individual prints of this composite picture are so engaging as independent images that it is not immediately apparent that they were designed to form a single continuous composition of five prints. The setting is a residential compound in Yokohama's foreign quarter. In the print at the far left an American on horseback is shown entering the gate from the street, where a Japanese peasant carries a large burden wrapped in a sizable cloth (*furoshiki*). The couple in the adjacent courtyard is identified in the caption as Prussian. The center print of the pentaptych (fig. 23),[1] not represented in the Leonhart collection, shows servants specified as Chinese and perhaps Indian. The two prints at the far right show the entrance to the residence where the women and children are designated as

South American and Portuguese. Neither Prussia nor Portugal had a commercial treaty in force in 1861, when this print was published, yet Sadahide's print reflects accurately the presence of merchants from those nations in Yokohama. Edward Loureiro & Company, a Portuguese firm, was one of the first foreign businesses to establish an office in Yokohama in 1859. In 1865, when the first town council was formed for the foreign settlement, both the Portuguese and Prussians were represented.[2]

Of special interest is the portrait of the dashing American on horseback, which identifies its subject by name. The caption suggests that the figure may be Eugene Van Reed,[3] an American who maintained close relations with the daimyo of the Satsuma domain

in Kyushu; Van Reed even succeeded in negotiating a private treaty to handle foreign trade for Satsuma.[4] Sadahide captures Van Reed's bold, charismatic personality. The subject is pictured frontally, holding his riding crop in his raised left hand, and his saddle is ornamented with a striking pattern. The portrayal of Van Reed appears more than once in Sadahide's work; it is not inconceivable that the artist saw Van Reed or even made preparatory sketches for the prints.

1. Kanagawa, *Yokohama ukiyo-e*, 56–57.

2. Paske-Smith, *Western Barbarians*, 268–69.

3. I am indebted to Fred G. Notehelfer for this identification.

4. Notehelfer, "Visions of Early Yokohama," 24.

cat. no. 27
(a, b) *Yokohama torai ishō jūka no zu:*
Horutogaru, Minami Amerika;
(d) *Yokohama torai shōnin: Furoisen*
koku danjo no zu; (e) *Amerikakoku:*
Uenriito

Edo period, 1861:9
by Sadahide (1807–ca. 1878)
publisher: Moriya Jihei
woodblock print
ink and color on paper
four prints from an *ōban* pentaptych;
each approx. 34.8 × 27.6 cm
(13¹¹⁄₁₆ × 10¾ in.)

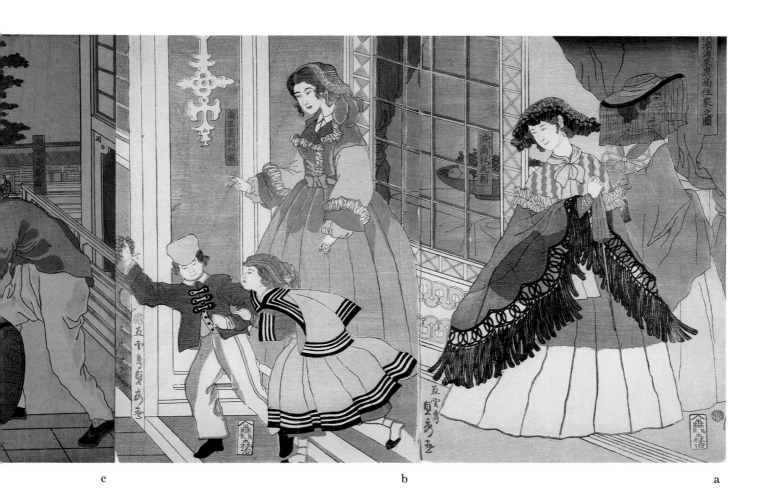

c b a

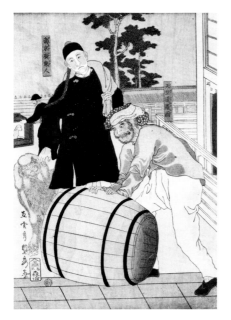

Figure 23 *Chinese Man from Nanking*
and an Indian Man, 1861, by Sadahide
(1807–ca. 1878). Woodblock print; ink
and color on paper. Kobe City Mu-
seum. This print is the center member
(c) of Sadahide's pentaptych.

28 Life Drawings of People of Foreign Nations: Picture of Russians Raising Sheep for Wool

cat. no. 28
Ikiutsushi ikoku jinbutsu: Roshiajin rashayō kau no zu
Edo period, 1860:11
by Sadahide (1807–ca. 1878)
publisher: Yamaguchiya Tōbei
woodblock print
ink and color on paper
ōban: 34.8 × 23.8 cm (13¹¹/₁₆ × 9⅜ in.)

Sadahide's prints reveal the artist's interest in precisely recording the appearance and behavior of the foreigners in Japan. Here a military officer wearing an appropriately ornamented uniform looks on while another man offers food to a long-haired goat. Stretching its neck upward, the goat is depicted in the sympathetic and endearing manner typical of Sadahide's portrayals of animals, which ranged from pet dogs to walruses.

The foreigners in Yokohama kept domesticated animals as pets and for food. Although imported woolen fabrics had been used occasionally for the garments of daimyo, sheep were not raised successfully in Japan during the Edo period (1615–1868).[1] For Sadahide the livestock imported to Yokohama made an exotic subject worthy of describing in his documentary pictures. Here he depicts a goat rather than the sheep mentioned in the title. The term used for wool in the title is *rasha,* from the Portuguese word *raxa.*

1. Victor and Takako Hauge, *Folk Traditions in Japanese Art* (Tokyo: Kodansha International; Washington, D.C.: International Exhibitions Foundation and the Japan Foundation, 1978), 26.

29 Life Drawings of People of Foreign Nations:
Picture of Dutch Women Raising a Wineglass and Caring for a Child

cat. no. 29
Ikiutsushi ikoku jinbutsu: Oranda fujin sakazuki o age jidō o aisa
Edo period, 1861
by Sadahide (1807–ca. 1878)
publisher: Yamaguchiya Tōbei
woodblock print
ink and color on paper
ōban: 34.7 × 23.9 cm (13¹¹⁄₁₆ × 9⅜ in.)

Figure 24 Illustration from *La Belle Assemblée; or, Belle's Court Fashionable Magazine*, 1821. This fashion plate from a French publication typifies the sources for Western costume that Japanese print artists used for their depictions of Americans and Europeans.

The Western custom of drinking wine from stemmed glasses is often represented in Yokohama prints. This print, from the same series as catalogue number 28, describes the costumes in charming detail. The necklace adorning the woman in the foreground is a Western accessory that would have seemed novel in Japan, where jewelry of that style was not worn. Her dress is probably based on the artist's study of fashion plates from European magazines of the 1820s (see fig. 24).[1] Knowledge of European fashions of the 1820s may have come indirectly through a Nagasaki print by artist Kawahara Keiga (ca. 1786–ca. 1860). The print, *Picture of Dutch Women*, portrays Mevrouw Cock Blomhoff, a resident of the community of Dutch merchants who were confined to the island of Deshima in Nagasaki harbor before the commercial treaties of 1858 were negotiated.[2]

Images of foreign children are abundant in Yokohama prints despite the rarity of foreign children in Japan during the years immediately following the opening of Yokohama. Contrary to the series title of this print, the theme was probably chosen for its popular appeal rather than its authenticity as a drawing from life.

1. Claudia Brush Kidwell, curator, Division of Costume, National Museum of American History, Smithsonian Institution, provided this reference.

2. N. H. N. Mody, *A Collection of Nagasaki Color Prints and Paintings Showing the Influence of Chinese and European Art on That of Japan*, vol. 1 (London: Kegan Paul, Trench, Trubner & Co., 1939), plate 80.

30 Among the Five Nations: Americans

cat. no. 30
Gokakoku no uchi: Amerikajin
Edo period, 1861
by Kunihisa (1832–1891)
publisher: Tsujiokaya Bunsuke
woodblock print
ink and color on paper
ōban: 34.8 × 23.9 cm
(13¹¹⁄₁₆ × 9¹³⁄₃₂ in.)

The glossary of Japanese and English words filling the space to the left of the blue title cartouche is a notable feature of the series of five prints to which this image belongs (see also cat. nos. 31 and 32). Each print in the series represents one of the five nations that had treaty relations with Japan upon Yokohama's opening to foreign trade. Prints of this type illustrate the first Japanese effort in a popular medium to contend with the newly introduced European languages: the prints in the series exhibit a similar selection of words from the various languages of the Five Nations, with transliterations to the closest equivalent Japanese pronunciation.[1] Awkward approximations of American English resulted from the uncomplicated phonetics of Japanese, which has only five vowel sounds. Imprecise translation of terminology is typical of the glossaries devised for Yokohama prints, which were made up without recourse to dictionaries, except possibly in the case of Dutch. The results—such as "singing woman" for geisha, and "misshaven" (or misshapen) for the Japanese word for unsightly or ugly—are often amusing.

The text, which presents one Japanese word and its English equivalent per line, reads in part:

Ten is called "hebun" [heaven]; *chi* is "eruzutsu" [earth]; *hi* is "zon" [sun]; *tsuki* is "mūn" [moon]; *ame* is "rein" [rain]; *kaze* is "uin" [wind]; *yuki* is "sui" [snow]; *umi* is "shii" [sea]; *yama* is "hiru" [hill]; *kawa* is "ribara" [river]; *konnichi* is "tottei" [today]; *yo* is "naito" [night, for nightfall]; *yūbe* is "iuningu" [evening]; *asa* is "mōninda" [morning]; *hirumae* is "teōasūn" [forenoon]; *myōnichi* is "tomoro" [tomorrow]; *kuregata* is "naito" [night]; *otoko* is "men" [man or men]; *onna* is "uwomen" [women]; *chichi* is "fowauzō" [father]; *haha* is "mōsō" [mother]; *otto* is "konsoruto" [consort for husband]; *musume* is "tōtoru reitehei" [daughter lady]; *kerai* is "taeruhen" [servant]; *geisha* is "shinjinku uwomen" [singing woman, for a professional entertainer]; *utsukushii* is "fuain" [fine, for beautiful]; *sake* is "wain" [wine]; *meshi* is "boiruto raishi" [boiled rice]; *sai* is "waifu" [wife]; *kodomo* is "chiyairuto" [child]; *gejo* is "meido" [maid]; *yūjo* is "harurotto" [harlot]; *shū* is "misuseheibun" ["misshaven" or "misshapen" for unsightly]; *cha* is "tei" [tea]; *amai* is "suitto" [sweet]; *uo* is "fuisu" [fish]; *nigai* is "hittoru" [bitter].

An American couple with the woman on horseback—a curiosity to the Japanese during a period in which only male warriors rode horses—is the pictorial subject of this print. The distinctive feathered hat in the form of a pineapple crown is a detail of costume that appears in many Yokohama prints.

1. Japanese vowels are pronounced *a* as in father, *i* as in meet, *u* as in root, *e* as in let, *o* as in pole. Doubling the vowel or marking with a macron (e.g., ō) indicates longer duration of the same sound.

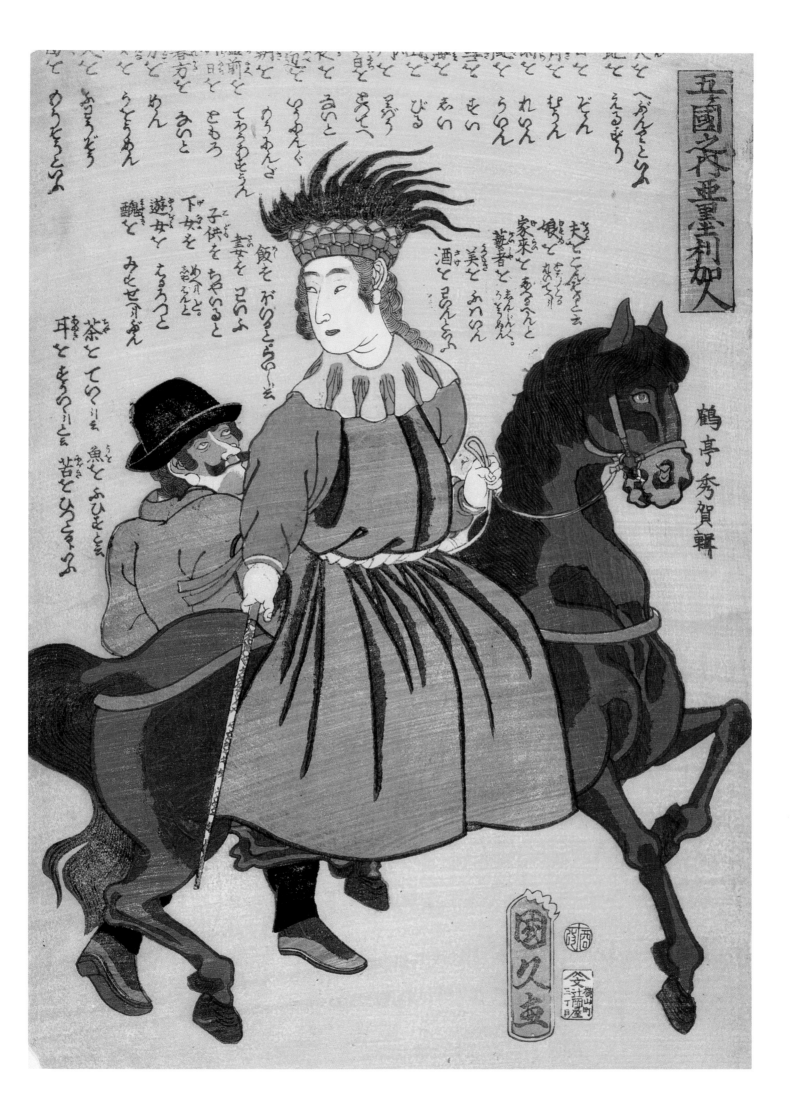

31 Among the Five Nations: The French

cat. no. 31
Gokakoku no uchi: Furansujin
Edo period, 1861:10
by Kunihisa (1832–1891)
publisher: Tsujiokaya Bunsuke
woodblock print
ink and color on paper
ōban: 34.8 × 23.5 cm (13¹¹⁄₁₆ × 9¼ in.)

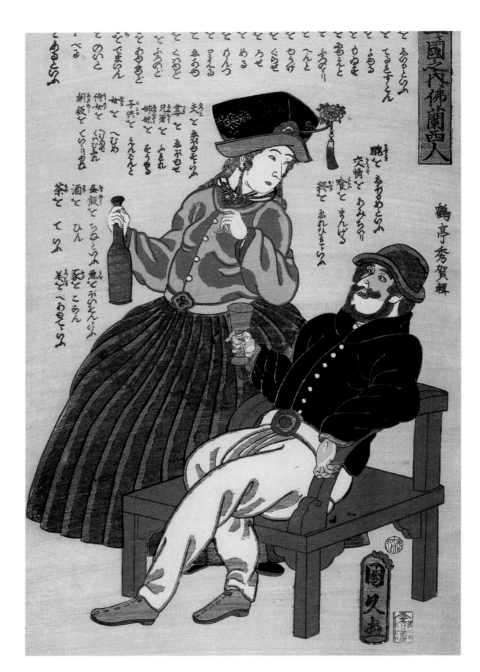

The text of this print is a Japanese-French dictionary of a sequence of words similar to that in catalogue numbers 30 and 32. As the transliterations reflect, the sounds of spoken French were even more problematic than English to approximate in Japanese:

Ten is called "shiiru" [*ciel*]; *chi* is "teruresuton" [*terrestre*]; *nichi* is "yoyuru" [*jour*]; *getsu* is "moisu" [*mois*]; *kumo* is "nyue" [*nuée*]; *ame* is "furoii" [*pluie*]; *kaze* is "hen" [*vent*]; *yuki* is "neuge" [*neige*]; *kōri* is "gurase" [*glace*]; *tsuyu* is "rose" [*rosée*]; *umi* is "meru" [*mer*]; *yama* is "montsu" [*mont*]; *kawa* is "rieru" [*rivière*]; *mizu* is "eyayu" [*eau*]; *atsusa* is "kuiyudo" [*chaud*]; *samusa* is "furoido" [*froid*]; *kyō* is "ayuyoyudo" [*aujourd'hui*]; *myōnichi* is "demain" [*demain*]; *yo* is "noito" [*nuit*]; *chichi* is "peru" [*père*]; *haha* is "meru" [*mer*]; *otto* is "epoyusu" [*époux*]; *tsuma* is "epoyuse [*épouse*]; *ani-otōto* is "furere" [*frère*]; *ane-imōto* is "sūyuru" [*soeur*]; *kodomo* is "enbon" [*enfant*]; *onna* is "hemume" [*femme*]; *koshimoto* is "hemumede kuwamufure" [*femme de chambre*]; *asameshi* is "teishiyune" [*déjeuner*]; *shū* is "chihorume" [*déformé*]; *kōjō* is "amichii" [*amitié*]; *kurau* is "mangeru" [*manger*]; *owari* is "erehire" [*dernier?*]; *hirumeshi* is "chine" [*diner*]; *sake* is "hin" [*vin*]; *sakana* is "hoison" [*poisson*]; *buta* is "kokon" [*cochon*]; *utsukushisa* is "beayutei" [*beauté*].

The illustration of a French couple features a woman prepared to serve wine into the stemmed glass held by a man seated awkwardly in an oddly shaped chair. Western alcoholic beverages were imported in large quantities to Yokohama, where dinner and drinking parties were major modes of entertainment.

32 Among the Five Nations: Russians

cat. no. 32
Gokakoku no uchi: Roshiajin
Edo period, 1861:10
by Kunihisa (1832–1891)
publisher: Tsujiokaya Bunsuke
woodblock print
ink and color on paper
ōban: 34.8 × 23.9 cm
(13¹¹⁄₁₆ × 9¹³⁄₃₂ in.)

The selection of terms exhibited here is similar to that of the two preceding prints (cat. nos. 30 and 31) from the same series.

Ten is called "hemeru" [*himmel*[1]] ; *chi* is "semuriya" [*zemlya*]; *minami* is "yugu" [*yug*]; *hi* is "dau" [*den'*]; *ame* is "tosedose" [*dozhd'*]; *kaze* is "uyūderu" [*veter*]; *yuki* is "uechiiru"[2]; *umi* is "moshi" [*more*]; *mizu* is "ogu" [*voda*]; *otoko* is "mūsuteina" [*muzhchina*]; *onna* is "shishietana" [*zhenshchina*]; *chichi* is "otetsuse" [*otets*]; *haha* is "mochi" [*mat'*]; *ani* is "obura" [*brat*]; *kodomo* is "marichiru" [*mladenets*]; *ki-musume* is "dote" [*deva*]; *hitori* is "ojin" [*odin*]; *konomu* is "horoshii" [*khoroshii*]; *fune* is "subachii" [?]; *kusa* is "torawa" [*trava*]; *take* is "banbuku" [*bambuk*]; *hana* is "tsuietoku" [*tsvetok*]; *sake* is "ino" [*vino*]; *kome* is "risu" [*ris*]; *kurau* is "kūshiyachii" [*kushat'*]; *fur* is "furoito" [*fleyta*]; *sumi* is "tsuushin" [*tush'*]; *fude* is "kisuchii" [*kist'*]; *ishi* is "kanme" [*kamen'*]; *hito* is "chiyurōeiki" [*chelovek*]; *asa* is "ūtoro" [*utro*]; *yoru* is "notee" [*noch'*]; *ima* is "niu" [*nyune*]; *kimi* is "nachiaruniu" [?]; *hirudoki* is "porutenii" [*polden'*]; *atsuki* is "koriya-chii" [*goryachiy*]; *samuki* is "tsu-roshin" [?]; *neru* is "subachii" [?].

The Russian couple is dressed in appropriately warm clothing. In other impressions of this print (the Leonhart collection contains two states) the details of costume vary.

1. No Russian word meaning sky or heaven seems to have the pronunciation given here, which suggests that the author may have confused Russian with German.

2. The Japanese transliteration does not seem to correspond to the Russian word for snow, *sneg*.

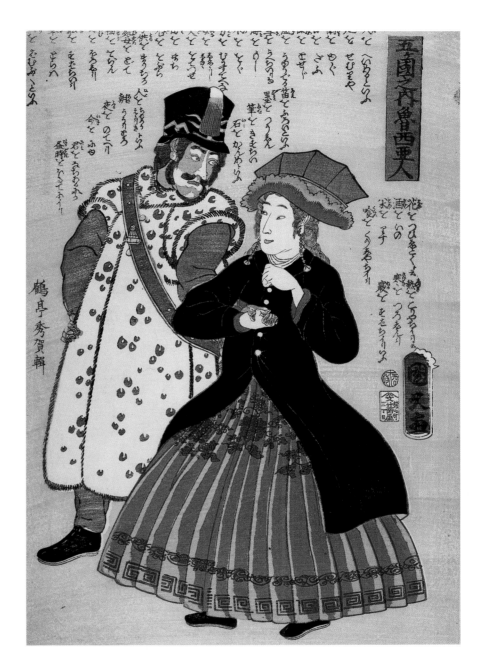

33 An Illustrated English Vocabulary for Children

cat. no. 33
Igirisu-kotoba osana etoki
Edo period, 1860:7
by Yoshitoyo (1830–1866)
publisher: Daikokuya Kinnosuke,
Kinjirō
woodblock print
ink and color on paper
ōban: 37.4 × 25.6 cm
(14¹¹⁄₁₆ × 9⁷⁄₁₆ in.)

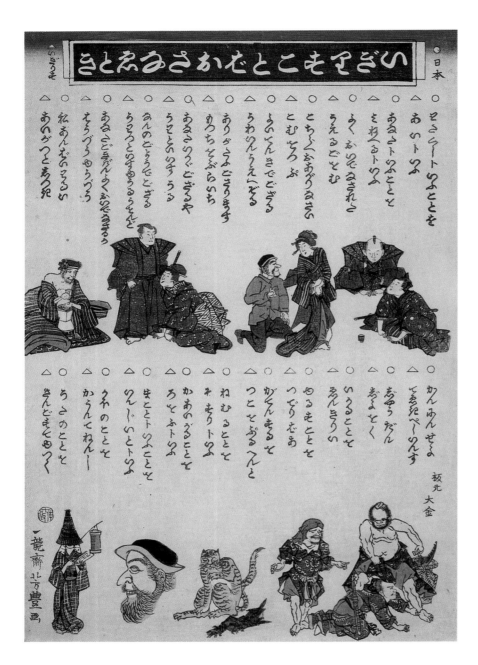

Alternating phrases in Japanese (marked by circles at the top of each line) and English (marked by triangles) form the text of this print, which was published only about a year after the opening of Yokohama.

[top row, right to left]
Watakushi is "ai" [I]
Anata [you] is "minetsuru" [minister]
Yoku oide nasareta is "uerugōmu" [welcome]
Kochira e oagarinasai [literally, come this way] is "komu woppu" [come up]
Yoi tenki de gozaru is "uwain uezoru" [fine weather]
Arigatō gozarimasu is "mecchi oburai-chi" [much obliged]
Anata ika de gozaru ya? is "uwato isu uru?" [What is you?]
Nan no goyō de gozaru? is "uwatto isu yūru uwondo" [What do you want?]
Anata gokigen yoku oide nasaru ka? is "hou zū yū zū" [How do you do?]
Watashi anbai warui is "ai gotto shikki" [I got sick]

[bottom row, right to left]
Kannin sei is "teyiki pekuinsu" [take patience]
Jōdan is "jyōku" [joke]
Ikaru koto is "wenkiri" [angry]
Yurusu koto is "ideriba" [liberate]
Gaten suru is "tsukowopuruhento" [comprehend]
Nemuru koto is "sosurito" [sleep]
Kawaigaru is "rofu" [love]
Makoto is "injii" [indeed]
Kao no koto is "kauntenenshi" [countenance]
Uta no koto is "sangosu teyutsuku" [songs . . .]

Beneath the inscriptions are humorous pictures illustrating some of the phrases: at the upper right, two men bow greeting for "welcome"; a Western man kneels beside a Japanese courtesan for "come this way"; a woman bows before a man of high rank for "much obliged."

34 Picture of People of the Five Nations: Holland

cat. no. 34
Gokakoku jinbutsu zue: Oranda
Edo period, 1861:1
by Sadahide (1807–ca. 1878)
publisher: Daikokuya Kinnosuke,
Kinjirō
woodblock print
ink and color on paper
ōban: 37.3 × 25.3 cm
(14¹¹⁄₁₆ × 9³¹⁄₃₂ in.)

The text reads:

Holland is called Horurando. This country is a neighbor of France and England. Long ago it was established as an independent nation, but recently it has become a nation of the Western alliance. The people are exceptionally wise, and they excel in craftsmanship. Continuously on the trade routes, frigates, [stern boats?], and "susquehanna" boats[1] cross thousands of miles over the seas. For this reason they understand the circumstances and languages of various countries. Knowledge about a myriad aspects of heaven and earth are said to have come from this country to other Western nations.

Reported by Kanagaki Robun.

Sadahide, an avid annalist of Western customs in Yokohama, depicts a Dutch man holding a telescope, one of the Western inventions that would have been familiar to many Japanese. Telescopes were already in use in Japan by the end of the eighteenth century, when they were featured in teahouses for the entertainment of patrons who could use them to explore scenic views.[2] Sadahide seems to delight in depicting the figure of the Dutch woman from a dramatically close standpoint, and the man in profile. The artist employs foreshortening, a Western artistic convention of which he was especially fond, to illustrate the large dog in the background.

The author of the inscription is Kanagaki Robun (1829–1894), a satirical writer and journalist whose original name was Nozaki Bunzō.[3]

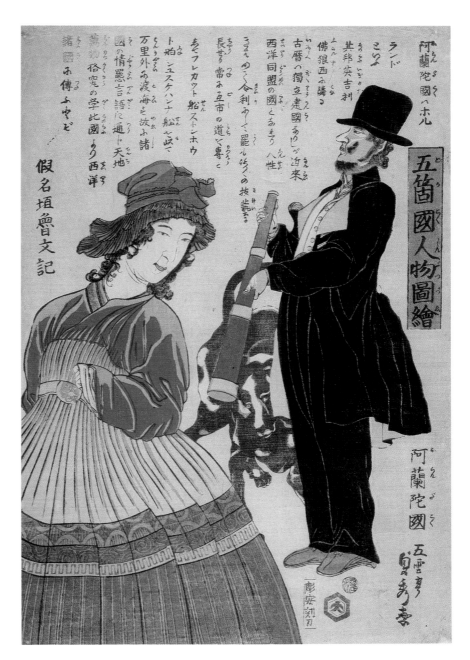

2. H. D. Smith II, "World without Walls," 16, in Bernstein and Fukui, eds., *Japan and the World.*

3. The pen name Kanagaki Robun means, literally, "foolish tales written in *kana.*" *Kana* was the phonetic Japanese syllabary that could be read by many Japanese who were not fully literate in the more difficult Chinese characters (*kanji*) used to write Japanese prose.

1. The author apparently thought of the *Susquehanna,* one of Perry's ships, as a specific type of boat. It was the subject of numerous sketches and prints around the time of Perry's arrival in Japan in 1853.

35 Picture of Foreign Figures

cat. no. 35
Gaikoku jinbutsu zuga
Edo period, 1861:2
by Yoshiiku (1833–1904)
publisher: Kobayashi Tetsujirō
woodblock print
ink and color on paper
ōban: 37 × 24.8 cm (14⁹⁄₁₆ × 9¾ in.)

The text reads:

Nanking: Nanking is in China, but the people look very much like Japanese people. It is close to our country and not to the equator. Both [Chinese and Japanese people] can be said to have become experts in arithmetic, writing, and sagacity.

France: A kingdom of Europe, near England and Holland. Recently the land was allocated to eighty-six districts; the capital is called Paris. The people especially value propriety.

The Chinese man is dressed in Western-style clothing with his hair in the long queue that was customary in China during the Qing dynasty (1644–1911). He stands and gestures almost as if lecturing to the seated French merchant, who holds a stemmed goblet. The Japanese text expresses close identification with the man from Nanking, who represents the vital community of Chinese immigrants to Yokohama who functioned as intermediaries between the Japanese and Western merchants.

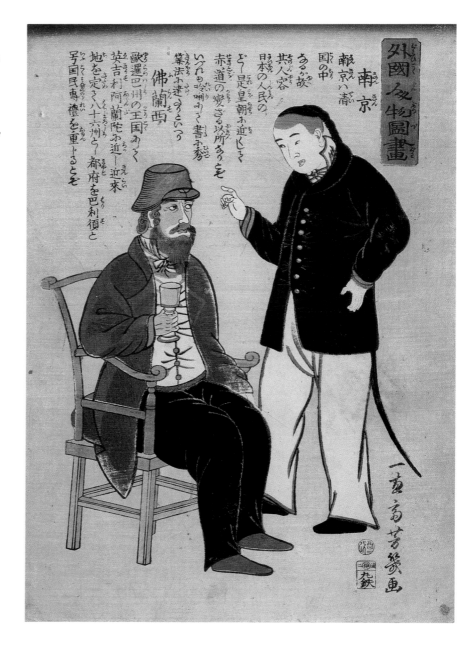

36 Russia: On the Asian Continent, Now Associated with Europe

cat. no. 36
Oroshiyakoku: Ajiya shū no uchi, ima Yōroppa ni konzu
Edo period, 1861:10
by Yoshikazu (fl. ca. 1850–70)
publisher: Izumiya Ichibei
woodblock print
ink and color on paper
ōban: 34.8 × 23.9 cm (13¹¹⁄₁₆ × 9⅜ in.)

The text reads:

Oroshiya or Oroshiya:[1] Among the rich and powerful nations of the world, it is the largest. Its boundaries originate in Europe and extend into central and north Asia as far as Kamchatka, which is separated only by a narrow strait of water from our remote Ezo region. The boundaries with respect to Europe are 88,000 *ri*.[2] There are forty pacification sites for a population of thirty-five million. The imperial city is called Petersburg. It has eight thousand households; its population including soldiers is 570,000. The climate is generally bitterly cold, and it is said that at times it reaches the point of freezing mercury.

Recorded by Kanagaki Robun.

The journalist Kanagaki Robun (1829–1894) notes in the text that the easternmost territory of Russia is contiguous with Japan's most remote territory, Ezo (modern Hokkaido). Japan's location at the northeastern edge of the Russian empire had encouraged Russian expansionist ambitions long before Commodore Perry successfully negotiated for United States' trade relations with Japan. The picture illustrates a Russian man seated for a meal of bread, sweets, and other dishes. The woman holds a large bottle to serve him an alcoholic beverage.

1. Two alternative sets of Chinese characters that represent phonetic transliterations of "Russia" are given in the Japanese text.

2. One *ri* is 2.44 miles, or 3.93 kilometers. Eighty-eight thousand *ri* equal 214,720 miles.

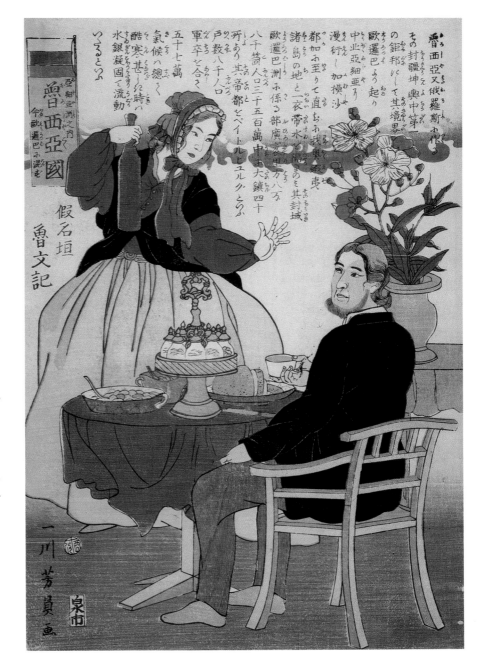

37 On the European Continent: England

cat. no. 37
Yōroppa-shū no uchi: Igirisukoku
Edo period, 1862:3
by Yoshikazu (fl. ca. 1850–70)
publisher: Izumiya Ichibei
woodblock print
ink and color on paper
ōban: 34.8 × 23.9 cm (13¹¹⁄₁₆ × 9⅜ in.)

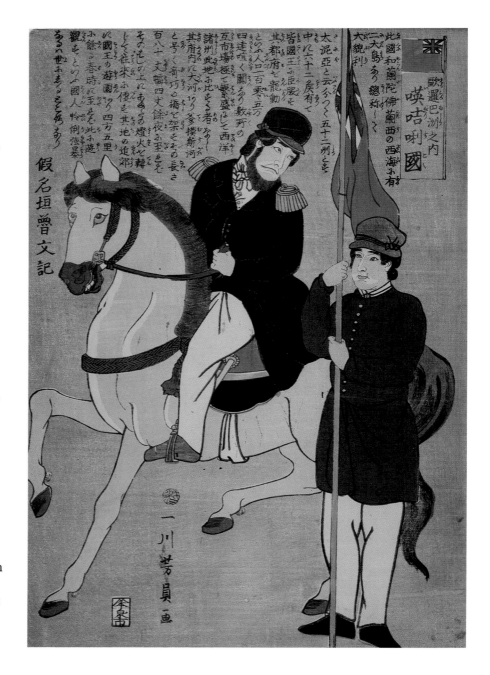

The text reads:

This country is two large islands in the Western ocean of Holland and France. It is commonly known as Dai [Great] Brittania. It is divided into twelve provinces. Within these are sixty-two lords, and the whole nation is subject to a monarch. The capital is called London; its population is one million fifty thousand. It is bustling with activity and its many marketplaces are exceptionally prosperous. There is no comparable place among the Western continents. In this metropolis is a great river that is called the Thames River. A remarkable bridge spans it. Its length is one hundred eighty *jō* and its width, more than four *jō*.[1] When night falls on the bridge, many lamps are lit and it is convenient for coming and going. Near this place is a pleasure park for the king that extends in four directions for five *ri*.[2] In spring, they come here for sightseeing. The people of this nation are known in the world for their intelligence and toughness.

Recorded by Kanagaki Robun.

The picture portrays an English man with a stern demeanor. A youthful attendant holding a flag-staff stands by. The British were quick to establish their interests in Japan as soon as the ports of Nagasaki and Yokohama opened in 1859. Led by the firms of Jardine Matheson & Company and Dent & Company, both of which had been active in China's treaty ports, the British from the beginning were the largest national group of foreign residents in Yokohama. As the brief narrative of this print reflects, the author perceives the British temperament as strong and perhaps arrogant, an impression that may well have been communicated by some of the early residents of Japan. George Smith, bishop of Hong Kong, who visited Japan in 1860, expressed concern about the behavior of foreign residents of Japan:

I have seen Englishmen and others of my acquaintance in different parts of Japan riding at a rapid pace through the villages and suburbs of cities amid crowds of people, who had to scamper in hurried movement from side to side to avoid being knocked down, and who may doubtless be supposed to view with no kind feelings the presence of such equestrians. . . . Such scenes . . . entail annoyance of the native population and may bring danger on foreigners themselves.[3]

1. One *jō* is 3.31 yards, or 3.03 meters. One hundred eighty *jō* equal 594 yards, or 1,782 feet.

2. One *ri* is 2.44 miles, or 3.93 kilometers. Five *ri* equal 12.2 miles.

3. G. Smith, *Ten Weeks in Japan*, 239.

38 On the North American Continent: The United States, or Republican Government

cat. no. 38
Kita Amerika-shū no uchi: Gasshūkoku mata wa kyōwa seiji shū
Edo period, 1862:3
by Yoshikazu (fl. ca. 1850–70)
publisher: Izumiya Ichibei
woodblock print
ink and color on paper
ōban: 34.8 × 24 cm (13¹¹⁄₁₆ × 9⁷⁄₁₆ in.)

The text reads:

The north of this country is in contact with England, the south reaches Mexico; the east and west face oceans. Originally, there were eight states, which subsequently became thirteen. Recently, the number has increased many times to more than thirty states. However, there is no king. In each state a wise person governs with the support of many people and, furthermore, no class distinctions are established. Although this place is but one part of the continent of America, because of its strength and great size, its abundance of people, its power and also its prosperity, it is now popularly known as America, and its people as Americans. This region at the beginning was but a boundless vast plain, when in about the sixth year of the Manji era of our country [1663], English men were the first people to settle in the state of Carolina in the South and these people made a great country without peer.

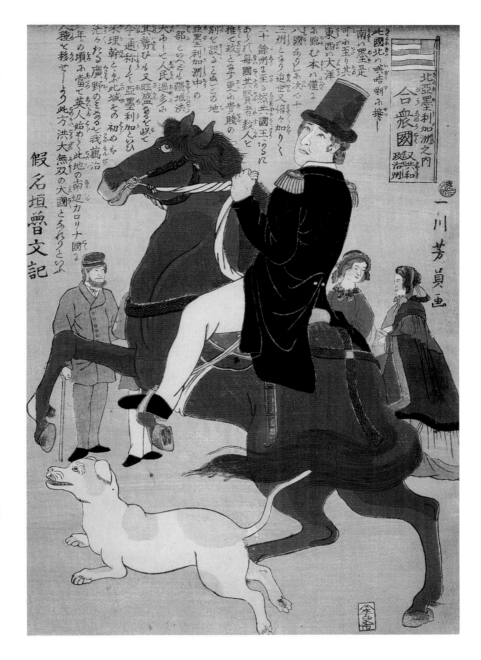

Admiration of the United States, not yet one hundred years old when this print was published, is apparent from the simple text. Although a few details such as America's contiguity with England are mistaken, the Japanese author clearly perceived the vast size of the country and its influential position in the world. The text also describes the American system of government, which contrasted markedly to the hierarchical class structure of Japanese society during the Edo period (1615–1868).

The print illustrates a man on horseback accompanied by a dog. A group of women and men stand in the background. By 1860, less than ten years after the landing of Commodore Perry's black ships, Japan's first embassy to the United States had successfully crossed the Pacific to California, traveled to Washington, D.C., and other American cities, and returned to Japan. Their historic journey intensified Japanese interest in the United States, whose efforts to establish trade relations had altered fundamentally Japan's relations with the world.

39 Eight Views of Yokohama in Bushū (Modern Musashi Province): Sails Returning to the Landing Pier

cat. no. 39
Bushū Yokohama hakkei no uchi:
Hatoba no kihan
Edo period, 1861:1
by Yoshitora (fl. ca. 1850–80)
publisher: Yamadaya Shōjirō
woodblock print
ink and color on paper
ōban: 36.3 × 25.4 cm (14 ⁵⁄₁₆ × 10 in.)

The title of this charming series of eight prints by Yoshitora (see also cat. nos. 40–43) identifies it as one of the popular Japanese adaptations of the Chinese artistic and literary theme "Eight Views of the Xiao and Xiang Rivers" (*Xiao Xiang bajing*). Chinese paintings imported to Japan during the Muromachi period (1392–1573) introduced the theme into Japan, where it was assimilated and adapted by Japanese painters, who arranged their interpretations of the Chinese landscapes in order of the four seasons (beginning with spring), a major convention of Japanese art. Later, the themes of the Chinese "Eight Views" were identified with Japanese locales, initially focusing on the region around Lake Biwa near Kyoto, in sequences of paintings called "Eight Views of Ōmi" (*Ōmi hakkei*). In Japanese prints the "Eight Views" theme was adapted to sites around Edo and was the subject of many puns in titles using homophones for *hakkei*.

Yoshitora's series of eight prints represents yet another Japanese permutation of "Eight Views." Eight sites around the new harbor of Yokohama are linked with the traditional subjects of the "Eight Views" landscapes, yet *Sails Returning to the Landing Pier* has none of the evocative quality found in Chinese paintings of the theme "Sails Returning to a Distant Shore." Yoshitora's series of prints departs completely from the emphasis upon landscape traditionally seen in "Eight Views" pictures. Instead, an American couple dressed in striking attire stands beneath an umbrella, virtually obstructing the view of the sailboats in the distance. The foreigners of Yokohama become the dominant subject, as if the famous sites of Yokohama would be incomplete without them.

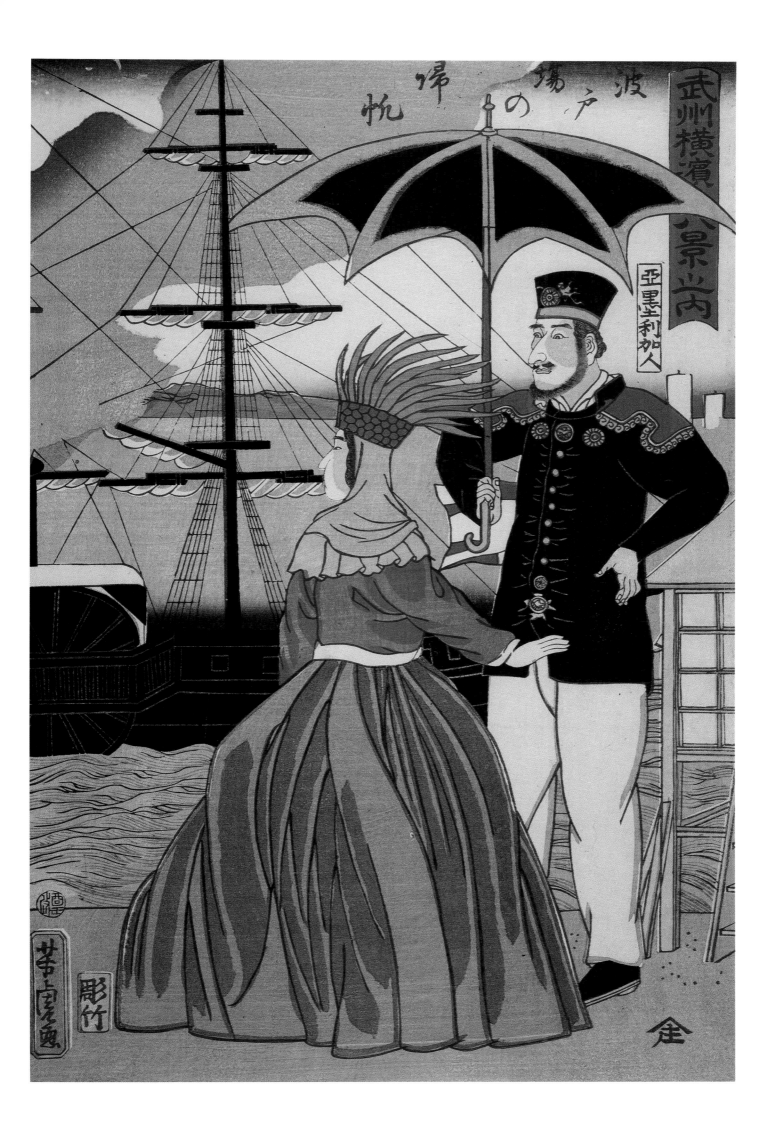

40 Eight Views of Yokohama in Bushū (Modern Musashi Province): Distant Bell of Michiyuki

cat. no. 40
Bushū Yokohama hakkei no uchi: Michiyuki no enshō
Edo period, 1861:1
by Yoshitora (fl. ca. 1850–80)
publisher: Yamadaya Shōjirō
woodblock print
ink and color on paper
ōban: 36.5 × 25.4 cm (14⅜ × 10 in.)

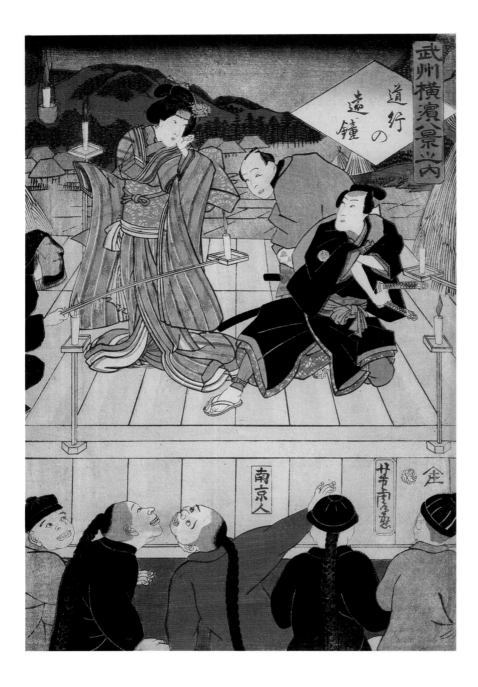

Yoshitora's liberal interpretation of the Chinese theme "Eight Views" in this instance departs entirely from landscape and the traditional subject to which it alludes, referred to in China as "Evening Bell from a Distant Temple." The print presents a kabuki performance viewed by an audience of Chinese merchants. At the far left a stagehand wearing a black hood holds a candle for illumination; other candles are set on the stage. The term *michiyuki* has various meanings in Japanese theater, where it generally refers to modes of travel, including elopement.

41 Eight Views of Yokohama in Bushū (Modern Musashi Province): Sunset Glow at Noge

cat. no. 41
Bushū Yokohama hakkei no uchi: Noge no seiran
Edo period, 1861:1
by Yoshitora (fl. ca. 1850–80)
publisher: Yamadaya Shōjirō
woodblock print
ink and color on paper
ōban: 35.7 × 24.5 cm (14¹/₁₆ × 9⁵/₈ in.)

Noge Bridge spanned a narrow channel along the causeway from Yokohama toward Kanagawa, a post town on the Tōkaidō, one of Japan's principal highways during the Edo period. Although foreign residents were restricted from traveling far from Yokohama, riding was one of their favorite pastimes, and many scenic spots lay within the sanctioned limits. Here an American is accompanied by a Japanese groom, or *bettō*, who customarily ran alongside a Japanese rider to supply fresh straw shoes for the horse and warn passersby to make way. In this print, which depicts the scenic landscape in the warm glow of the setting sun, Yoshitora follows the traditional theme somewhat more closely than in his other prints from the "Eight Views of Yokohama" series.

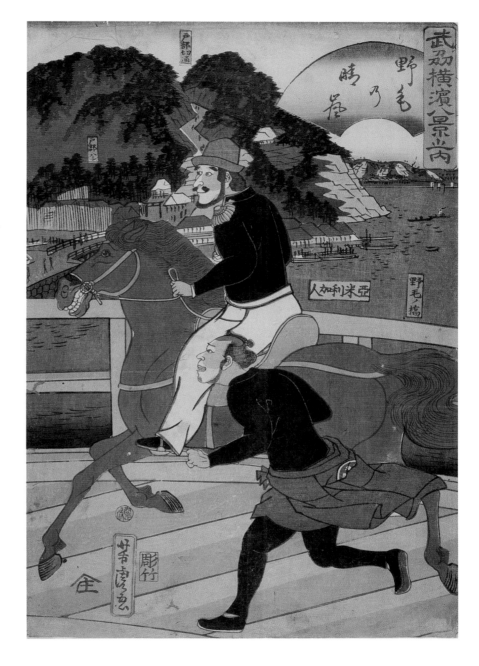

42 Eight Views of Yokohama in Bushū (Modern Musashi Province): Autumn Moon at Miyozaki

cat. no. 42
Bushū Yokohama hakkei no uchi:
Miyozaki no aki no tsuki
Edo period, 1861:1
by Yoshitora (fl. ca. 1850–80)
publisher: Yamadaya Shōjirō
woodblock print
ink and color on paper
ōban: 36.3 × 24.5 cm (14⁵⁄₁₆ × 9⁵⁄₈ in.)

This print from Yoshitora's "Eight Views of Yokohama" series depicts Miyozaki, the entertainment district. Located a short distance from the main part of the town, Miyozaki comprised several establishments on a man-made island for providing entertainment and companionship for the residents of Yokohama. Gankirō, which this print probably depicts, catered to foreign clients. A courtesan wearing a kimono decorated with a motif of chess (*shōgi*) pieces joins a bearded foreigner who points through the open paper window toward the full moon.

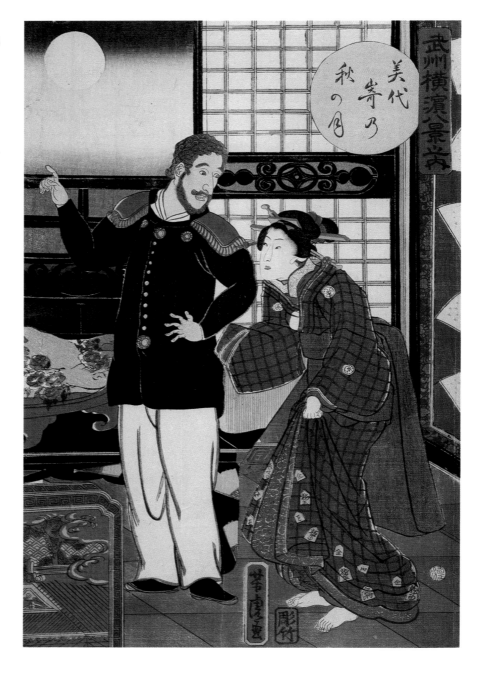

43 Eight Views of Yokohama in Bushū (Modern Musashi Province): Snow on the Morning Market

cat. no. 43
Bushū Yokohama hakkei no uchi: asaichi no yuki
Edo period, 1861:1
by Yoshitora (fl. ca. 1850–80)
publisher: Yamadaya Shōjirō
woodblock print
ink and color on paper
ōban: 36.3 × 24.3 cm (14⅝ × 9⅞ in.)

This charming winter scene, a rarity among Yokohama prints, portrays a street in the market where two Chinese merchants carry a container of food and a bottle; a man standing just behind them bears a large fish in a basket. The foreign residents, many of whom were accustomed to severe winters, consistently described Yokohama weather as mild.

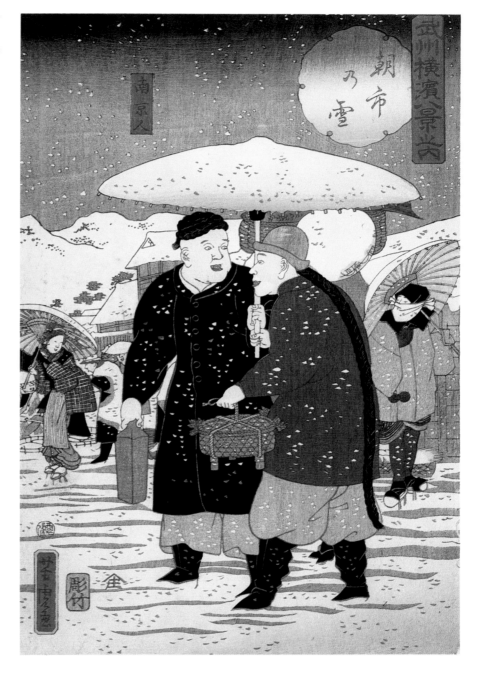

44 Comparison of Scrapbook Pages of Foreign Countries

cat. no. 44
Bankoku harimaze awase
Edo period, 1861:10
by Yoshiiku (1833–1904)
publisher: Maruya Tetsujirō
woodblock print
ink and color on paper
ōban: 36.1 × 24.5 cm (14³⁄₁₆ × 9⅝ in.)

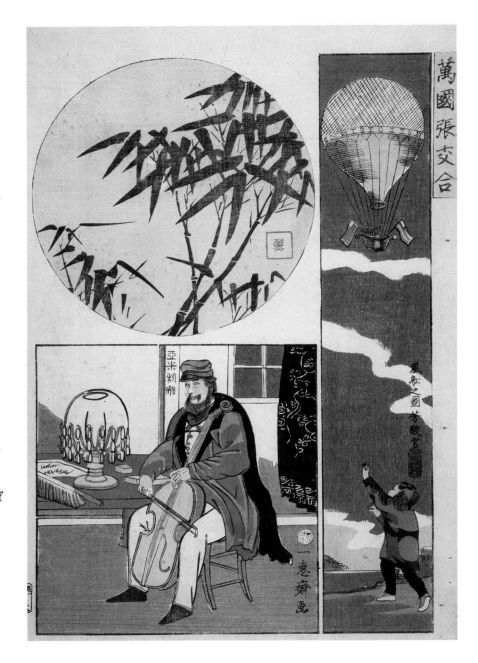

As if they were pictures collected in an album, the prints in the series by Yoshiiku to which this image belongs present assorted themes of foreigners. Each print combines several pictures of different subjects and formats. The title here alludes to the various Japanese games of matching or comparing (*awase*) pictures, painted shells, or incense. This example features a circular picture of bamboo, rendered as if it were a Chinese ink painting. Below is a square picture labeled "America," which shows a man playing a cello on an instrument missing one of its "f" holes. On the table is a lamp with pendant ornaments on the shade, a brush, and paper with writing on it.

The long, narrow format to the right is effectively employed for the picture of a child looking upward toward a balloon displaying two American flags. The balloon is a copy, probably several steps removed, from engravings illustrating the ascent from Philadelphia of the *Constitution*, the balloon launched in 1860 to celebrate the visit of the first Japanese embassy to the United States. Here the name of the balloon, which was correctly reproduced in an illustration in the *Futayo gatari*, the diary of Katō Somō,[1] a member of the embassy, has become almost unintelligible. Yoshiiku's series assimilates the foreigners into composite prints of a popular type; their placement in the context of a scrapbook renders the foreigners more familiar than exotic.

1. Meech-Pekarik, *World of the Meiji Print*, 20–21.

45 Painting and Calligraphy of Fifty-Three Stations: Distant View of Yokohama and Kanagawa in Bushū (Modern Musashi Province)

cat. no. 45
Shoga gojūsan eki: Musashi Kanagawa Yokohama chōbō
Meiji period, 1872
by Yoshimori (1838–1884)
publisher: Ōtaya Takichi
woodblock print
ink and color on paper
ōban: 35.9 × 24.2 cm (14⅛ × 9½ in.)

The inscription in Chinese characters at the upper right reads:

The wind sends flags and sails in brocade waves, revealing copper masts and iron hawsers. It stops in the distance, in the inlet of the bay. We hear news of its name and its signal fires, and know that a steamship approaches the harbor.

The title of Yoshimori's print refers to the fifty-three stations along the Tōkaidō, the eastern highway linking Edo and Kyoto. The theme was made famous through the prints of Hiroshige I (1797–1858) and many of his contemporaries. Kanagawa, one of those stations, lay directly across a bay from Yokohama. From that vantage point, the prosperous town of Yokohama with its substantial Western-style buildings is illustrated in the distance.

Dominating the scene is the figure of a woman, portrayed with studied attention to details of light and shadow that reflect the artist's awareness of Western wood engravings or other pictorial sources. Her image may in fact be derived from a figure in the foreground of an illustration of India published in the *Illustrated London News* (see fig. 31 and detail). Combining elements of traditional Japanese art with an exceptionally successful reproduction of a Western artistic model, the print presents a striking if somewhat disconcerting visual effect.

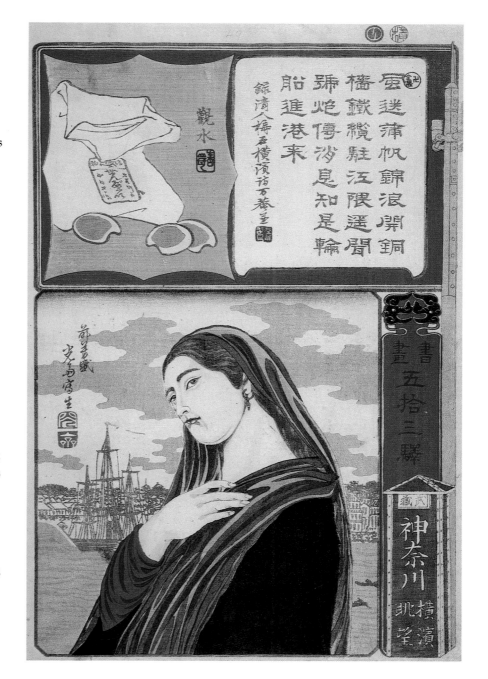

Detail, fig. 31

LEISURE AND ENTERTAINMENT
IN AND AROUND YOKOHAMA

YOKOHAMA HAD only basic accommodations and few amenities at the time of its opening in 1859. The foreign community was restricted by the terms of the treaties of 1858 to travel no more than ten *ri*, or about twenty-five miles, in each direction from Yokohama, except toward Edo, where the boundary was the Rokugō River (called Logo or Loco in Western accounts of the period) just north of the town of Kawasaki.[1] Travel was therefore restricted to the treaty limits unless one could obtain a passport to journey into the interior, and foreigners were required to return to Yokohama by nightfall rather than seek lodging in nearby towns.

The principal amusements in the new foreign settlement were occasional dinner and drinking parties and riding excursions to the local countryside. Yokohama was surrounded by scenic terrain, and the historic town of Kamakura lay within the treaty limits. Kamakura's ancient temples and the colossal bronze Great Buddha (Daibutsu, known to the foreigners as "Daibouts") were as much an attraction in the 1860s as they are to tourists today. Sir Ernest Satow (1843–1929) recollected that upon his arrival in Yokohama in 1862:

> On a nominally small income, it was . . . possible to live well, keep a pony, and drink champagne. . . . Money was abundant, or seemed to be, every one kept a pony or two, and champagne flowed freely at frequent convivial entertainments. . . . A favourite Sunday's excursion was the ride along the Tôkaidô to Kawasaki for tiffin, and back again toward evening. Longer outings were to Kanazawa, Kamakura and Enoshima; but anyone who ventured as far as Hachiôji or Hakoné, which were beyond the Treaty limits, was regarded as a bold, adventurous spirit.[2]

Western riding customs were different from those of the Japanese. Upon purchasing a Japanese horse, the British minister Sir Rutherford Alcock (1809–1897) complained, "A walk, an amble, and a canter I got out of him, but nothing deserving the name of a trot."[3] Japanese horses were shod with straw shoes and customarily ridden at a walking pace. The Japanese regarded the brisk pace of the Western riders as rude and reckless, and in their regulations for conduct in the treaty ports consular officials issued warnings against fast riding in the towns.

Satow recalled, "There were few ladies in the settlement. Japan was a long way from Europe, with no regular steam communication, and the lives of foreigners were supposed to be not very safe at the hands of the arm-bearing classes."[4] The Japanese builders of Yokohama had provided a Japanese-style entertainment district where women were readily available. They modeled Yokohama's entertainment quarter, Miyozaki-chō, after Yoshiwara, the famous "nightless city" of Edo. Innkeepers from post towns around Yokohama set up licensed businesses in Miyozaki to serve the Japanese residents. Gankirō, the largest establishment in Miyozaki, catered to Yokohama's foreign community. It was built by Hatagoya Sakichi, who managed a similar operation in Shinagawa, a town located along the Tōkaidō highway between Yokohama and Edo.[5]

Early prints of Yokohama, published shortly after the official opening of the port in 1859, show Miyozaki resplendent with blossoming cherry trees in the midst of the undeveloped rice paddies. The gaudily decorated Gankirō was a popular subject of Yokohama prints, as British horticulturalist Robert Fortune observed:

> Scenes in the Gan-ke-ro—a place got up by the Government for the amusement of foreigners—are also portrayed in a manner not particularly flattering to our habits and customs. Boisterous mirth, indulgence in wine and strong drinks, and the effects thereof upon those who are inclined to be quarrelsome, are all carefully depicted.[6]

In reality, Miyozaki was an island surrounded by canals where two hundred or more Japanese women lived from 1859 until Yokohama's great fire of 1866, which, having begun in Miyozaki, completely destroyed the quarter's flimsy wood buildings and killed most of its residents.

As the foreign community of Yokohama grew, horse racing, sailing, riflery, cricket, and other sports were added to the amusements available to Yokohama residents, and regattas and a rifle association were organized. The Bluff Gardens, established in 1865, became the site of concerts by the military

Figure 25 *Kinryūzan (Temple) at Asakusa*, 1861, by Hiroshige II (1826–1869). •
Woodblock print triptych; ink and color on paper. Collection of William and Florence Leonhart. The Buddhist temple Kinryūzan in the Asakusa district in Edo
(modern Tokyo) had a thriving market and was a favorite site for spring and autumn excursions. Here a group of foreigners whose costumes are based on both
earlier and contemporary sources are shown among the Japanese visitors. Since
travel to Edo from Yokohama was restricted at the time this print was published,
it is likely that the image represents the artist's imaginative visualization of foreigners at the famous site.

bands of the French and English forces garrisoned at Yokohama. The military troops also staged amateur theatrical performances, and their occasional practice of military maneuvers was a colorful spectacle that attracted the attention of Japanese print artists.

Leisure activities in the foreign community are a prominent theme of Yokohama prints. Sunday promenades and private parties in the merchants' residences, the more boisterous parties at Gankirō, exotic imported animals, a visiting circus, and military exercises all appealed to the appetite for novelty among the artists, publishers, and audience of Japanese prints. Collectively, such prints portray the foreign community in an exuberant and festive spirit that reveals no trace of the complex and ambivalent attitude that some Japanese officials held toward the newcomers.

1. See this book's endleaves for a map showing the treaty limits.

2. Satow, *Diplomat in Japan*, 26–27.

3. Alcock, *Capital of the Tycoon*, vol. 1, 164.

4. Satow, *Diplomat in Japan*, 26–27.

5. Meech-Pekarik, *World of the Meiji print*, 32.

6. Fortune, *Yedo and Peking*, 37.

46 Picture of People of the Five Nations Walking in Line

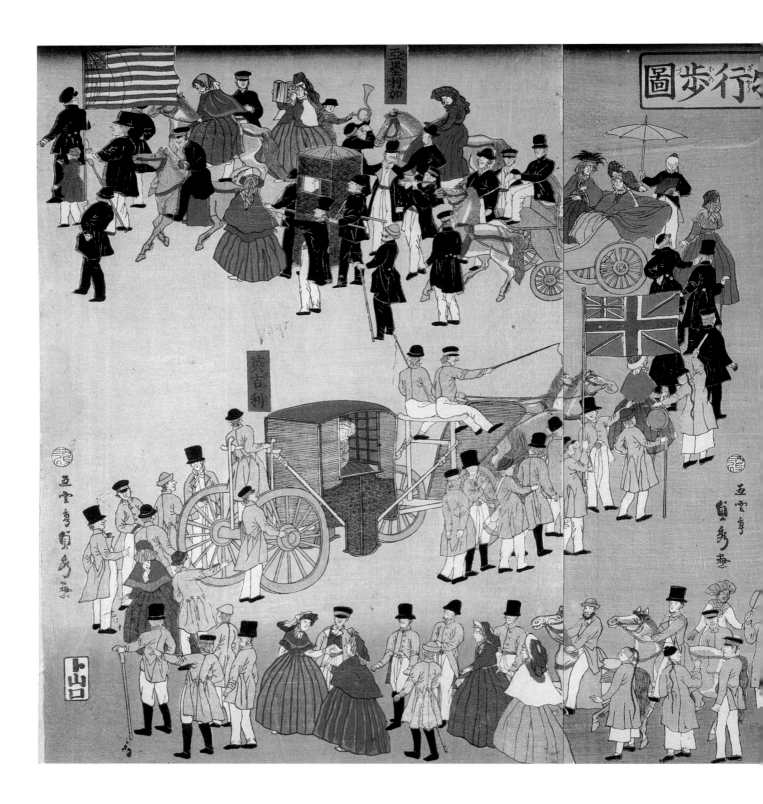

More than 150 figures number in this triptych, a colorful artistic construction that represents the international community of Yokohama as if it were on parade. In groups led by the flags of the United States, Great Britain, France, Russia, and the Netherlands, men in military and civilian dress are accompanied by women and a few children. Men from India, wearing turbans, and Chinese men with their hair plaited in queues accompany the people representing the Five Nations. Large horse-drawn carriages of various designs are arrayed. One person in the American group at the upper left is carried in a sedan chair by a most unlikely looking group of

cat. no. 46
Gokakoku jinbutsu gyōho no zu
Edo period, 1861:3
by Sadahide (1807–ca. 1878)
publisher: Yamaguchiya Tōbei
woodblock print
ink and color on paper
ōban triptych: 36.3 × 73.9 cm
(14⅝ × 29¹⁄₁₆ in.)

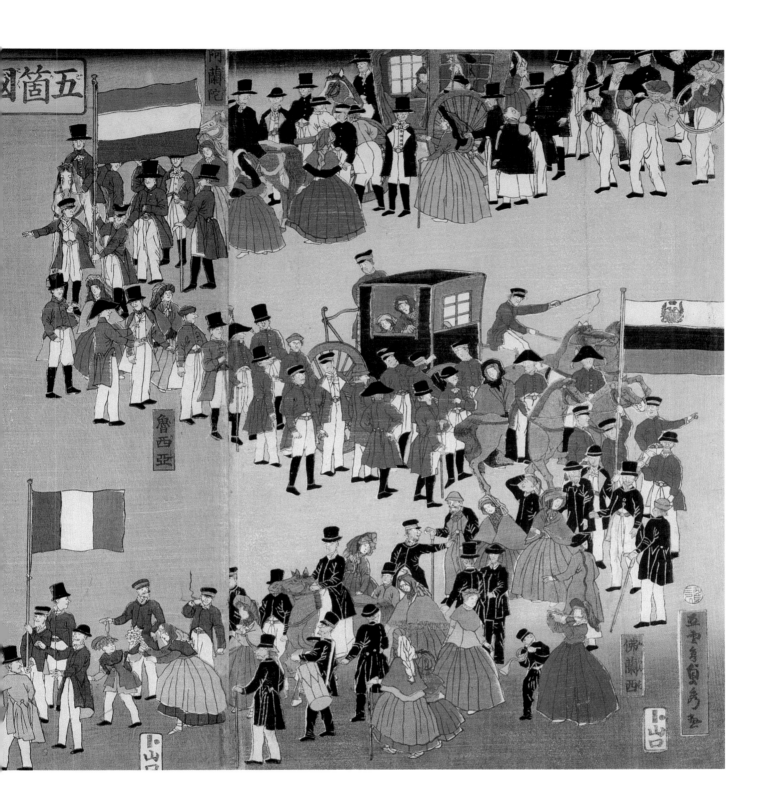

bearers wearing tailcoats and hats.

In 1861 the entire foreign community of Yokohama would have been no more extensive than the population Sadahide has encompassed in this print. The colorful picture is an imaginative fantasy that combines the artist's own observations in Yokohama with information from indirect sources such as illustrations from Western newspapers and magazines.

47 Picture of a Sunday in Yokohama

cat. no. 47
Yokohama dontaku no zu
Edo period, 1861:2
by Sadahide (1807–ca. 1878)
publisher: Yamaguchiya Tōbei
woodblock print
ink and color on paper
ōban triptych: 36.4 × 74.2 cm
(14⁵⁄₁₆ × 29³⁄₁₆ in.)

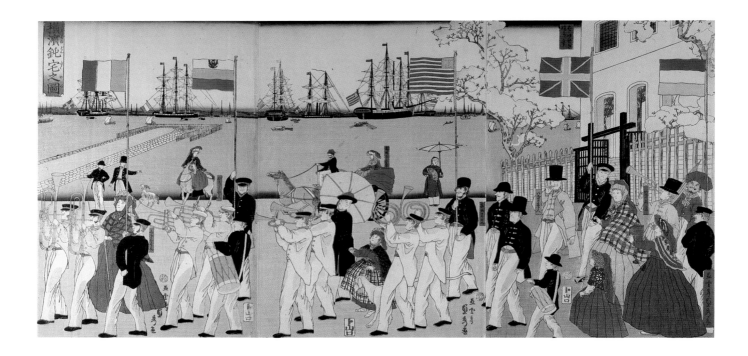

Dontaku, the term associated with the customary day of rest observed by the foreigners, came from the Dutch word, Zondag, for Sunday. This colorful scene depicts a brass band parading along the waterfront of Yokohama near a merchant's residence. Although music was occasionally performed in Yokohama, the pictorial model for this print is an earlier, Nagasaki print, *Red-Haired Men: Picture of a Procession of a Marching Band of Musicians.*[1]

1. Kanagawa, *Yokohama ukiyo-e*, 44, 494.

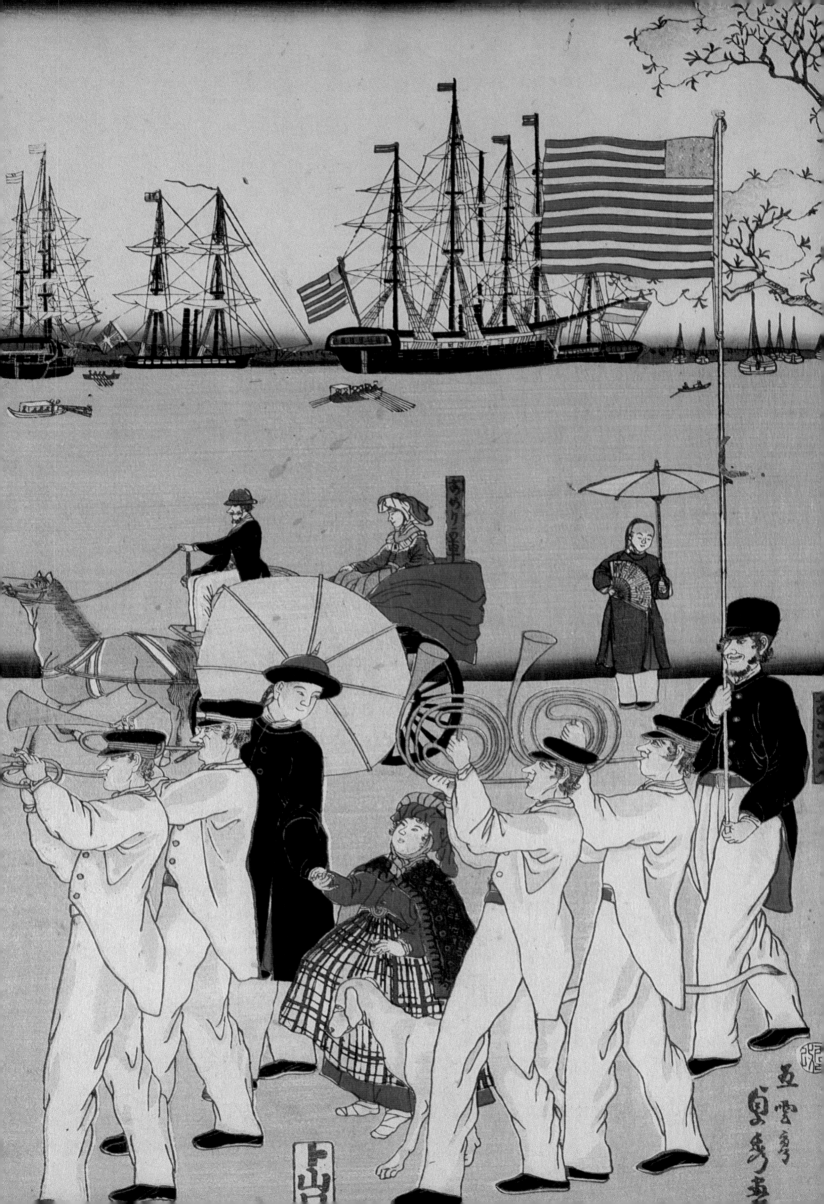

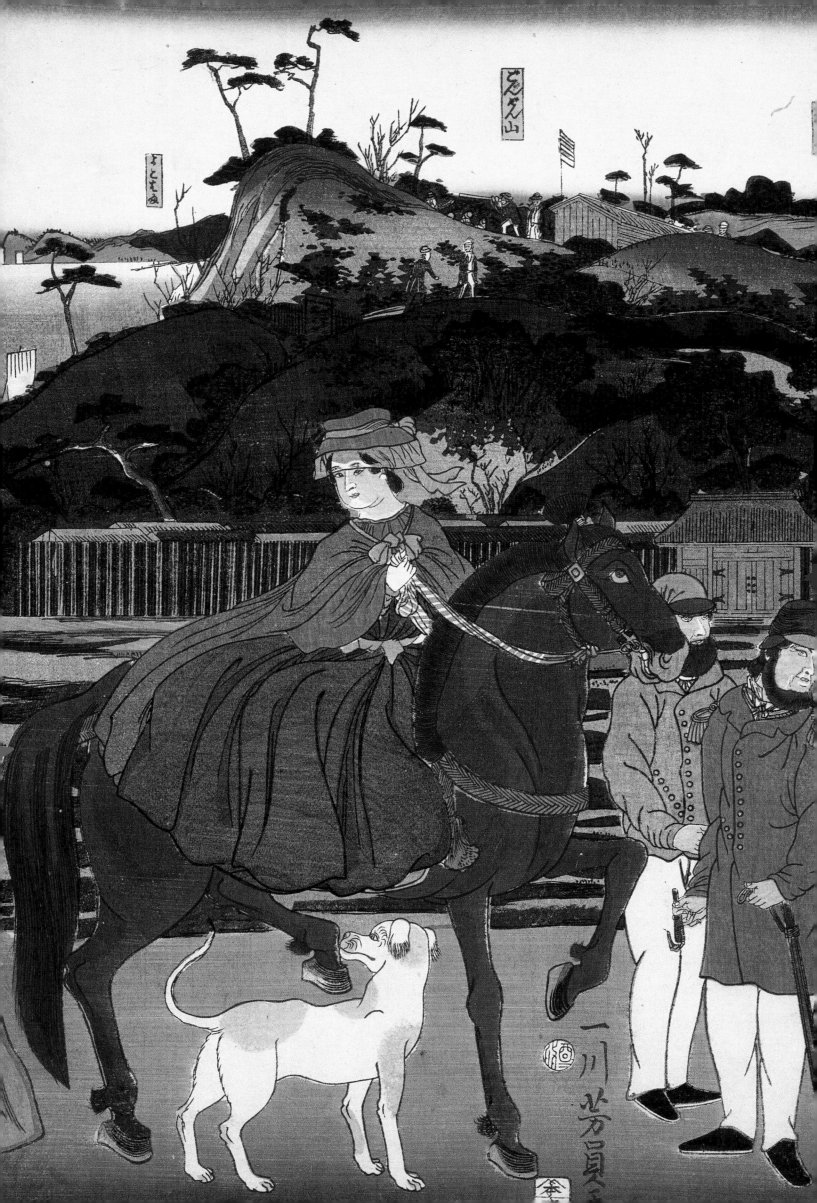

48 Foreigners Visiting the Famous Site of Mount Gongen in Kanagawa

cat. no. 48
Kanagawa Gongenyama gaikokujin yūran
Edo period, 1861:2
by Yoshikazu (fl. ca. 1850–70)
publisher: Izumiya Ichibei
woodblock print
ink and color on paper
ōban triptych: 36.5 × 73.8 cm
(14⅜ × 29 1/16 in.)

Dominating the foreground of this scenic landscape of Gongenyama, a bluff overlooking the town of Kanagawa, is a group of foreign men, women, and children and a pet dog. One of the women rides a horse, a sight that was astonishing in Japan, where women did not ride. Japanese peasants beside the road and a Japanese woman and her children pause to stare at the sightseers.

To the left of the promontory, a label identifies the town of Kanagawa. In the distance, across the harbor, are large steamships anchored near Yokohama. At the top of Gongenyama several foreign men use a telescope to look across the bay. Although the foreigners in Yoshikazu's prints have been adapted from his study of Western illustrations, the artist has created a credible portrayal of a sightseeing excursion. Kanagawa remained the site of foreign diplomatic residences for some time after the opening of Yokohama and continued to have a significant foreign community.

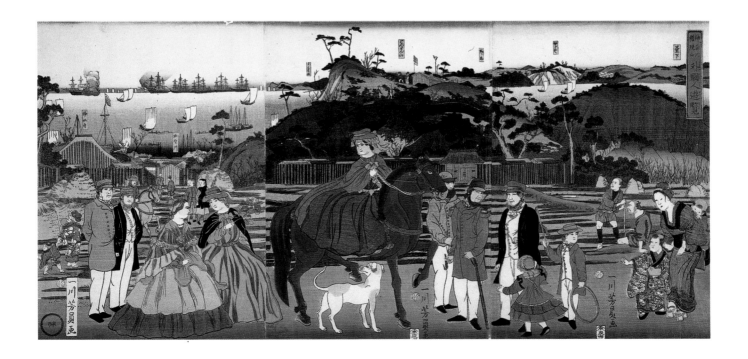

49 Foreigners Sightseeing at the Famous Sites of Edo

cat. no. 49
Edo meisho kenbutsu ijin
Edo period, 1861:9
by Sadahide (1807–ca. 1878)
publisher: Yamaguchiya Tōbei
woodblock print
ink and color on paper
ōban: 37.5 × 27.2 cm
(14¾ × 10¹¹⁄₁₆ in.)

Two distinctive, steeply arched bridges, called *taikobashi,* or "drum bridges," marked the approach to the Kameido Tenjin Shrine, located in Edo east of the Sumida River. The shrine was dedicated in the 1660s to the deified Sugawara Michizane, the patron deity of calligraphy and learning. Hiroshige I (1797–1858) included the bridges to the Kameido Tenjin Shrine among his famous series of prints, "One Hundred Famous Views of Edo" (*Meisho Edo hyakkei*), published in 1856–58.[1]

The bridges of the Kameido Tenjin Shrine were especially attractive to children. In this print three American children rush ahead of their father to climb up the bridge as a Japanese boy and his father approach from above, their expressions reflecting curiosity and surprise at the sight of the foreign family. Permission to travel to Edo, which was beyond the limits of the treaties of the Five Nations, was restricted to those invited by resident diplomats. Allowance seems to have been granted relatively liberally, however, according to the many travel accounts from the early 1860s. Nevertheless, it is unlikely that Sadahide's print documents an actual scene. It probably represents instead his sympathetic understanding of the universality of children's amusements.

1. Henry D. Smith II and Amy G. Poster, *Hiroshige: One Hundred Famous Views of Edo* (New York: George Braziller and the Brooklyn Museum, 1986), 65.

50 Americans Strolling About

cat. no. 50
Amerikajin yūkyō
Edo period, 1861:2
by Yoshifuji (1828–1887)
publisher: Aito
woodblock print
ink and color on paper
ōban: 35.4 × 24.6 cm
(13¹⁵⁄₁₆ × 9¹¹⁄₁₆ in.)

Using the roman alphabet, the artist has written in the label the Japanese word for "Americans," dividing the syllables to arrange the characters within the traditional narrow, vertical title cartouche. An American family is the subject of the print: the father smokes a cigarette while the mother carries a boy on her back. Shaded areas on the clothing and faces of the figures reveal the artist's study of light and shadow from Western pictorial art.

51 Games of Foreign Children

cat. no. 51
Gaikoku kodomo yūgi no zu
Edo period, 1860:11
by Yoshikazu (fl. ca. 1850–70)
publisher: Maruya Jinpachi
woodblock print
ink and color on paper
ōban: 36.9 × 25.4 cm
(14½ × 10 in.)

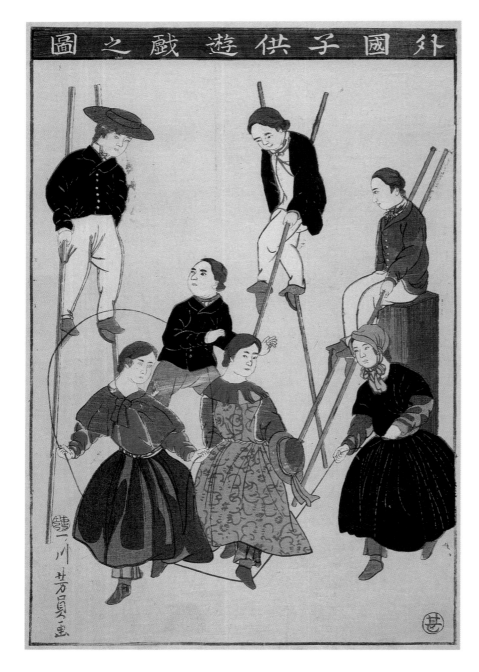

Among the most delightful subjects of Yokohama prints is the series by Yoshikazu of foreign children at play. Yoshikazu devised the prints from monochromatic illustrations in Western newspapers and magazines. Consequently, he occasionally had difficulty in interpreting such essential details as snow; a print of children sledding, for example, shows them speeding down a grassy slope (fig. 26). Here the boys play on stilts while the girls skip rope. The rope is drawn in an awkward and impractical position, probably owing to the artist's lack of familiarity with the sport.

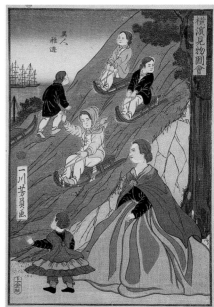

Figure 26 *Picture of Sights in Yokohama: Foreign Children Playing,* 1860, by Yoshikazu (fl. ca. 1850–70). Woodblock print; ink and color on paper. Kanagawa Prefectural Museum, Yokohama. One of the most delightful of Yoshikazu's prints of foreign children is this composition of children sledding down a hill. Copied, like others of this series, from monochromatic engravings in newspapers and magazines, this picture omits an essential element—snow.

52 Picture of People of the Five Nations: A Sunday

cat. no. 52
Gokakoku jinbutsu: Dontaku no zu
Edo period, 1861:12
by Yoshitora (fl. ca. 1850–80)
publisher: Yamashiroya Jinbei
woodblock print
ink and color on paper
ōban triptych: 34.9 × 72.9 cm
(13¾ × 28¹¹⁄₁₆ in.)

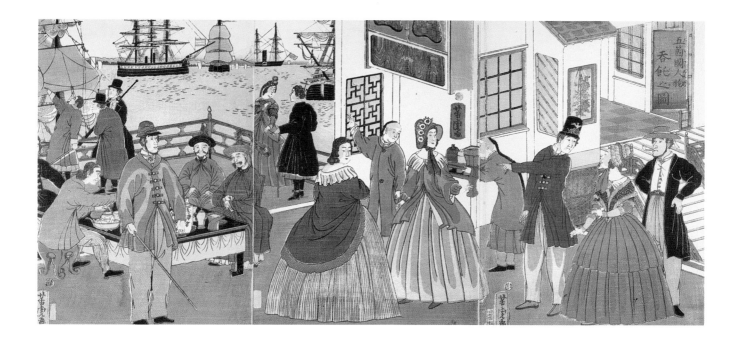

Foreign merchants, officers, and ladies gather for refreshments in a setting that represents a mercantile establishment along the Yokohama waterfront. The scene is composed of figures duplicated from other works, including prints from the series "Pictures of Foreign People" (*Gaikoku jinbutsu zuga*) by Yoshiiku (1833–1904; artist of cat. nos. 9, 35, 44, and 59),[1] which was published earlier in 1861. The somewhat awkward representation of the building suggests that it, too, was composed from fragmentary elements gleaned from a number of sources by an artist whose understanding of linear perspective was less than perfect.

1. Kanagawa, *Yokohama ukiyo-e*, 497.

A lively party in a large mercantile firm is the subject of one of Sadahide's most famous Yokohama prints. The stripes of an American flag in the upper left corner identify the establishment as American. Making effective use of the L-shaped configuration of the open veranda, Sadahide highlights a row of figures in large scale in the foreground while a dinner party occupies the middle ground. The large number of bottles on the dining table accurately reflects the prominent role of alcoholic beverages in early Yokohama. Ample quantities of wines and spirits are among the listed cargo imported there—2,783 cases from British ships alone in 1863.[1] One of the dinner guests demonstrates the use of Western eating utensils by raising a morsel of food held on the tines of a fork. A framed picture of a Western ship sailing by Mount Fuji hangs overhead.

Among the foreground figures are a professional entertainer, or geisha, and Japanese courtesans who mingle with the Americans. At the far left an American child playfully tugs at the queue of a Chinese servant who is descending the stairs. The kimono worn by the courtesan at the far right, an outer robe with bold, horizontal blue stripes and tie-dyed under-robes with white dots against a red ground, incorporates patterns probably based on the American flag but with the colors reversed.[2] She observes a musical performance by an American woman who plays an instrument of the violin family, and beside her a geisha playing a samisen held across her lap. Instead of supporting the instrument in the appropriate position under the chin or upright, the American holds it in the position of a samisen and plays it with a samisen plectrum rather than a bow. Despite Sadahide's extensive

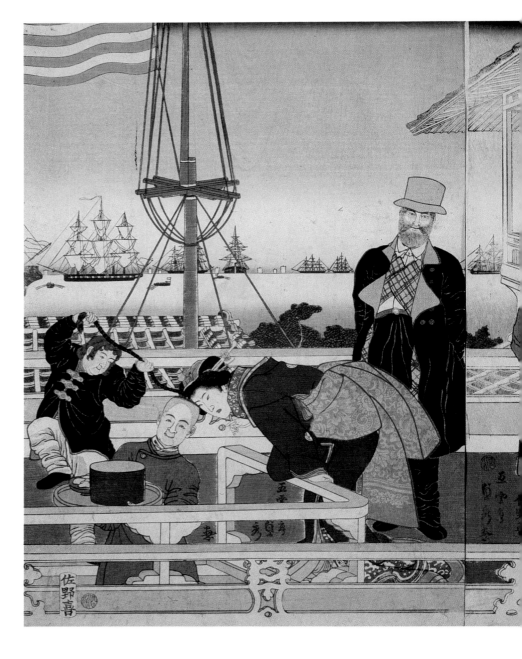

knowledge of Western customs and material culture, he was apparently unaware of the technique of playing Western stringed instruments.

Overhead is a large framed picture of an exotic subject: men riding camels. Sadahide's faithful rendering of the unfamiliar image of camels and their riders suggests that he had seen either a Western painting[3] brought to Yokohama by an early resident, or

one of the more widely disseminated illustrations in Western newspapers or magazines. After two camels had been brought to Japan by the Dutch in 1821 and exhibited in Osaka and Edo, they were frequently depicted in prints of the period.[4]

1. Paske-Smith, *Western Barbarians*, 328.

2. Meech-Pekarik, *World of the Meiji Print*, 24–25.

cat. no. 53
Yokohama ijin shōkan no zu
Edo period, 1861:9
by Sadahide (1807–ca. 1878)
publisher: Sanoya Kihei
woodblock print
ink and color on paper
ōban triptych: 36.5 × 75.3 cm
(14⅜ × 29¹¹⁄₁₆ in.)

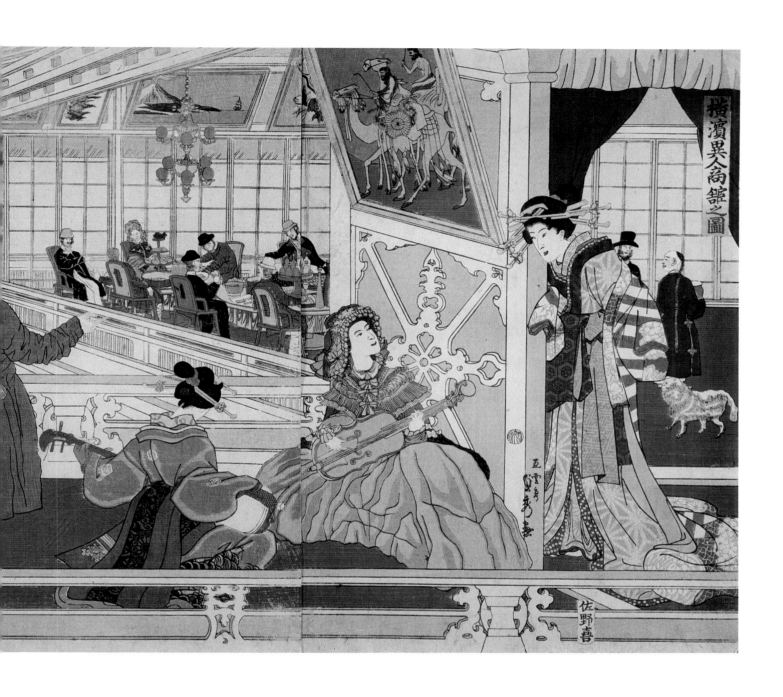

3. Camel caravans were a subject favored by orientalist painters. A painting of a camel caravan by Léon-Adolphe-Auguste Belly (1827–1877), *Pélerins allant à la Mecque* (1861) in the Musée d'Orsay, Paris, is led by two figures dressed much like the riders in Sadahide's picture (see Mary Anne Stevens, ed., *The Orientalists: Delacroix to Matisse* [New York: Thames and Hudson and the National Gallery of Art, 1984], 82, 115–16). Although Sadahide could not have seen Belly's painting, it is clear that he had seen a similar image, probably an illustration in a European newspaper.

4. Cal French, *Through Closed Doors: Western Influence on Japanese Art, 1639–1853* (Rochester, Mich.: Meadow Brook Art Gallery, Oakland University, 1977), 48.

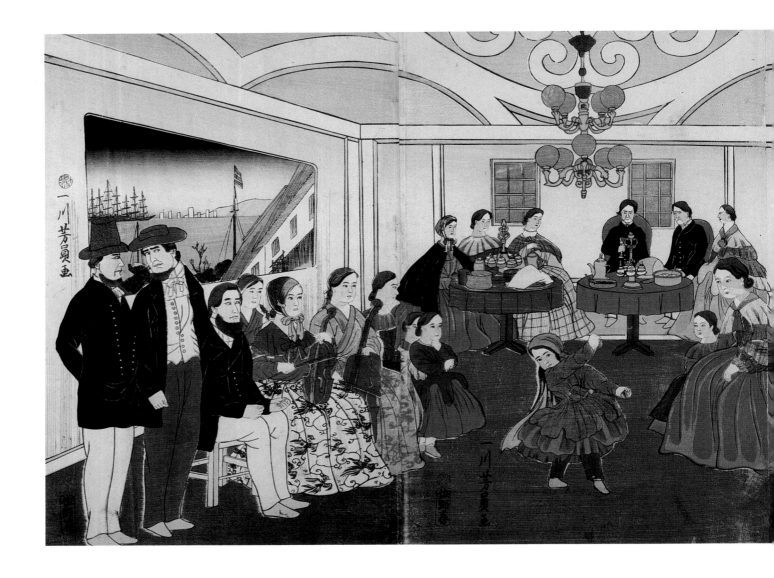

Although this print includes a view of Yokohama's harbor through the open window to the left, it is closely based on an illustration of a performance in honor of Japan's first embassy to the United States in 1860. The illustration of a young girl dancing at the May Festival Ball of the Children at Willard's Hotel (now the Willard Inter-Continental) in Washington, D.C., was published in *Frank Leslie's Illustrated Newspaper* (fig. 27).[1] Katō Somō, a member of the Japanese delegation, describes the children's ball in his diary, published in 1861:

About one hundred boys and girls ranging from five to nine years of age were dressed in beautiful clothes. The boys smaller than seven or eight had ribbons hanging from their shoulders, and the girls had bracelets and hair ornaments in gold, silver, and coral. They had neither powder nor rouge, but their natural, beautiful complexion was whiter than snow, and more resplendent than jewels. They looked like goddesses [*tennyo*] in Paradise [*shinsenkyō*].[2]

Yoshikazu's triptych is probably based directly upon the illustration in *Frank Leslie's Illustrated Newspaper*. Although the artist might not have been fully aware of the location of the scene he was copying, he quite closely reproduced the features of the room—such as the chandelier of gaslights above—as depicted in the documentary sketch. Moreover, Yoshikazu added such interior furnishings as the wall clock, which had been represented in earlier Japanese illustrations of the Dutch at Deshima. The shading of the costumes and the somewhat stiff and unnatural poses of the figures reflect the artist's dependence upon secondary sources. The young girl dancing with castanets appears in almost precisely the same stance in several other prints by Yoshikazu.

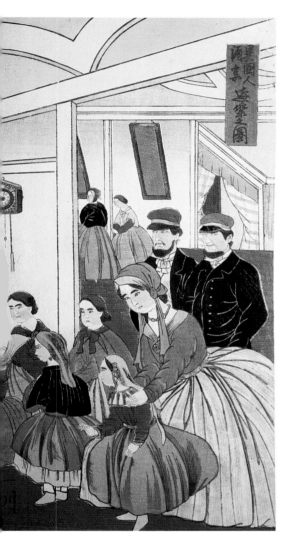

cat. no. 54
Ikokujin shūen yūraku no zu
Edo period, 1860:12
by Yoshikazu (fl. ca. 1850–70)
publisher: Sanoya Kihei
woodblock print
ink and color on paper
ōban triptych: 36.3 × 72.8 cm
(14½ × 28¹¹/₁₆ in.)

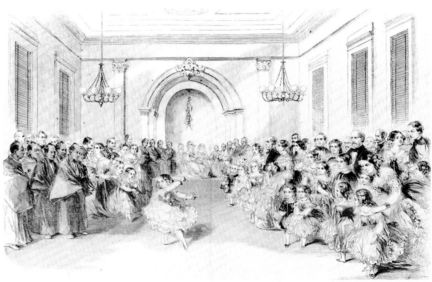

Figure 27 *May Festival Ball of the Children (at) Willard's Hotel, Given in Honor of the Japanese Ambassadors*. Illustration from *Frank Leslie's Illustrated Newspaper*, 9 June 1860. The children's ball, held on 23 May 1860, was one of many social events held in Washington and other cities to honor the diplomats from Japan.

1. Kanagawa, *Yokohama ukiyo-e*, 481. See also Miyoshi, *As We Saw Them*, 63–64.

2. Katō Somō, *Futayo gatari* (1861); quotation and translation in Miyoshi, *As We Saw Them*, 63.

55 Picture of Amusements of Foreigners in Yokohama in Bushū (Modern Musashi Province)

cat. no. 55
Bushū Yokohama gaikokujin yūgyō no zu
Edo period, 1861:1
by Yoshitora (fl. ca. 1850–80)
publisher: Yamadaya Shōjirō
woodblock print
ink and color on paper
ōban triptych: 36.3 × 74.4 cm
(14 5/16 × 29¼ in.)

In this fanciful composition that compresses and juxtaposes scenes in and around Yokohama, Yoshitora has combined many scenes of the port city taken from his individual prints. The foreigners in the foreground are shown using a variety of transportation, from horses to a large carriage labeled "an official going out." A Chinese man is carried aboard a palanquin (*kago*) designated "Nankin *kago*." The ubiquitous equestrian woman in the pineapple-crown hat and the man riding at a gallop with a Japanese groom rushing behind can be recognized from other Yokohama prints, such as catalogue numbers 30 and 41. Several images from Yoshitora's "Eight Views of Yokohama" (see cat. nos. 39–43), published in the same month of 1861 as this print, appear in this composite composition.

In the distance, at the upper right, a Japanese merchant shows his wares to two Western customers. Two Chinese men, virtually identical to the Chinese men in the winter scene from "Eight Views of Yokohama" (cat. no. 43), stand outside. In the center panel is a scene of a party in a brothel in Miyozaki, Yokohama's entertainment district. Two women dance to the music of samisen played by geisha seated incongruously in chairs while several Western men enjoy sake and other refreshments.

The label identifies the setting of the left panel as Gankirō, the establishment in Miyozaki that catered to foreign clients. The top of the panel shows a performance of kabuki, a subject portrayed in another print of Yoshitora's "Eight Views of Yokohama" series (see cat. no. 40), but here the audience consists of Western men instead of Chinese. The scene comes from the famous kabuki play *Yoshitsune senbonzakura*, which is based on the historic story of the flight of Minamoto Yoshitsune from his rival, Yoritomo. It takes place in the hills of Yoshino, near Kyoto, which is famous for its spring cherry blossoms. Shizuka, Yoshitsune's mistress, has been saved by Tadanobu, a fox in human guise, who protects her in order to remain close to the hand-drum Shizuka holds, which was made from the skin of his parents.

In contrast to most kabuki prints, which focus exclusively on famous actors, this scene includes the stage attendants who provide light, sound effects, and management of props. By convention they are "invisible," and simply omitted from most Japanese prints of actors. Yoshitora's prints of kabuki provide realistic impressions of the staging of a performance before an audience.

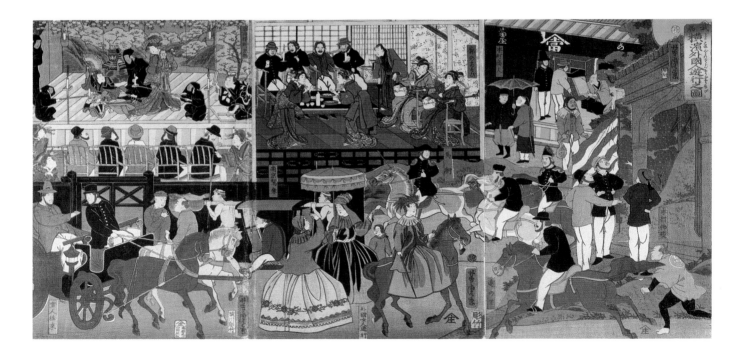

56 American Drinking and Carousing

cat. no. 56
Amerikajin yūkō sakamori
Edo period, 1861:1
by Yoshitora (fl. ca. 1850–80)
publisher: Enshūya Hikobei
woodblock print
ink and color on paper
ōban: 35.4 × 24 cm (13¹⁵/₁₆ × 9⁷/₁₆ in.)

A bearded American holds a stemmed glass while his companion, a Japanese courtesan, holds a large bottle. Hundreds of courtesans lived in Miyozaki, the entertainment district of Yokohama; few other women lived in the port city in the first years after its opening to international trade. Drinking was a major pastime for the foreign merchants and sailors there, whether at private parties such as those in the Gankirō in Miyozaki, or in the "grog shops," which numbered twenty-four by 1865.[1] Public drunkenness was not uncommon among the men of many nationalities who came to Yokohama, and their drinking was frequently portrayed in Yokohama prints.

1. Paske-Smith, *Western Barbarians*, 277.

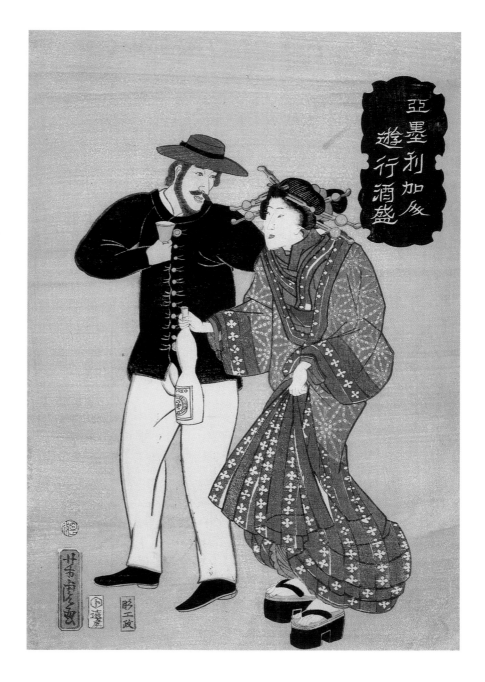

Wearing elaborate costumes, young girls perform dances at Gankirō, the most prominent establishment in Yokohama's entertainment district. In contrast to kabuki, in which all roles were played by male actors, the performances of children's dances were exclusively by females. The girls began training in childhood to learn skills they would need as geisha, professional entertainers proficient in dance and vocal or instrumental music.

Yoshikazu's triptych is unusual for its vantage point from backstage, from which one looks through the performance toward the audience of foreign men and women. In the foreground, offstage, the performers dress, apply makeup, and adjust their costumes under the supervision of older women. Above the dressing table to the left are male and female wigs. In the center, two women assist a girl dressed in the costume of a nobleman. On stage, playing male and female roles, two young dancers strike the stylized poses of a dramatic dance. Their performance is lit by candles extended on long poles by stagehands. To the right, men provide sound effects using wood clappers and a large drum hidden offstage. With its wealth of detail, Yoshikazu's print presents a colorful and convincing illustration of a theatrical performance in the Gankirō.

cat. no. 57
Yokohama Gankirō kodomo teodori no zu
Edo period, 1861:1
by Yoshikazu (fl. ca. 1850–70)
publisher: Maruya Jinpachi
woodblock print
ink and color on paper
ōban triptych: 36.4 × 73.7 cm
(14 5/16 × 29 in.)

58 Picture of Foreigners' Revelry at the Gankirō in the Miyozaki Quarter of Yokohama

cat. no. 58
Yokohama Miyozaki-kaku Gankirō ijin yūkyō no zu
Edo period, 1861:1
by Yoshikazu (fl. ca. 1850–70)
publisher: Maruya Jinpachi
woodblock print
ink and color on paper
ōban triptych: 36.4 × 73.8 cm
(14 5/16 × 29 1/16 in.)

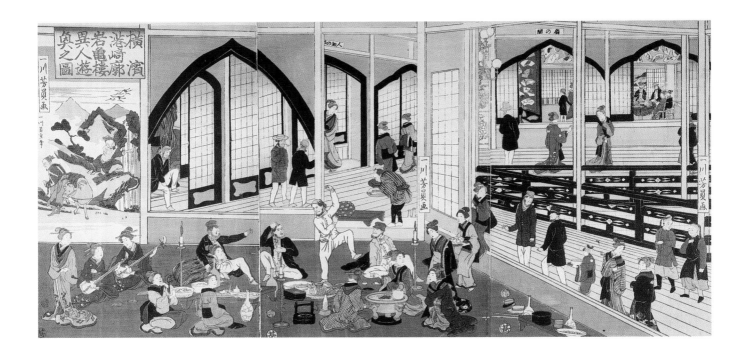

Among the attractions of the Gankirō, the largest establishment in Miyozaki, was the so-called Fan Room decorated with fan paintings pasted to the walls. Shown in the upper right corner of this triptych, the Fan Room is the setting for a Western-style dinner party, where male patrons and Japanese hostesses are seated at a table with chairs.

In the foreground a boisterous party has been under way for some time. Sitting on the floor in Japanese style, several foreign men enjoy food, sake served from ceramic bottles, and the companionship of Japanese women. To the left two geisha play the samisen as one of the foreign guests performs a dance.

59 Picture of Foreigners of the Five Nations Carousing in the Gankirō

cat. no. 59
Gokakoku Gankirō ni oite sakamori no zu
Edo period, 1860:12
by Yoshiiku (1833–1904)
publisher: Kiya Sōjirō
woodblock print
ink and color on paper
ōban triptych: 37.8 × 75.3 cm
(14⅞ × 29¹¹⁄₁₆ in.)

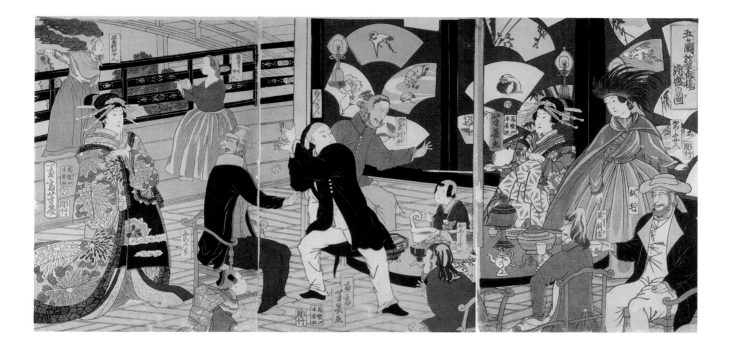

The Fan Room of the Gankirō is the setting for this print of a drinking party of foreigners. In the background are sliding paper doors (*fusuma*) decorated with the painted fans for which the room was named. Outside the room is the second-story walkway built around a central courtyard, which is distinctive for the black-lacquered railing commonly seen in prints of the Gankirō (see cat. no. 58).

Foreign men and women, each labeled with the name of a country of the Five Nations, gather for a party around a low table laden with serving dishes. Counterclockwise from the lower right of the center print the labels read: Russia, England, Holland,¹ Russian woman, America, English woman, American woman, France, and Nanjing [China].

Two magnificently dressed *oiran*, the upper class of Japanese courtesans, attend the party with two young Japanese boys, who may be the sons of women employed by the Gankirō. The *oiran* maintain a dignified, almost regal demeanor befitting their high rank. The one seated to the right offers a long-handled Japanese tobacco pipe (*kiseru*) to the American man. Regardless of their rank within the hierarchy of entertainers in Miyozaki, all of the women employed in its establishments lived in the circumscribed world of the quarter, which was surrounded by a moat and approachable by a single bridge from the roadway to Yokohama's main town. Contemporary records of Miyozaki indicate that in reality it was much less colorful than it appears in Yokohama prints, which were probably intended in part to promote business in the new pleasure quarter.²

1. The man wearing a brimmed hat is labeled "red-hair," an old Japanese term for the Dutch that came to be generically applied to European foreigners.

2. The dozen or so prints and booklets inspired by the exotic Gankirō were produced between approximately the second month of 1860 and the first month of 1861, during its first year in business (Meech-Pekarik, *World of the Meiji Print*, 33).

60 Untitled (Circus in Yokohama)

The foreigners in Yokohama perform acrobatics in a circus. In all nations where this is performed it is valued, and human nature is the same, so would this not indeed be a pleasure for many peaceful generations?

Thus reads the inscription in Yoshikazu's print that shows acrobats performing in a Western-style circus. A group of musicians accompanies a man and woman standing on horseback, trapeze artists, and a man balancing on a ball, which he maneuvers along a raised platform.

The first Western circus to visit Japan came to Yokohama in 1864 under the direction of "Professor" Risley, an acrobat and adventurer from New Jersey. After establishing residence in Yokohama, Risley founded the town's first icehouse and dairy. In 1866 he organized a group of Japanese street entertainers for a two-year tour of the United States.[1]

This print, although untitled, probably depicts Risley's circus of 1864, which consisted primarily of acrobats and equestrians. The novelty of the circus attracted spectators from Edo and encouraged other entrepreneurs to send performers to Yokohama. In 1869, P. T. Barnum's midget couple, Mr. and Mrs. Tom Thumb, began their three-year international tour in Yokohama. Mrs. Tom Thumb (1841–1919) later recounted in her memoirs, "While in Japan, we exhibited before the high officials, the Japanese ladies and the few Europeans to be found in the empire. We were everywhere received with great expressions of kindness and hospitality."[2]

Beginning in the Meiji period, circus performances were presented in Tokyo. The French Soullier troupe performed there in 1871, and was followed by the

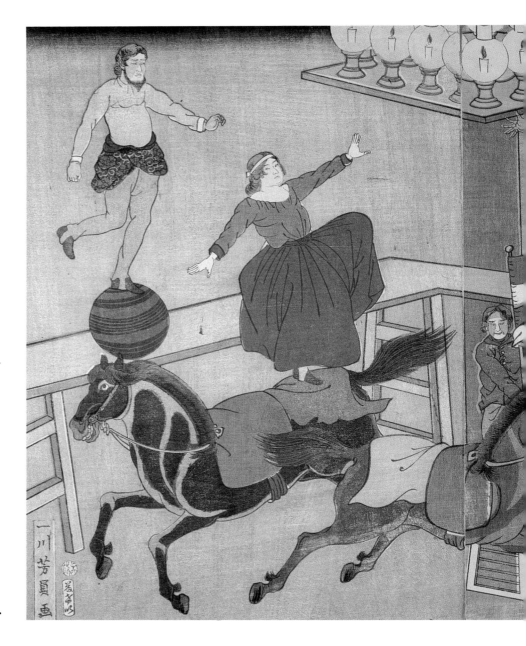

Italian circus of Giuseppe Chiarini in 1886–87. Like Risley's circus, these also became the subject of woodblock prints.[3]

1. Markus, "Carnival of Edo," 535.

2. Ibid., 538, quotation from M. Lavinia Magri, *The Autobiography of Mrs. Tom Thumb (Some of My Life Experiences)*. Ed. A. H. Saxon (Hamden, Conn.: Archon Books, 1979), 118.

3. Ibid., 539.

cat. no. 60
Edo period, 1864:4
by Yoshikazu (fl. ca. 1850–70)
publisher: Fujiokaya Keijirō
woodblock print
ink and color on paper
ōban triptych: 35.5 × 74 cm
(14 × 29⅛ in.)

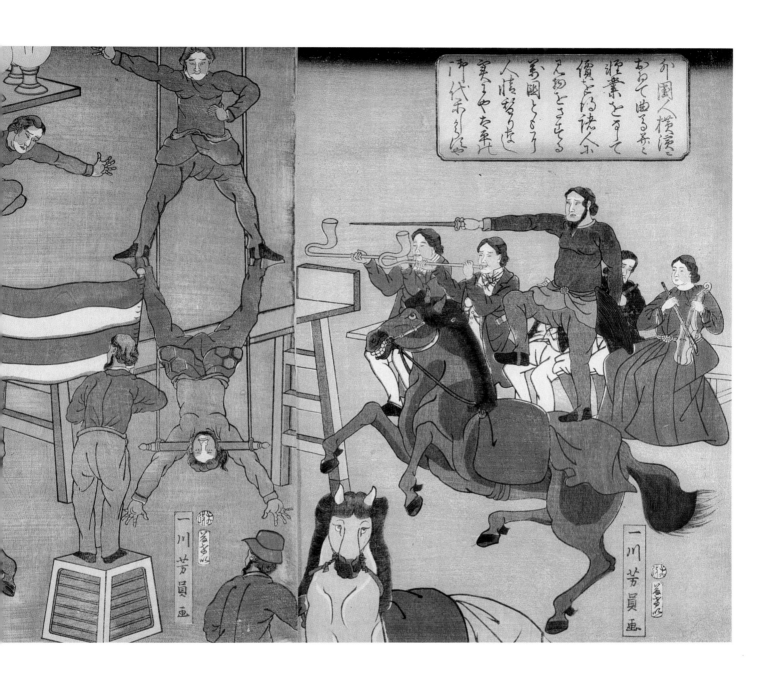

61 Display at Nishi Ryōgoku

cat. no. 61
Nishiryōgoku ni oite kōgyō
Edo period, 1860:7
by Yoshitoyo (1830–1866)
publisher: Kikuya Ichibei
woodblock print
ink and color on paper
ōban: 36.3 × 25 cm
(14¼ × 9¹³⁄₁₆ in.)

Exotic animals had been introduced to Japan by the Dutch through the port of Nagasaki in the early nineteenth century: an elephant imported in 1813 was followed by two camels in 1821.[1] Shortly after the opening of Yokohama to foreign trade in 1859, two tigers were brought to Japan. Sir Rutherford Alcock (1809–1897), the British minister, wrote of the tigers:

Worth about $100 in the Straits, they sold here to Japanese for purposes of exhibition for three or four thousand. And in this, as in other things, the Japanese appetite appeared to grow by indulgence, for the tigers led to an order for a brace of elephants.[2]

According to Alcock and others, the Japanese customs officials initially refused to pass the tigers through customs because they were not listed as an import commodity. But when the Dutch consul intervened and suggested that the tiger simply be let loose, the officials relented.

Notwithstanding the validity of that story, numerous prints attest that a tiger was indeed exhibited in 1860 in Edo's busy Ryōgoku district, which was famous as a locale for displays of exotic animals and other spectacles.[3] Yoshitoyo's print depicts a leopard ferociously attacking a rooster, whose feathers fly about the cage. Compared to some other portrayals of the "tiger" exhibited at Ryōgoku, in which the animal seems little more fierce than a domestic cat, Yoshitoyo's print effectively expresses the frightening and deadly energy of the beast. The inscription by Kanagaki Robun (1839–1894) reads:

When the tiger and the leopard roar from the ground, the rooftiles will all shake, and wine on a table will tip over, as Shazaikan records. Being able to view such a frightening beast in a prosperous district spreads the moral reform of peace widely across the seas and has been a blessing for this auspicious reign.

To Robun the importation to Japan of such magnificent, exotic animals as tigers, leopards, and elephants was a manifestation of Japan's new international status.

1. French, *Through Closed Doors*, 48–49.

2. Alcock, *Capital of the Tycoon*, vol. 2, 385.

3. See Andrew L. Markus, "The Carnival of Edo: *Misemono* Spectacles from Contemporary Accounts," *Harvard Journal of Asiatic Studies* 45, no. 1 (1985): 507–10.

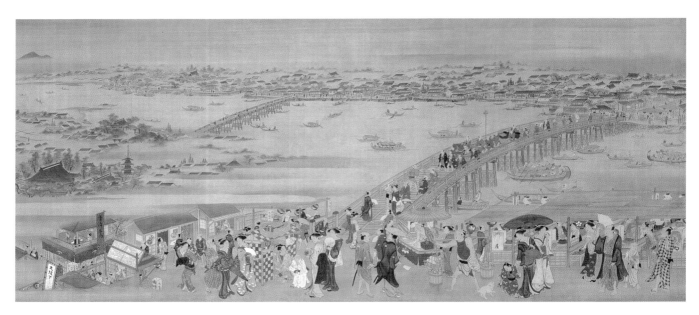

Figure 28 *Ryōgoku Bridge* (detail), date unknown, by Utagawa Toyoharu (1735–1814). Painting; ink, color, and gold on silk. Freer Gallery of Art, Smithsonian Institution, Washington, D.C., 03.217. The Ryōgoku Bridge across the Sumida River was a lively center for entertainment and exhibits of curiosities including exotic animals.

62 Recently Imported Large Elephant

cat. no. 62
Shintosen rai no daizō
Edo period, 1863:4
by Yoshitoyo (1830–1866)
publisher: Tsujiokaya Bunsuke
woodblock print
ink and color on paper
ōban: 36.7 × 25 cm (14 7/16 × 9 13/16 in.)

When an elephant in 1813 and two camels in 1821 were brought into Nagasaki by the Dutch, they toured Japan and were exhibited in the major cities. Extraordinarily popular, they inspired prints and poems.

In the third lunar month of 1863 a Portuguese merchant brought an Indian elephant into Japan at the port of Yokohama. Like a tiger in 1860, the elephant was exhibited in Edo at Ryōgoku, and its novel sight prompted a number of prints of the large beast. The note beside the title of this print reads: "Since the early part of the third [lunar] month, it has been on exhibition at Hirokōji in Nishi Ryōgoku." An inscription by the satirist Kanagaki Robun (1829–1894) is followed by a humorous verse: "Performing the eating of a bundle, oh!/The elephant's nosebridge."

Other prints of the elephant provide the animal's dimensions or include a brief essay by Robun. The essay always ends with the verse reproduced on this print. The rest of the text, which does not appear on this print, reports:

The elephant is only three years old. It has a shape like a large mountain and a trunk that looks just like a suspension bridge. . . . It understands what people say and can guess their feelings. It gets rid of poisonous things. For those who see it, the seven fortunes will decrease and the seven fortunes will grow. All gentlemen should compete for a look at it.[1]

Yoshitoyo seems to have enjoyed portraying the elephant. One of his prints published in the previous month of 1863 depicts a large elephant in profile; a diptych format accommodates the animal, an attendant, and several spectators. Here the elephant is portrayed in a single print, with a frontal view showing the animal's head and trunk twisted to one side to grasp food offered by a Japanese man in formal dress. The rounded form of the elephant nearly fills the page, an effect that emphasizes his large size. Prints of the period of Japanese sumo wrestlers employ similar visual devices.

1. Meech-Pekarik, *World of the Meiji Print,* 31–32.

63 Picture of Great Military Exercises of the Cavalry and Infantry

cat. no. 63
Kiheitai hoheitai sanpei daichōren no zu
Edo period, 1867:8
by Yoshitoshi (1839–1892)
publishers: Yorozuya Magobei and
Sekiguchi Gyokumeidō
woodblock print
ink and color on paper
ōban triptych: 34.9 × 72.2 cm
(13¹¹⁄₁₆ × 28⁷⁄₁₆ in.)

The organization, technology, and tactical methods of Western military units had attracted renewed interest in Japan even before Commodore Perry's arrival in 1853. Daimyo, lords of domains in southwestern Japan that were threatened by frequent contact with Western ships, preceded the Tokugawa shogunate (1603–1867) in studying Western military technology and arming themselves with guns.[1] After failing to persuade the British, who had a regiment in Yokohama in 1864, to provide technical training to the government troops, the shogunate sought aid from the French and eventually established a training school in Yokohama.

This triptych by Yoshitoshi depicts field maneuvers at the Yokohama training ground. Infantry, artillery, and cavalry—the "three arms," or *sanpei*, of the modern European military techniques—are illustrated here.[2] Both British and French troops are shown, al-though it is uncertain whether they would actually have cooperated in demonstrations of field maneuvers at the time the print was published.

1. D. Eleanor Westney, "The Military," in Marius B. Jansen and Gilbert Rozman, eds., *Japan in Transition from Tokugawa to Meiji* (Princeton: Princeton University Press, 1986), 166–73.

2. Conrad Totman, *The Collapse of the Tokugawa Bakufu, 1862–68* (Honolulu: University Press of Hawaii, 1980), 185.

64 Artillery Drill of Great Guns

cat. no. 64
Taijū chōren no zu
Edo period, 1867:3
by Yoshikazu (fl. ca. 1850–70)
publisher: Maruya Jinpachi
woodblock print
ink and color on paper
ōban triptych: 35 × 73.1 cm
(13¾ × 28¹³⁄₁₆ in.)

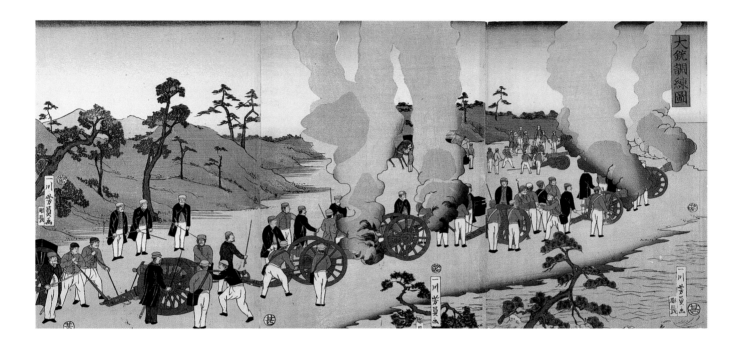

Yoshikazu's triptych of 1867 depicts an artillery drill by Western soldiers. Among prints of the late Edo period (1615–1868) that illustrate military exercises, it is distinctive for its realistic portrayal of the appearance of cannon firing from the shoreline.[1] Salutes discharged by Western gunboats that settled in Yokohama's harbor startled the Japanese, who had no comparable artillery. Concern for security prompted the Japanese, beginning under the sponsorship of the Tokugawa government (1603–1867), to study and adopt Western military technology.

The artistic quality of this print, which portrays the activities of the Western troops without neglecting the scenic landscape setting, reflects Yoshikazu's development as an artist since his first slightly awkward essays illustrating foreigners in Japan (see cat. nos. 17–20). The triptych combines techniques learned from Western engravings—seen in the linear patterns in the clouds of smoke—with a particularly sensitive use of color gradation and a realistic approach to the subject

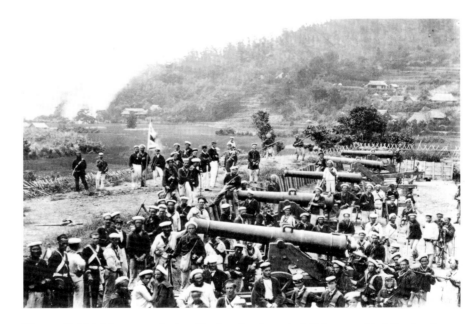

Figure 29 British troops during the bombardment of Shimonoseki, 5 September 1864. Photograph by Felice Beato (ca. 1825–ca. 1908). Yokohama Archives of History. Shimonoseki in southwestern Japan was bombarded by a combined naval force led by the British in retaliation for sporadic shelling of Western vessels in the Strait of Shimonoseki.

that prefigures documentary prints of the Meiji period (1868–1912).

1. Kanagawa, *Yokohama ukiyo-e*, 504.

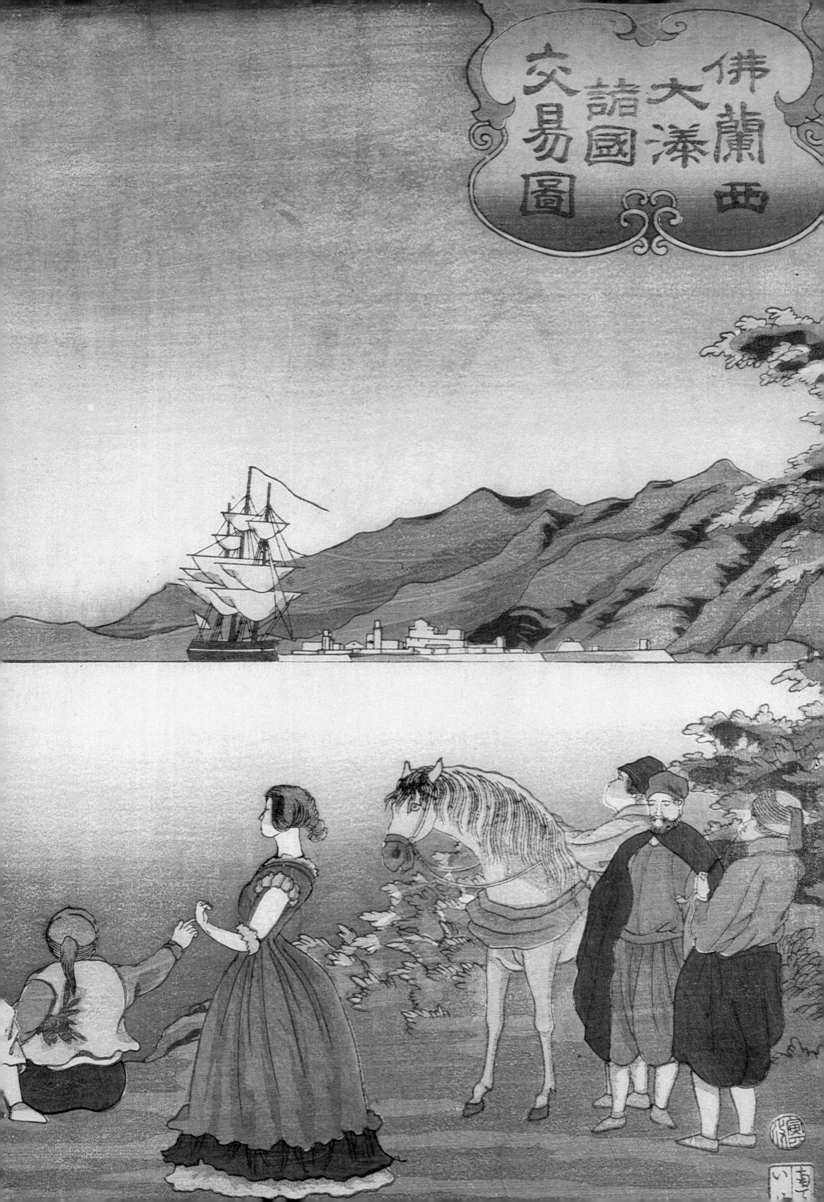

ENVISIONING FOREIGN NATIONS AND THEIR REMARKABLE DISCOVERIES

POPULAR YOKOHAMA prints depicting the people of the Five Nations in Japan stimulated an interest in stories and images of foreign countries. Kanagaki Robun (1829–1894), prominent among those writers who took up the subject of the Western presence in Japan shortly after the opening of the port city, provided explanatory texts for many Japanese prints of scenes in foreign lands. Artists fabricated the images from many sources, primarily illustrations from newspapers and magazines. Since they could not read the foreign-language captions, they frequently incorporated buildings, for example, from localities unrelated to the title of the print or its text.

The technological wonders of the Western nations were a captivating subject for Japanese artists and their audiences. Steamships and armored warships were already familiar to the Japanese who lived near Yokohama, Edo, Nagasaki, or other areas along the coastline where foreign naval vessels passed by. In 1860 the first Japanese embassy to the United States had witnessed a balloon launch in Philadelphia. The event inspired many artists to produce prints copied from illustrations of Western balloons. A Japanese balloon was eventually launched in the Tsukiji district in 1872.

Western inventions of many kinds, from sewing machines to cameras, were recorded in Japanese prints beginning in the 1860s. Those inventions as represented in popular prints produced after the Meiji Restoration of 1868 reflect the rapid modernization of Japanese technology and institutions along Western models. By extension other aspects of Western discoveries are also recounted in amusing and anecdotal narratives in a series of prints of the Meiji period (1868–1912), several images of which are contained in the Leonhart collection (see, for example, cat. nos. 72–75).

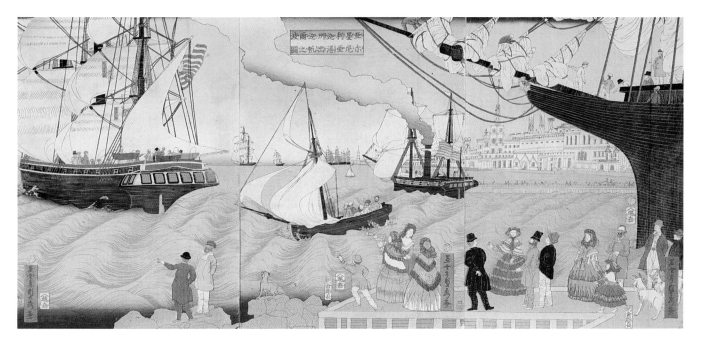

Figure 30 *A Ship Sailing from a Port in California, an American State*, 1862, by Sadahide (1807–ca. 1878). Woodblock print triptych; ink and color on paper. Kanagawa Prefectural Museum, Yokohama. An imaginative view of California, this print expresses the artist's awareness of America's westernmost state, where the first Japanese embassy to the United States had landed at San Francisco in March 1860.

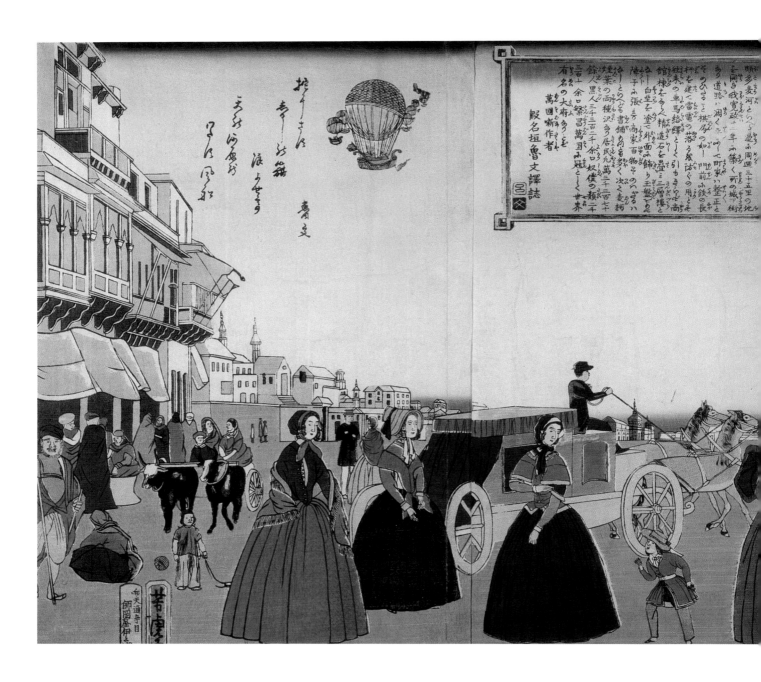

The center print of this triptych bears an inscription by Kanagaki Robun (1829–1894), author of some of the earliest Japanese accounts of Western nations after the opening of Yokohama in 1859:

The metropolis called Washington is on the continent of North America in the United States. It is said to be bounded by the borders of the states of Virginia ["hiruginiya"] and Maryland ["mareirando"] and the Potomac ["hotomaku"] River, an open space of thirty-five *ri*.[2] In the twelfth year of our Kansei era [1800], on the land below the castle, the roads were widened and tradesmen's houses were arranged in order like a go board.[3] In front of the gates, iron poles are erected to protect against lightning. The coming and going of carts and horses is continuous and incessant. The ridgepoles of the mercantile firms are arranged and the stones for building piled up to produce three-storied buildings. White clay is applied to enhance the exterior walls. The *shōji*[4] are covered with jade plaques. Although there are many kinds of merchandise for sale in the shops, book-shops and tobacco shops are two numerous types. The population exceeds 13,370; of black people, over 3,320; of slaves over 2,300. Its prosperity is first among the nations of the world, and it is a city that is famous throughout the world.

Translated by Kanagaki Robun, author of *Tales of All Nations*.

To the left of the inscription is a verse: "In flags that embrace them, gathering in billows, balloons cross the heavens."

cat. no. 65
Bankoku meisho zukushi no uchi:
Amerika Washinton fu
Edo period, 1862:6
by Yoshitora (fl. ca. 1850–80)
publisher: Moro'okaya Ihei
woodblock print
ink and color on paper
ōban triptych: 35.2 × 72 cm
(13¹⁵⁄₁₆ × 28⅜ in.)

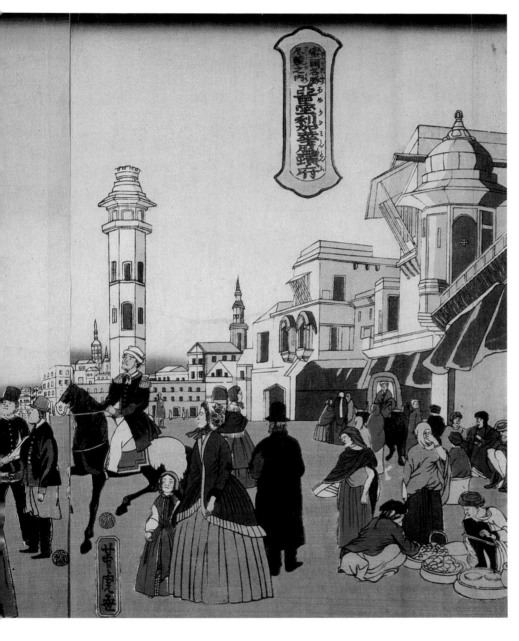

Figure 31 *The Main Street of Agra.* Illustration from the *Illustrated London News*, 27 November 1858. (Detail reproduced on p. 125)

The source for many elements of Yoshitora's triptych, and the book referred to in Robun's inscription, was an illustrated book, *Warabe etoki bankoku banashi* (Tales of All Nations with Captions for Children), published in 1860 by collaboration of Robun and Yoshitora. Architectural elements and figures from a number of unrelated sources are combined here; the buildings and many of the figures to the left and right are based on an illustration of the city of Agra, India (fig. 31). The artist, Yoshitora, has divided the elements of the illustration of Agra to bracket the central scene of his print. His model for many of the figures and distant buildings in the center print is probably an illustration of Boston rather than Washington.[5] The artists of Yokohama prints were unable to read the captions to Western illustrations that provided their impressions of urban architecture.

1. In the Japanese title of this series (see also cat. no. 68) the Chinese character meaning barbarian is used for the first syllable of the compound *bankoku*, which is commonly written with a homophone meaning myriad. In its more common form the compound *bankoku* means all nations of the world.

2. One *ri* is 2.44 miles, or 3.93 kilometers. Thirty-five *ri* equal 85.2 miles.

3. Go is a Japanese game of strategy played with black and white stones placed at intersections of lines ruled off on a board at regular intervals to form a square grid.

4. Shoji, Japanese sliding doors constructed of wood grids covered with paper, diffuse the light admitted to a room. Perhaps the author was describing glass windowpanes.

5. Kanagawa, *Yokohama ukiyo-e*, 498.

66 The Transit of an American Steam Locomotive

cat. no. 66
Amerikakoku jōkisha ōrai
Edo period, 1861:1
by Yoshikazu (fl. ca. 1850–70)
publisher: Maruya Jinpachi
woodblock print
ink and color on paper
ōban triptych: 37.1 × 75.7 cm
(14 ⁹⁄₁₆ × 29¹³⁄₁₆ in.)

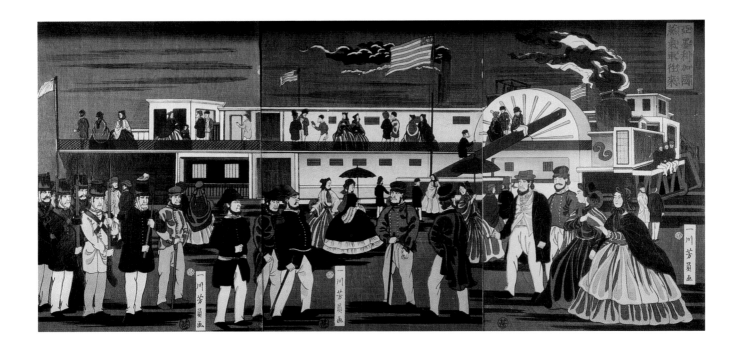

The popular image the Japanese held of the United States in the early 1860s was that of a powerful and technologically advanced nation. The first Japanese embassy to the United States in 1860 provided a group of well-educated and promising young men with a firsthand experience in the young Western country. Wood engravings for newspaper illustrations of that embassy to America provided Japanese artists with models for the costumes and customs of Americans. Figures based on those illustrations were repeated in later prints of foreign subjects.[1]

The figures in the foreground of this print are also drawn from illustrations of Americans from Western periodicals. The dominant image in the background purports to represent a steam locomotive, but its scale and some of its details, such as the large wheel on the right, make it clear that the artist has depicted instead a paddle-wheel steamboat. The print is colored almost entirely in black and gray, shades that impart a nocturnal ambience.

1. Kanagawa, *Yokohama ukiyo-e*, 471. See, for example, catalogue number 54.

67 America

cat. no. 67
Amerikakoku
Edo period, 1867:6
by Yoshitora (fl. ca. 1850–80)
publisher: Shimizuya Naojirō
woodblock print
ink and color on paper
ōban triptych: 37.4 × 75.4 cm
(14¾ × 29¹¹⁄₁₆ in.)

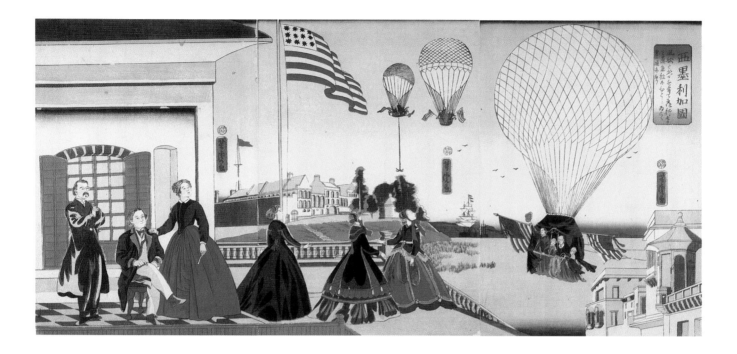

The text reads:

What they call the balloon is like a steamship that flies. It is the foremost conveyance of foreign nations.

In June 1860 two gas balloons displaying the flags of the United States, Japan, and Great Britain were launched from Philadelphia, to be flown from New York to celebrate the opening of Japan.[1] One of the balloons, called the *Constitution*, was illustrated in *Futayo gatari*, the diary published in 1861 of Katō Somō, one of the members of the Japanese embassy that witnessed the launch[2]; later Japanese prints of balloons, including this one, frequently depended on that illustration or one of its derivations. The architecture rendered here appears to be based not on pictures of America but of India, specifically buildings in Agra.[3] Japanese artists, confused about the localities of architecture portrayed in Western illustrations, often produced incongruous representations of foreign lands.

1. Miyoshi, *As We Saw Them*, 52.

2. Meech-Pekarik, *World of the Meiji Print*, 20–21.

3. Kanagawa, *Yokohama ukiyo-e*, 500. See also catalogue number 65.

68 Complete Enumeration of Scenic Places in Foreign Nations:[1] Port of London, England

cat. no. 68
Bankoku meisho zukushi no uchi:
Igirisu Rondon no kaikō
Edo period, 1862:[2]
by Yoshitora (fl. ca. 1850–80)
publisher: Yamadaya Shōjirō
woodblock print
ink and color on paper
ōban triptych: 36.5 × 73.9 cm
(14⅜ × 29⅛ in.)

Using methods of composite visualization typical of his prints of foreign nations he had not seen, Yoshitora combined elements from various sources to create his image of London. The domed building in the distance represents Saint Paul's Cathedral, the source of which was probably the masthead of the *Illustrated London News*. The river Thames, shown in the foreground, is spanned by a stone bridge on the left with large ships beyond; many of the near figures are based on other prints by Yoshitora. The building compound with large trees on the right derives from an illustration in *Warabe etoki bankoku banashi* (Tales of All Nations with Captions for Children), Yoshitora's collaborative work with author Kanagaki Robun (1829–1894).[2] Many principles of Western perspective drawing and light and shadow are employed in this picture, but the artist's inconsistency has produced a curious overall effect.

Robun's inscription is framed in the center of the print:

The great metropolis London in England is on the Thames River. The houses are [numerous] like the teeth of a comb, so the people are all very happy. Extending across the river is a great bridge. Its length is one hundred eighty *jō* and its width four *jō*.[3] In three places, lighthouses are provided, and at night lamps are lit for the convenience of the travelers. Also, on the riverbanks batteries are constructed, and on their tops, they are endowed with various places where trade takes place, and with souvenir merchandise merchants from the whole world trade. The merchant ships gather in the harbor where the surface of the water is like level land. The population of the metropolis is more than 1,050,000. The students in the large schools never go below tens of thousands daily. The native girls have exceedingly deep passion and the boys' character is exceptionally clever, but nevertheless, hoping to expand commerce, they construct large ships and cross the seas to the countries of the world; trading goods, they amass profits in the millions. The merchant fleet numbers 28,080 vessels. Officers on the ships number 180,000. The ships in the king's possession range from forty to one hundred twenty guns; it is said that there are more than eight hundred.

Translated by Kanagaki Robun, author of *Tales of All Nations*.

Yoshitora's picture complements Robun's text, which stresses British mercantile ambition and naval capacity, both commercial and military. In the busy foreground scene are military and civilian men and women walking and riding horses and carriages. The Western-style umbrella with its distinctive rounded framework is prominently featured. In the foreground of the right-hand print a man holds the standard of an American rather than a British flag.

1. In the Japanese title of this series (see also cat. no. 65) the Chinese character meaning barbarian is used for the first syllable of the compound *bankoku*, which is commonly written with a homophone meaning myriad. In its more common form the compound *bankoku* means all nations of the world.

2. Kanagawa, *Yokohama ukiyo-e*, 98.

3. One *jō* is 3.31 yards, or 3.03 meters. The dimensions of the bridge are thus 1787.4 by 39.96 feet.

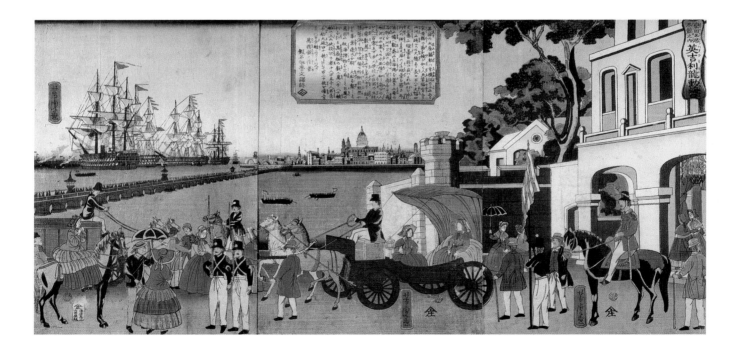

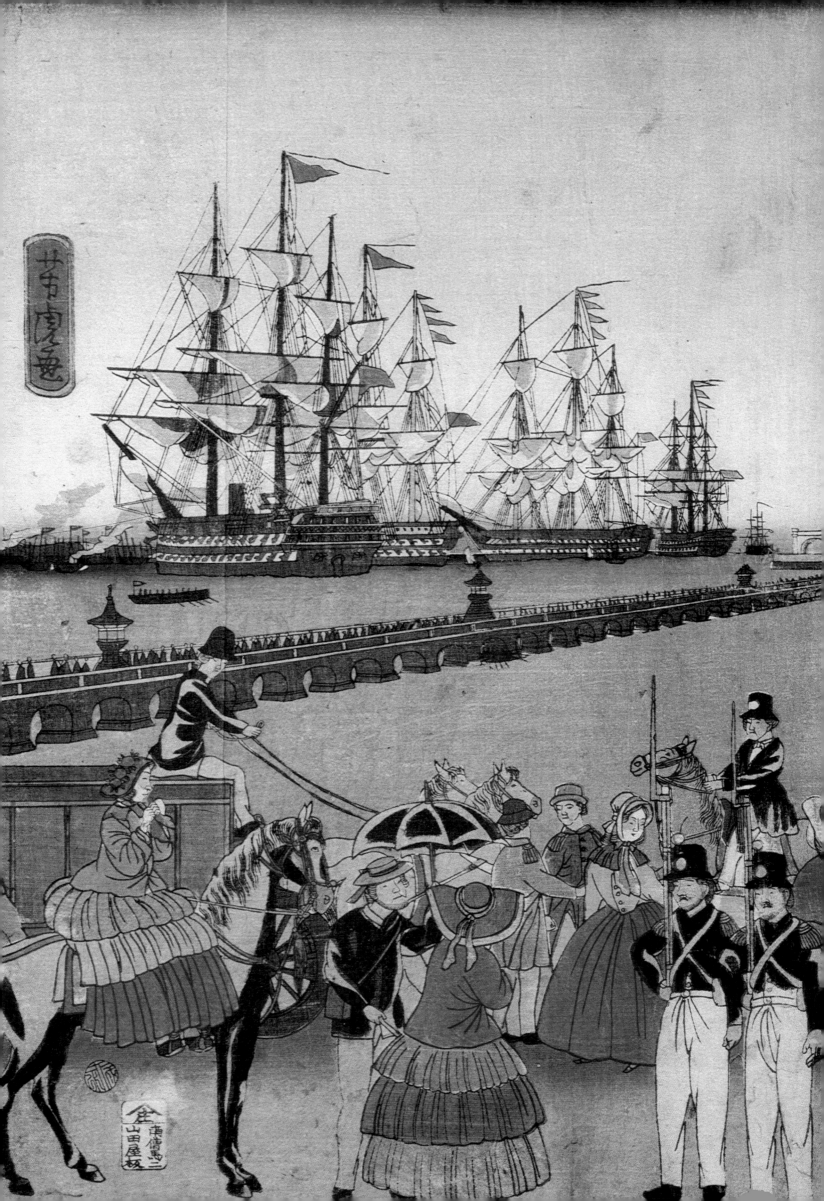

69 Picture of the Country of New Holland South Wales

cat. no. 69
*Shin Oranda Minami Waruresukoku
no zu*
Edo period, 1866:4
by Yoshitoshi (1839–1892)
publisher: Iseya Kisaburō
woodblock print
ink and color on paper
ōban triptych: 35.9 × 72 cm
(14⅛ × 28⁵⁄₁₆ in.)

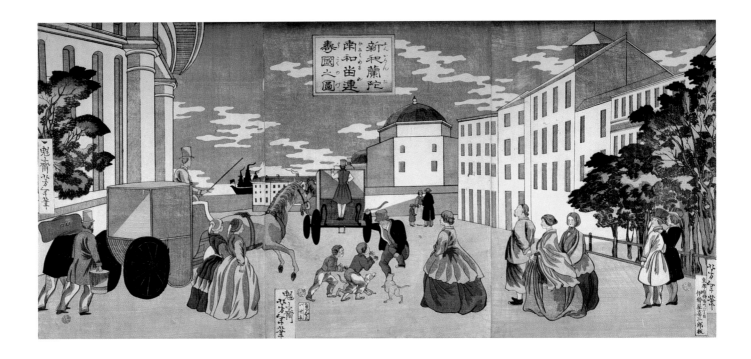

The title of this print probably refers to New South Wales, a province of Australia, which in the nineteenth century was scarcely known to the Japanese people. The insertion of the word "Oranda," or Holland, reflects confusion about geographic nomenclature. The extreme simplification of architectural motifs creates a strangely abstract setting for the figures in the roadway. The coaches lack doors and windows. Shadows depicted in the figures' garments and in the architecture reflect the artist's dependence on principles of Western art.

The linear patterns in the foliage of the trees reveal Yoshitoshi's familiarity with copperplate engraving, which was practiced by a few Japanese artists during the Edo period (1615–1868). The composition of the print appears to be based specifically on a European plaza illustrated in a Japanese copperplate engraving of 1809 by Aodō Denzen (1748–1822).[1] The triptych is thus linked less to the models for foreign scenes favored by Yoshitoshi's contemporaries than to works by an earlier generation of Japanese artists who had studied more thoroughly and successfully the principles, techniques, and subjects of European art.

1. French, *Through Closed Doors*, 158.

70 Picture of Trade with Many Nations in a Large French Port

cat. no. 70
Furansu ōminato shokoku kōeki no zu
Edo period, 1866:4
by Yoshitoshi (1839–1892)
publisher: Iseya Kisaburō
woodblock print
ink and color on paper
ōban triptych: 35.9 × 72 cm
(14⅛ × 28⁵⁄₁₆ in.)

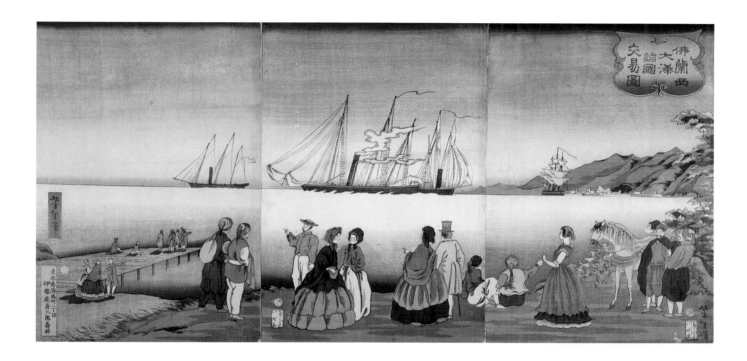

Harmonious and carefully executed coloring and delicate draftsmanship distinguish this composition by Yoshitoshi. In keeping with the foreign theme, even the title is enclosed in an appropriately ornamental frame with the characters symmetrically disposed. The figures in the foreground wear a variety of costumes, some of which are similar to those in other Yokohama prints while others appear to be based on European dress of an earlier date. Large steamships, one billowing trails of smoke, float lightly on the horizon line. Unlike the imposing ships of early Yokohama prints, these seem elegant and graceful.

The composition of the print, with the pier jutting into the bay at the left and Western figures on the shoreline looking toward the ships in the harbor, echoes that of many Yokohama prints. Yoshitoshi's successful assimilation of principles of Western art has produced, however, a dreamlike vision expressed in a visual language borrowed from the West.

71 The United States of North America

cat. no. 71
Kita Amerika Gasshūkoku
Edo period, 1861:10
by Yoshikazu (fl. ca. 1850–70)
publisher: Izumiya Ichibei
woodblock print
ink and color on paper
ōban: 34.8 × 23.9 cm
(13¾ × 9⅜ in.)

A frame embellished with an American flag surrounds the title of this print. The text by Kanagaki Robun (1829–1894) celebrates America's wealth, power, and commercial and technological superiority:

The thirty-one states that are known as the republic of the United States, as the name North America makes clear, generally extends from the extreme north to "Ukadan"[1] in the south. Although the United States are one part of America, its land is extensive and its population large. Because of its supreme prosperity and strength, it is now simply called North America. In recent years, the country has grown still more, and it administers nearby countries as territorial allies. The increase in productivity is immeasurable. The people are patriotic and, moreover, quite clever. In the world, they are foremost in science, armaments, and commerce. The women are elegant and beautiful.

Recorded by Kanagaki Robun.

Yoshikazu's print illustrates a man holding a pocket watch gazed upon by a woman operating a sewing machine; an iron rests on the table nearby. Representing the advanced technology of the United States in the mid-nineteenth century, the sewing machine had first appeared in a print by Yoshikazu published late in 1860; he rendered the earlier print after a newspaper illustration documenting the visit that year by the Japanese ambassadors to the United States, specifically to the sewing and laundry rooms of the Willard's Hotel (now the Willard Inter-Continental) in Washington, D.C.[2] The sewing machine, having been developed by American inventors Walter Hunt (1796–1859),[3] Elias Howe (1819–1867), and Isaac Merritt Singer (1811–1875), was an especially appropriate emblem of American technological innovation.

1. Lee Bruschke-Johnson has suggested that Robun may be referring to the Yucatan.

2. Meech-Pekarik, *World of the Meiji Print*, 18.

3. Robert Bruce Davies, *Peacefully Working to Conquer the World: Singer Sewing Machines in Foreign Markets, 1854–1920* (New York: Ariso Press, 1976), 3.

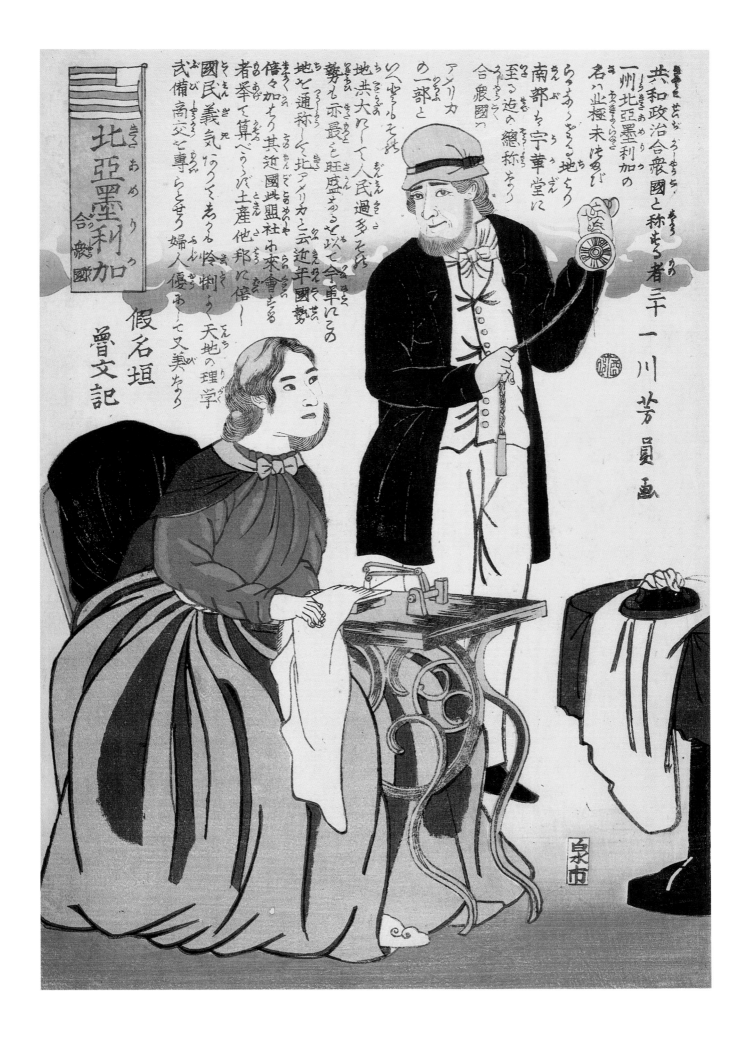

72 Untitled (Ben Franklin)

cat. no. 72
Meiji period (1868–1912)
anonymous; publisher unknown
woodblock print
ink and color on paper
ōban: 36 × 24 cm (14¹³⁄₁₆ × 9⁷⁄₁₆ in.)

During the early Meiji period several series of educational prints were published, some apparently under the supervision of the Mombushō, or Ministry of Education. A group of anonymous prints in the Leonhart collection (cat. nos. 72–75) relates in simple texts and illustrations educational anecdotes of Western scientists and inventors. The text of this print reads:

A North American man named Franklin on a summer day, expecting a sudden shower, released a paper kite attached to a pointed silver tube and put a bell on an iron pole on his roof so he could verify the electricity in lightning. This is the origin of the lightning rod. The telegraph and other such devices that are now prevalent all come from this. The iron pole is three *jō*[1] and at the top the point must be encased with silver and painted from the silver top to the wire chain to prevent rust.

The simple illustration shows a man and woman in a house, holding their hands over their ears against the thunder. A lightning rod, grounded by its chain to a water trough, attracts lightning from a dark cloud. The story describes the experiment designed by Benjamin Franklin (1706–1790) that ascertained the presence of electricity in lightning.

1. One *jō* is 3.31 yards, or 3.03 meters, making the iron pole about thirty feet.

73 Untitled (James Watt)

cat. no. 73
Meiji period (1868–1912)
anonymous; publisher unknown
woodblock print
ink and color on paper
ōban: 36 × 25.8 cm (14³⁄₁₆ × 10⁵⁄₃₂ in.)

The text reads:

Watt of England, according to a legend about the invention of the steam engine, was collecting the water drop by drop from steam coming from an earthen teakettle, when his aunt scolded him because it was of no benefit and time-consuming. But finally he developed the engine, which displayed many merits.

In this illustration by an anonymous artist a man representing Scottish inventor James Watt (1736–1819) sits beside a fireplace holding a spoon near the spout of a teakettle that is set on a stove; the woman beside him represents the skeptical aunt. On the desk are a scale and book, symbolizing Watt's scientific interests. As interpreted in this popular Japanese print, the legend of Watt encourages perseverance while it illustrates the physical phenomenon of the condensation of steam. Watt's improved design for the steam engine, patented in 1769, included a separate condensing chamber.[1]

1. Judith S. Levy and Agnes Greenhall, eds., *The Concise Columbia Encyclopedia* (New York: Avon Books, 1983), 909.

74 Untitled (James Audubon)

cat. no. 74
Meiji period (1868–1912)
anonymous; publisher unknown
woodblock print
ink and color on paper
ōban: 36.2 × 24 cm (14¼ × 9⁷⁄₁₆ in.)

A story about John James Audubon (1785–1851), whose paintings of birds were published in *The Birds of America* (1827–38), is illustrated in this print. The text reads:

Once, the famous American ornithologist, Audubon, in order to travel, placed his sketches, which he had made after several years of reflection, in a box, which he entrusted to a relative. Some months later, when he returned home and opened his box, [he discovered that] a rat had nested in it, and his drawings were entirely chewed to bits. Audubon, seeing this, was heartbroken. After many days, in complete rapture, like unrequited love, as he had formerly done, with a small gun in hand, carrying his notebook and pencil, he went into the woods to catch birds and draw them. In less than three years the pictures again filled his box and they were even finer than he remembered from before.

The anonymous Japanese artist has elected to depict the moment when Audubon discovered that his work had been destroyed by a rat. As in the previous print (cat. no. 73), the virtue of perseverance in pursuit of learning is extolled.

75 Untitled (Titian)

cat. no. 75
Meiji period (1868–1912)
anonymous; publisher unknown
woodblock print
ink and color on paper
ōban: 37.3 × 25.3 cm
(14¹¹⁄₁₆ × 9¹⁵⁄₁₆ in.)

The text reads:

Titian was a famous Italian painter. It is said that he persevered for many years, when he decided to make a difficult picture or an important subject, but his mind and hand were very skillful, so that later it became very easy. For other people, seeing his ease, few would understand his earlier difficulty. When a person would order a bust portrait that would be ready in ten days, when asked how much money it would cost, it would be one hundred *ryō*.[1] When [the patron] replied that it was extremely much for ten days of work, Titian said, "I have achieved [in this work] thirty years of learning in ten days."

1. A *ryō* was a unit of gold currency during the Edo period (1615–1868). The standard gold coin of the Tokugawa shogunate (1603–1867), the *koban*, was equal in value to one *ryō*.

ENLIGHTENMENT AND INTERNATIONALISM:
MEIJI JAPAN AND THE WORLD ABROAD

T HE RESIGNATION of the shogun in 1867 was followed in 1868 by the restoration of imperial rule, which brought to an end the system of civil government by the warrior class that had continued since the late twelfth century. Meiji (Enlightened Government) was the name assigned to the new era and its emperor. Edo, the seat of the Tokugawa shogunate, was renamed Tokyo (Eastern Capital) and shortly thereafter became the capital of Japan and the permanent home of the emperor; the emperor moved there from Kyoto, which had been the imperial capital since A.D. 794. The shift of the capital from Kyoto to Tokyo unequivocally transferred the cultural and political focus of Japan to Tokyo and reinforced the role of Yokohama as the point of direct contact with the West.[1]

The rule of the Emperor Meiji (1852–1912) from 1867 to 1912 encompassed a momentous period of restructuring for which the institutional and social models came from the West. Under the slogan "Civilization and Enlightenment" (*bunmei kaika*) the new government instituted a policy of modernization, and study of Western institutions, science, and technology.

The advancement of Japan following Western institutional and technological models, a process that acquired official support less than ten years after the opening of Yokohama, produced changes that attracted the enthusiastic attention of the publishers of popular prints. Just as the novelty of the new foreign settlement in Yokohama had stimulated a brief flurry of publication in the early 1860s, the rapid progress of Japan became a popular theme of the prints of the 1870s.

As the Japanese people were officially encouraged to assume Western dress, food, and technological innovations, the "foreign" became less alien. Foreigners themselves were no longer the focus of popular prints. Instead, prints of the 1870s reflect the ease with which the Japanese assimilated Western ways, particularly the various modes of transportation.

Wheeled vehicles, once limited to the ox-drawn carriages of the Kyoto aristocracy, were promptly embraced. Horse-drawn carriages imported from abroad and the jinrikisha, or ricksha, a Japanese invention, were adopted readily in Yokohama and Tokyo. They soon supplanted traditional vehicles such as the palanquin, in which the passenger rode in a basket or chamber suspended from a pole and carried by two or more men.

The jinrikisha (see fig. 32), a two-wheeled vehicle pulled by one or two men, swiftly displaced the less-efficient and less-comfortable palanquin. Production of the jinrikisha increased significantly from 1870, and the vehicle was in widespread use until the great Tokyo earthquake of 1923. Following the tradition of palanquins, jinrikisha embellished with gleaming black lacquer and ornamented with gold were employed as private vehicles by wealthy families. Its use also spread to China and Southeast Asia.

Japan's first railroad, completed in 1872, linked Yokohama, Japan's most important international port, with Tokyo. The new railway initially connected the stations at Sakuragichō in Yokohama with Shinagawa in the suburbs of Tokyo. Before the end of 1872 the line was extended to Shimbashi, a district in the heart of the new capital, for a total distance of 28 kilometers (17.4 miles). Built under

Figure 32 A jinrikisha. Photograph by Felice Beato (ca. 1825–ca. 1908). Yokohama Archives of History. Invented in Japan in 1870, the jinrikisha rapidly became an important vehicle in Japan and throughout Asia.

national sponsorship, the railway immediately established a uniform gauge for the tracks. Today's complex public and private system of Japanese rail transportation was thus spared from its inception the problems of incompatible gauges that had occurred in Europe and America, where the first railways had been built. The new railway made it possible to ride in one hour a distance that formerly required ten hours or so on foot.

Foreign experts headed by Edmund Morel, a British engineer, provided the technical design and supervision for the project. Under British oversight Japanese workers constructed and laid the tracks, but after the railway was completed British engineers initially operated the imported equipment. Ten locomotives, fifty-eight passenger cars, and seventy-five freight cars were imported from England.[2] An American architect, R. P. Bridgens, designed the station buildings.

Upon its opening on 14 October 1872 the new railroad was briefly the focus of public attention comparable to that which had followed the opening of Yokohama, but the news now centered on a practical manifestation of foreign technology rather than on the foreigners themselves. A large number of prints depicting the Yokohama-Tokyo railway, some of them antedating the completion of the project, were published.[3] A few of such prints include schedules between terminal and local stops.

The rapid assimilation of Western technology was most apparent in Tokyo and Yokohama, where buildings designed by Western architects began to transform the appearance of the cities, and modern modes of transportation became well established within the first decade of the Meiji period (1868–1912). In daily habits, however, the choice of Western dress and diet was extremely selective. Japanese men cut their hair and wore hats but continued to wear Japanese dress and footwear; their preference to retain aspects of native dress, especially in private life, diminished significantly only after the Second World War. The military and police, on the other hand, wore Western-style uniforms long before West-

Figure 33 *Comparison of Beautiful Women in Western Coiffures,* 1887, by Chikanobu (1838–1912). Woodblock print triptych; ink and color on paper. Collection of William and Florence Leonhart. Japanese men and women of the upper classes adopted Western fashions during the Meiji period (1868–1912).

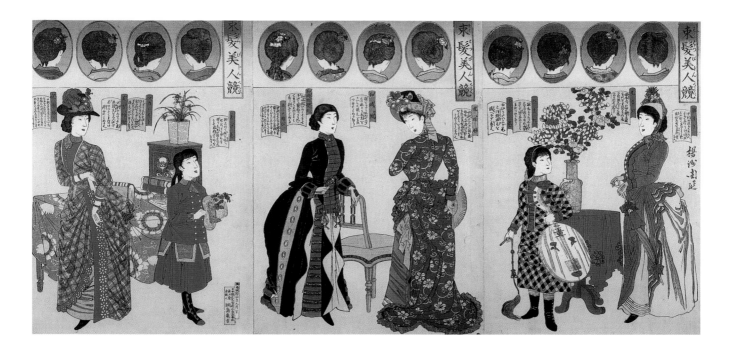

ern dress became widely accepted.

In assuming an increasingly visible role among the nations of the world, the emperor and his court assumed the trappings of European potentates. The Emperor Meiji, who had made his momentous journey from Kyoto to Tokyo in a palanquin in 1869, rode in an ornate first-class passenger car for the inaugural run of the Yokohama-Tokyo railway. A carriage, emblazoned with the chrysanthemum emblem of the imperial family and drawn by a team of horses, substituted for the majestic palanquin surmounted by a phoenix that had been the exclusive conveyance of the emperor since the Heian period (A.D. 794–1185). The Emperor Meiji often wore a Western-style military uniform for state visits of foreign dignitaries, while the empress would appear in a floor-length Western gown. Following her example, upper-class Japanese women wore fashionable Western dresses for special occasions.

One consequence of the rapid metamorphosis of Japan during the Meiji period was its gradually increasing role in international relations. Perception of the world beyond Japan expanded as talented young Japanese men and eventually women traveled abroad to study in foreign universities. During the Meiji period, Japan established its place among the technologically advanced nations of the world and began to define its position in relation to other nations both near and distant.

1. H. D. Smith II, "Edo-Tokyo Transition," in Jansen and Rozman, eds., *Japan in Transition,* 354, writes, "The port served as the major gateway for foreign influence in early Meiji Japan, generating intense public interest in Western customs and establishing Tokyo as the primary point of diffusion of Western culture to the rest of the country."

2. Kanagawa, *Yokohama ukiyo-e,* 514.

3. A print dated 1870 by Kuniteru II (1830–1874; artist of cat. nos. 16 and 77) depicts the imagined appearance of a train passing beneath a bridge at Takanawa in Tokyo (Meech-Pekarik, *World of the Meiji Print,* 85).

76 Enumeration of Vehicles in Transit in Tokyo

cat. no. 76
Tōkyō ōrai kuruma-zukushi
Meiji period, 1870:4
by Yoshitora (fl. ca. 1850–80)
publisher: Masadaya Heikichi
woodblock print
ink and color on paper
ōban triptych: 36.9 × 75.8 cm
(14½ × 29¹³⁄₁₆ in.)

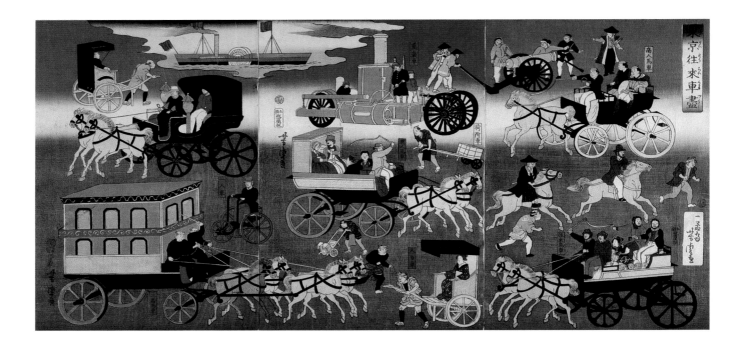

In this triptych of 1870, the artist Yoshitora has created a composite image of a variety of conveyances for goods and passengers, both Japanese and foreign. In the distance, in a gap in the clouds, is a steamship floating in the bay. Some of the vehicles, such as the "steam locomotive" in the upper center and the "horse and buggy for foreigners" below, are labeled. An early version of the jinrikisha, an upright chair with a canopy overhead, is shown at the upper left and at the bottom of the center panel. The peculiar vehicle having a cabin and team of four horses may be based on Western illustrations. The drivers in Japanese dress look strangely incongruous. Interspersed among the modern vehicles are a few Japanese push-and-pull old-fashioned wooden carts.

Rather than document Tokyo in 1870, Yoshitora's print celebrates the changes that were transforming Japan. The imaginative pastiche derives from a number of sources, probably incorporating the artist's observations as well as his interpretations from newspaper illustrations of vehicles he had not yet seen. Yoshitora nevertheless succeeds in capturing the spirit of enthusiasm for modern inventions that overtook Japan early in the Meiji period (1868–1912).

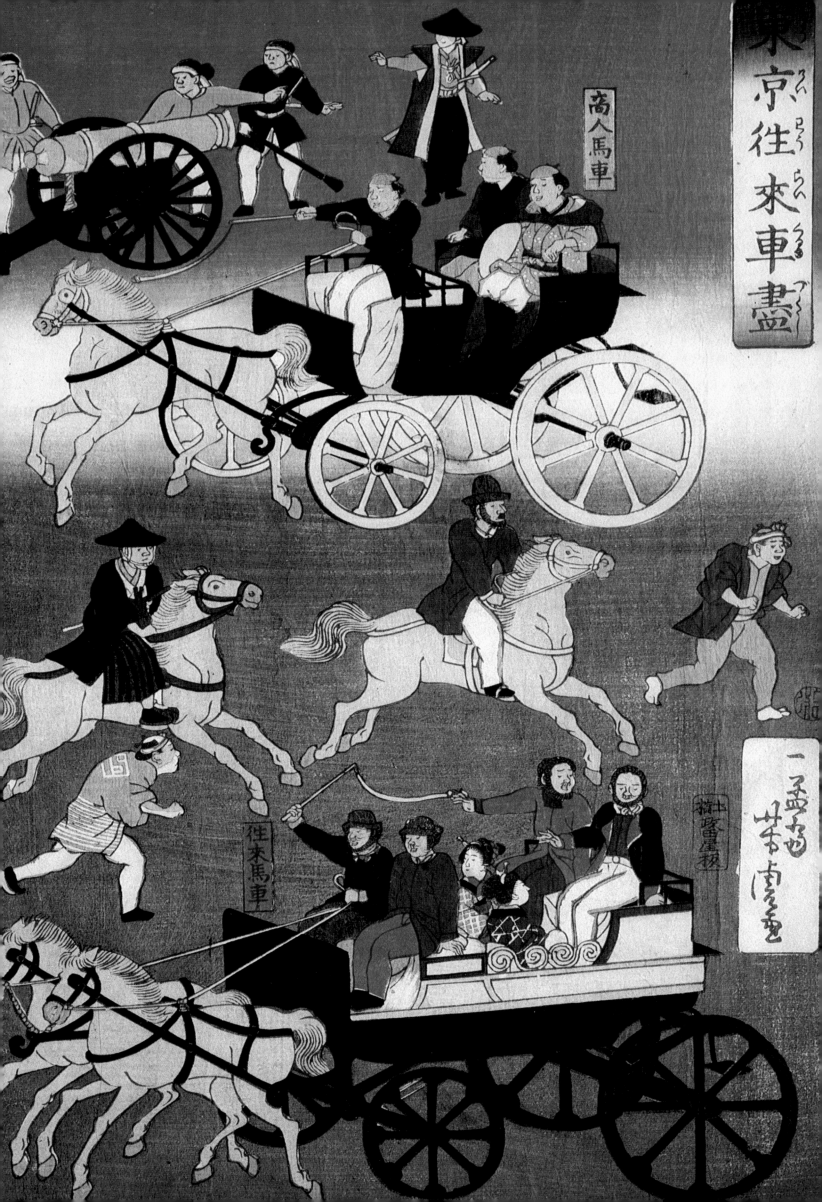

77 The Seaside Garden of the Tsukiji Hotel in the Eastern Capital

cat. no. 77
*Tōto Tsukiji Hoterukan kaigan teizen
no zu*
Meiji period, 1868
by Kuniteru II (1830–1874)
publisher: Sahaisho
woodblock print
ink and color on paper
ōban triptych: 36 × 72.9 cm
(14³⁄₁₆ × 18¹⁄₁₆ in.)

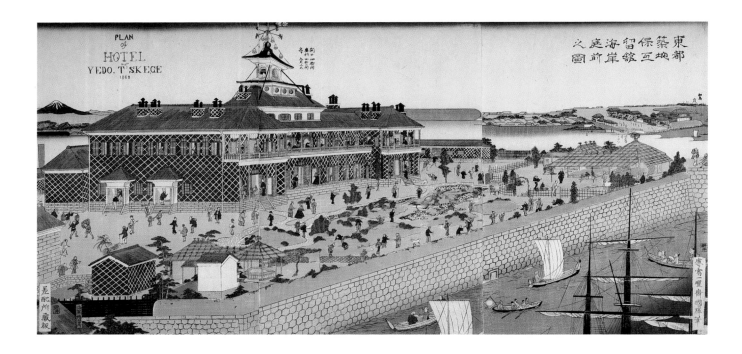

Tokyo's first Western-style hotel, the Tsukiji Hoterukan, opened in 1868. It was intended to provide comfortable lodging in a surrounding foreign settlement, which failed to flourish despite ambitious plans. The hotel itself was demolished by fire less than four years after its inauguration. Nevertheless, it represented the efforts of a Japanese master builder, Shimizu Kisuke II, to adapt Japanese building methods to some elements of Western architecture. One result of that incorporation was the hotel's central tower.

As in the "Western style" architecture of the foreign quarter of Yokohama as it was rebuilt after the devastating fire of 1866, many of the materials and techniques of traditional Japanese buildings remained unchanged. The ceramic roof tiling and outer walls, for ex-ample, are components of traditional Japanese structures that are retained in the hotel's design. The wall of masonry surrounding the hotel compound is built in Western style with an arched gateway.

78 Picture of the Steam Train from the Foreign Establishments of Yokohama

cat. no. 78
Yokohama ijinkan yori jōkisha tetsudō no zu
Meiji period, 1876
by Hiroshige III (1842–1894)
publisher: Maruya Tetsujirō
woodblock print
ink and color on paper
ōban triptych: 36.6 × 74.6 cm
(14 7/16 × 29 3/8 in.)

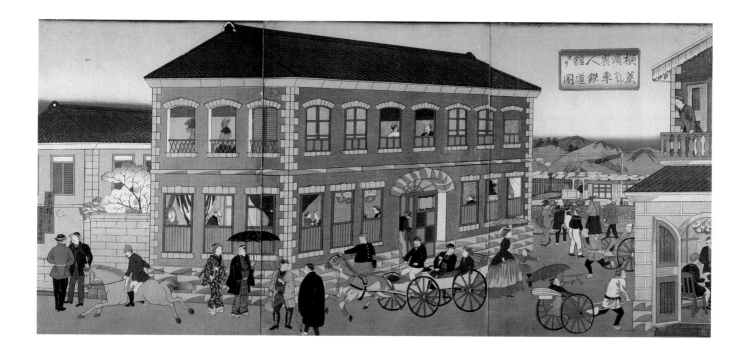

Hiroshige III's print provides a credible view of Yokohama in the 1870s. Just visible through the space between two buildings in the foreign settlement of Yokohama is the steam locomotive that linked Tokyo and Yokohama. Overhead are telegraph lines, which were installed in those cities in 1869; telephones were first brought to Japan in 1877, only one year after this print was published. The two-story buildings of Western merchants reflect the designs by Western architects who had first come to Japan in the 1860s; the tiled roofs, however, are Japanese in style.

Selective adoption of changing fashions alongside the persistence of tradition is apparent in the dress of the Japanese men. They wear, for the most part, Japanese garments, although their hair is cut short in the mode of the West.

A Japanese man in the foreground wears Western boots and trousers, together with a Japanese robe and jacket; another, dressed in kimono, carries a Western-style umbrella. Only the peasant with a bundle tied across his shoulders retains the traditional coiffure of the Edo period (1615–1867), that is, the hair worn long and tied in a knot with the top of the crown shaved.

The most modern style of all is demonstrated by the Japanese man who appears in the room at the lower right wearing eyeglasses and a Western vested suit as he makes a transaction with a Western merchant. The improved design of the jinrikisha can be seen in the vehicles pulled along the street, which keep pace with the horse-drawn carriage bearing a Western couple.

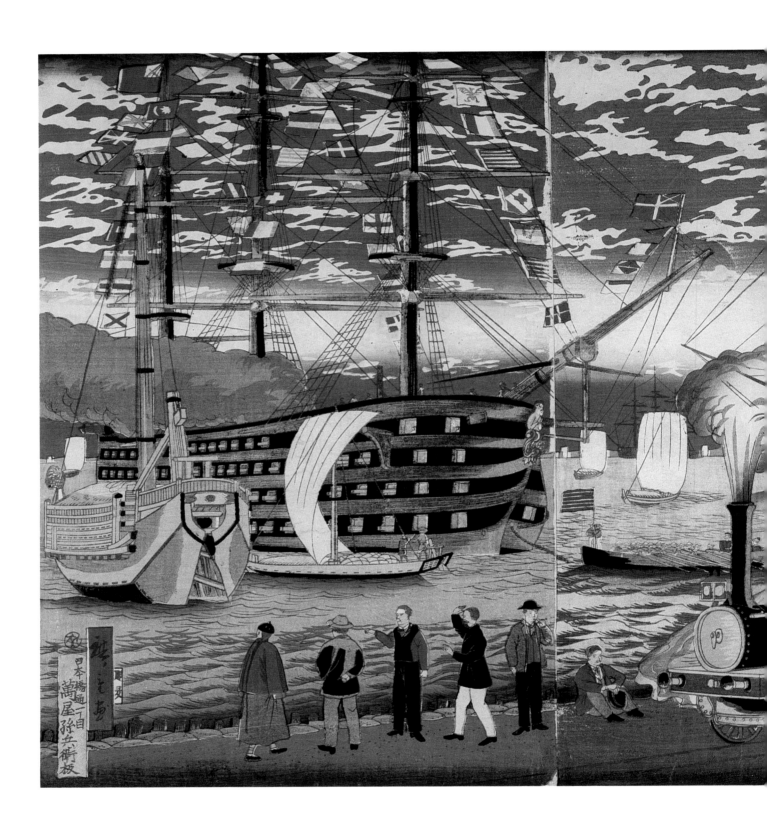

With its remarkable composition that recalls the grand harbor views of Yokohama prints of the early 1860s, this triptych print combines a commanding view of the bay with that of the new steam locomotive pulling passenger cars along tracks parallel to the shoreline. Steam from the locomotive trails toward the right, obscuring the sails of the ship in the distance. Foreign engineers operate the train, as was the practice for the first several years of service. Foreigners on the shoreline watch as the train speeds by; in the harbor, the square sails of small Japanese vessels are

cat. no. 79
Yokohama kaigan tetsudō jōkisha no zu
Meiji period, ca. 1874
by Hiroshige III (1842–1894)
publisher: Yorozuya Magobei
woodblock print
ink and color on paper
ōban triptych: 36.7 × 75 cm
(14 ⁷⁄₁₆ × 29½ in.)

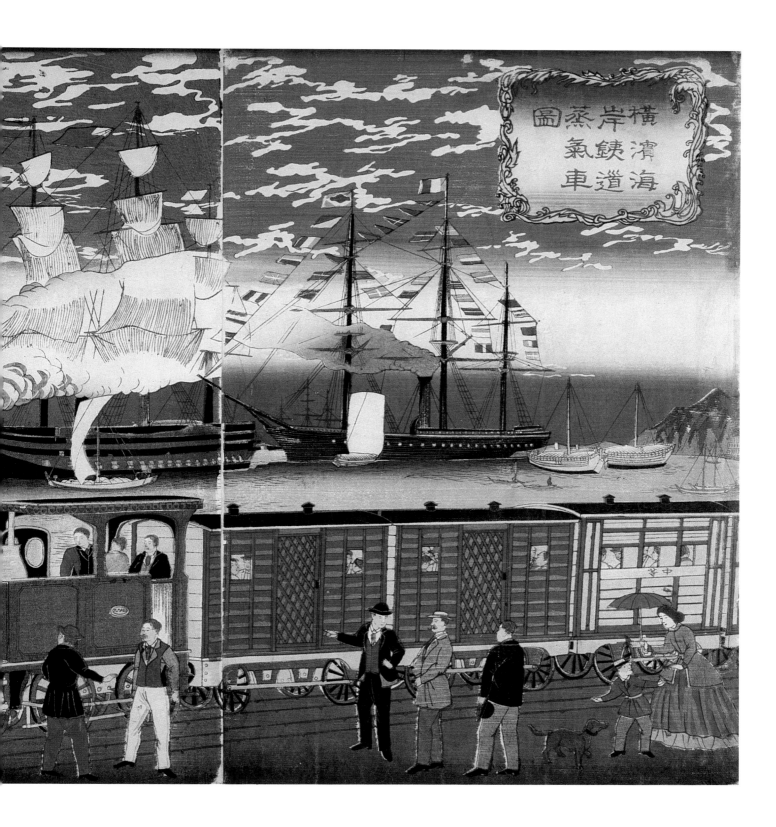

dwarfed by the huge Western
battleship in the foreground.

80 Railway Timetable

cat. no. 80
Tetsudō doku annai
Meiji period, 1872:9
by Yoshitora (fl. ca. 1850–80)
publisher: Iseya Kanekichi
woodblock print
ink and color on paper
ōban: 37 × 25 cm (14⁹⁄₁₆ × 9¹³⁄₁₆ in.)

A Japanese woman in this charming scene rides in a jinrikisha while a train rushes past in the middle distance. Two jinrikisha are parked beside the shore, awaiting passengers. The setting is the scenic harbor of Edo Bay as seen from Shinagawa, a town along the Tōkaidō where teahouses and beautifully appointed inns flourished during the Edo period (1615–1868).

Overhead, in the upper register, a timetable lists the hourly departures for trains going toward Yokohama at eight minutes after the hour; the lower register cites trains to Tokyo at forty-three minutes after the hour. The fares for first, second, and third class are written to the left: 56 sen, 35 sen, and 18 sen to Yokohama, and 93 sen, 62 sen, and 31 sen to Tokyo. Charges for freight are also provided. Train fares were relatively high compared to those for the ferry that covered the same route by water. Most passengers on the trains were Westerners with business in Yokohama.[1]

1. Edward Seidensticker, *Low City, High City: Tokyo from Edo to the Earthquake* (New York: Alfred A. Knopf, 1983), 48.

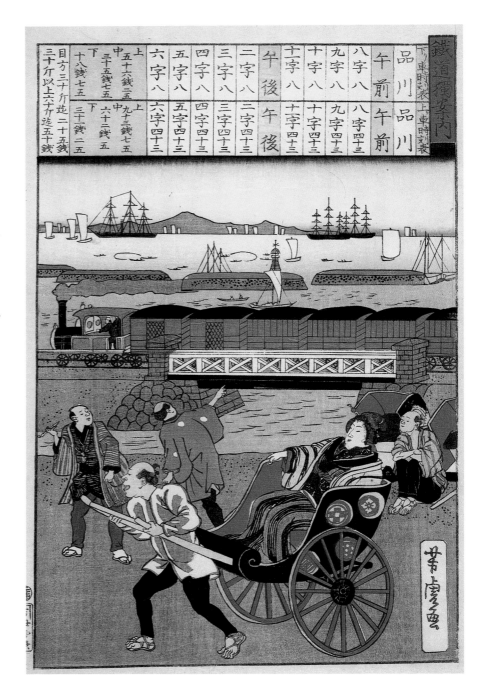

81 Famous Views of Metropolitan Tokyo: Shimbashi Station

cat. no. 81
Tōkyō fuka meisho zu: Shimbashi Suteishon
Meiji period, 1874
by Hiroshige III (1842–1894)
publisher: Tsujiokaya Kamekichi
woodblock print
ink and color on paper
ōban: 35.8 × 24.2 cm (14¹⁄₁₆ × 9½ in.)

Shimbashi Station became the urban terminal for the Yokohama-Tokyo railway line, and the Emperor Meiji himself rode the train to celebrate completion of the project. In this view of a locomotive approaching the station, the stone building designed by an American architect seems handsome and imposing, a symbol of Japan's modernity. In the foreground are telegraph lines, installment of which had begun in 1869.

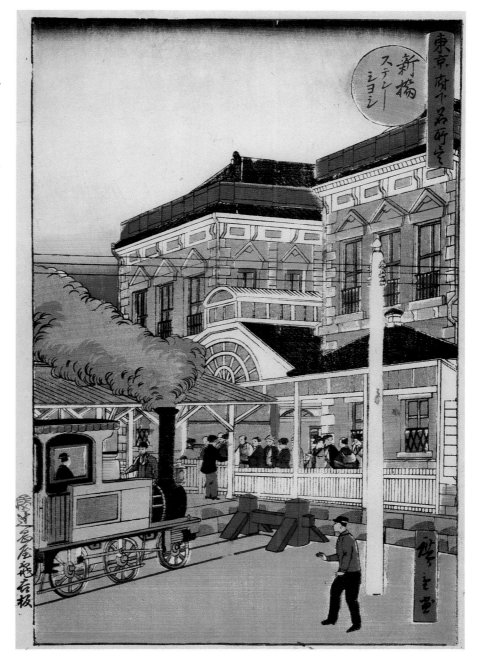

In the midst of a vast crowd of on-lookers, a manned balloon flying the Japanese flag pulls upward as men struggle with the anchoring ropes. The first Japanese to witness balloon flight had been the members of the Japanese embassy to the United States in 1860. A brief vogue for prints depicting balloons followed reports of the event.

Unlike those early prints, which were based on Western illustrations, Hiroshige III's dramatization of the balloon launch is conceived with convincing immediacy, as if he had actually witnessed such an event. The balloon lists sharply to one side as if blown by the wind, and men struggle to hold it steady. The crowd encompasses a variety of Japanese spectators, some dressed in fashionable Western suits and hats and others still wearing kimono and traditional hairstyles.

Artistic devices such as cropping the balloon at the top so that its size and upward motion is emphasized lend a visual dynamism to the scene. Hiroshige III's method of delineating the crowd in great detail in the foreground but with only a few abbreviated strokes in the distance is a convention continued from the Edo period (1615–1868). Mount Fuji, a familiar image in many Japanese prints, is just visible on the horizon, framed not by nature but by a wonder of modern technology.

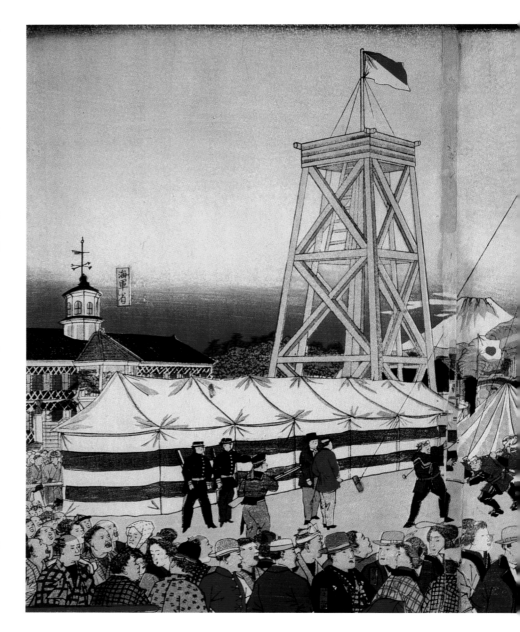

cat. no. 82
Tsukiji Kaigunshō Sōrenjō ni oite fūsen otameshi no zu
Meiji period, 23 May 1877
by Hiroshige III (1842–1894)
publisher: Tsuda Genshichi
woodblock print
ink and color on paper
ōban triptych: 37 × 74.3 cm
(14⁹⁄₁₆ × 29¼ in.)

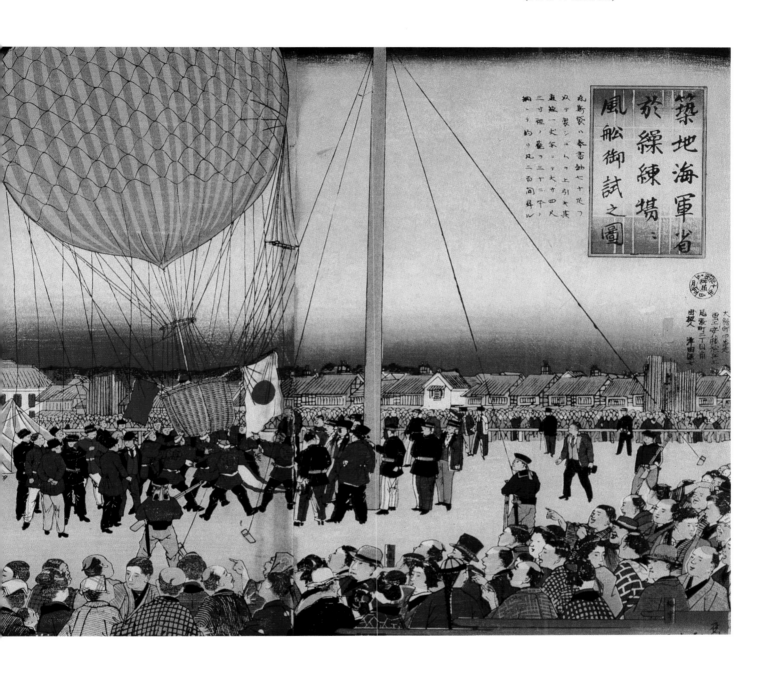

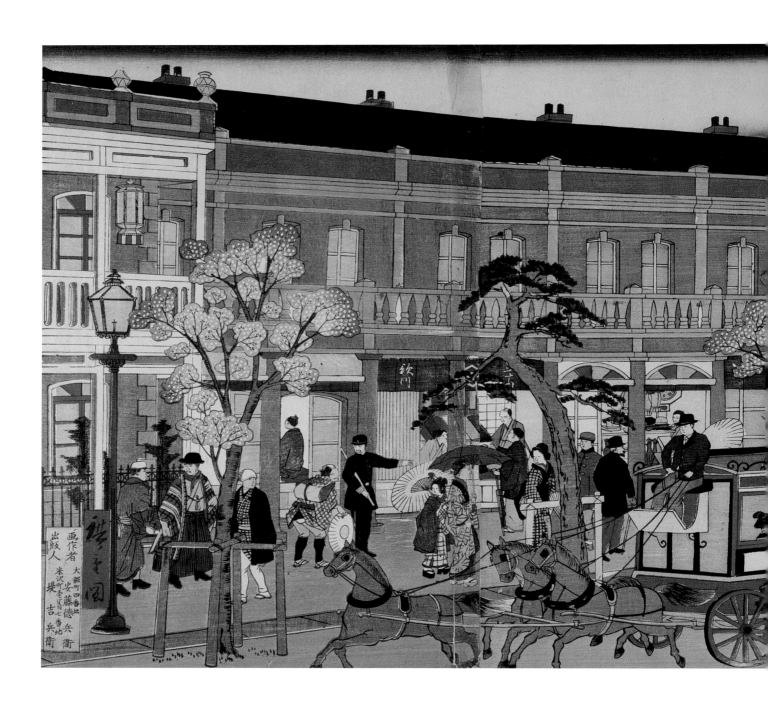

cat. no. 83
*Tōkyō meisho Ginzadōri renga
ishizukuri shōka no zu*
Meiji period, 20 October 1876
by Hiroshige III (1842–1894)
publisher: Tsutsumi Kichibei
woodblock print
ink and color on paper
ōban triptych: 37.7 × 73.1 cm
(14¹³⁄₁₆ x 28¾ in.)

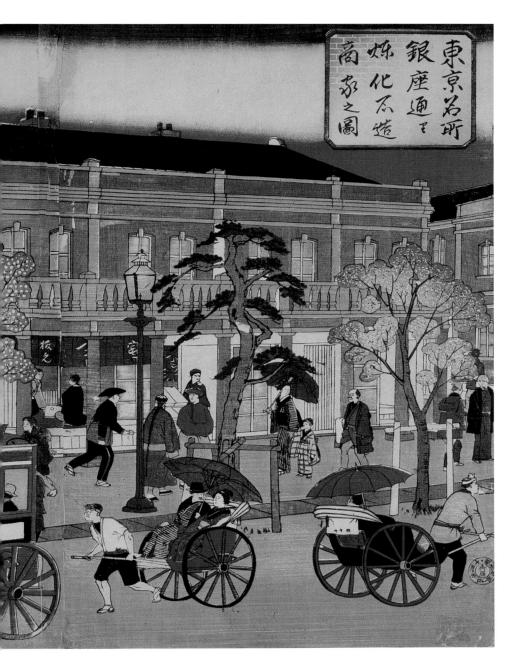

The Ginza commercial district suffered extensive destruction by fire in 1872. Thomas Waters, an English architect, was officially commissioned to rebuild the area in brick, with the hope that it would then be fireproof.[1] Although the effort to reconstruct in a completely Western style was not readily accepted by many Japanese, visits to Ginza became quite popular, as this image suggests.

Regularly spaced pine and cherry trees are shown growing along the roadway in Hiroshige III's triptych print from 1876; they would later be replaced by graceful willows.[2] Passing along the street are a passenger bus drawn by a team of horses and two jinrikisha. Strolling in front of the shops, which are hung with the traditional Japanese curtains bearing shop trademarks, are Japanese men and women wearing a variety of costumes, many of them combining elements of Japanese and Western dress. Behind the team of horses a Japanese woman dressed in kimono holds a Western-style umbrella, while a girl beside her carries the traditional Japanese umbrella of treated paper. At the far left, two men wear Japanese garments with Western shoes rather than native footwear, whereas the peasant carrying a parcel on his back wears completely indigenous clothing.

1. Seidensticker, *Low City, High City*, 58–59.

2. Ibid., 61.

Led by a spirited retinue of mounted officers, the carriage of the emperor approaches the entrance of the Imperial Diet (Teikoku Gikai), the legislative branch of the Japanese government that was established in 1890 on the basis of provisions in the Meiji Constitution of 1889. The Diet initially consisted of the elected House of Representatives (Shūgiin), housed in the left wing of the building, and the House of Peers (Kizokuin), in the right wing. In the left corner a crowd of common people watches as the procession passes by. The steep perspective, looking upward toward the grand new buildings, exaggerates the prominence of the figures in the promenade, while the common people seem diminutive in scale. According to a Japanese artistic convention, the size of figures denotes their importance rather than their relative position in space.

The extensive and profound changes that had occurred within Japan during the three decades since the opening of Yokohama are evident in Kunitoshi's print. Only twenty-three years after the resignation of the last shogun and the restoration of imperial rule, Japan had established a constitutional government and legislature. Western culture, associated with the enlightenment of modern Japan, had been studied and adopted in public architecture, dress, and modes of transportation. Even the emperor, who had been borne in a palanquin on his historic journey from Kyoto, the old imperial capital, to Tokyo, the capital of the new Japan, rode to the Diet in a horse-drawn carriage after the mode of a European monarch.

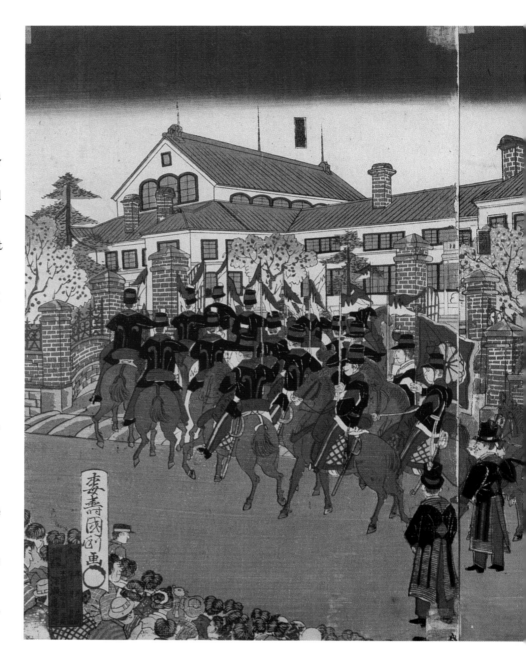

Nevertheless, the carriage is ornamented according to an ancient tradition, with a golden phoenix that since the Heian period (A.D. 794–1185) had marked the imperial palanquin.

cat. no. 84
*Tōkyō fuka Kōjimachi-ku Sawaishō
Kokkai Gijidō no kōkei*
Meiji period, 1890
by Kunitoshi (1847–1899)
publisher: Fukase Kamejirō
woodblock print
ink and color on paper
ōban triptych: 36.8 × 73 cm
(14½ × 28¾ in.)

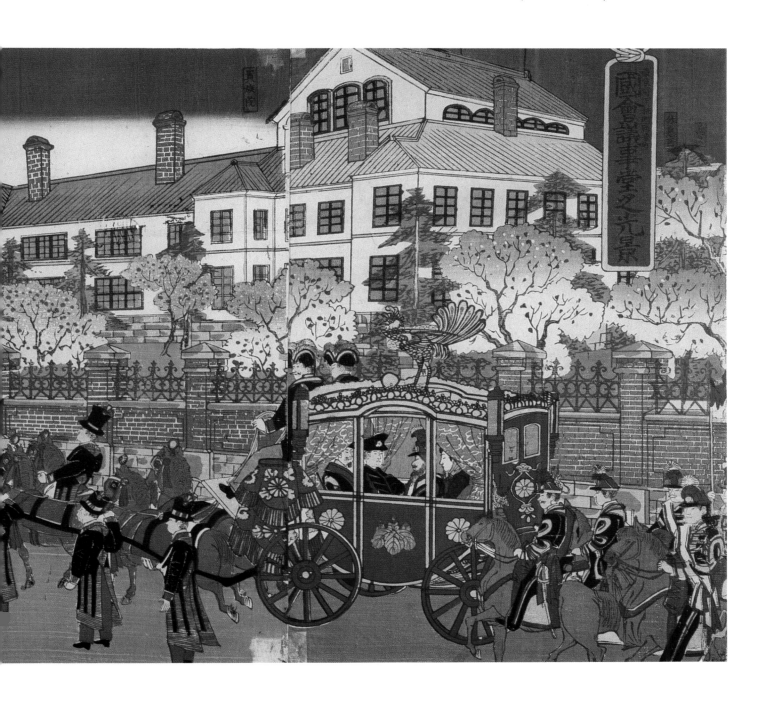

Each of eleven prints from an album of twelve depicts three different cities, labeled in English, in Chinese characters, and in phonetic Japanese. The prints, which portray countries in Asia, Europe, North and South America, Africa, and Australia, indicated by symbols, reflect the transformation since the 1860s of the Japanese view of their place in the world by the time Tankei's album was published. Japan, represented by the modern cities of Yokohama and Tokyo, claims itself a peer among the nations of the world.

The twelfth print portrays Japanese officials reporting on conditions abroad upon their return to Japan. They are dressed in Western-style military uniforms and seated with formal dignity in chairs in a large, carpeted reception room. Less than thirty years since the first official visit by the Japanese to the United States, where the carpeted floors of American hotels had so impressed the young Japanese diplomats, Japan had become a modern, prosperous nation.

cat. no. 85
Bankoku meisho zue
Meiji period, 1887
by Tankei [Inoue Yasuji] (1864–1889)
publisher unknown
woodblock print
ink and color on paper
six prints from an album; each approx.
17.6 × 23.6 cm (6¹⁵⁄₁₆ × 9¼ in.)

BIBLIOGRAPHY

Adams, F. O. *Report on the Silk Districts of Japan.* London: Silk Supply Association, 1869.

Alcock, Sir Rutherford. *The Capital of the Tycoon: A Narrative of a Three Years' Residence in Japan.* 2 vols. London: Longman, Green, Longman, Roberts, & Green, 1863. Reprint. Saint Claire Shores, Mich.: Scholarly Press, n.d.

Banta, Melissa, and Susan Taylor. *A Timely Encounter: Nineteenth-Century Photographs of Japan.* Cambridge, Mass.: Peabody Museum Press; Wellesley, Mass.: Wellesley College Art Museum, 1988.

Barr, Pat. *The Coming of the Barbarians: A Story of Western Settlements in Japan, 1853–1870.* London: Penguin Books, 1967.

Beasley, W. G. *Great Britain and the Opening of Japan.* London: Luzac & Co., 1951.

———. *The Meiji Restoration.* Stanford: Stanford University Press, 1972.

Beauchamp, Edward R. *An American Teacher in Early Meiji Japan.* Asian Studies at Hawaii, no. 17. Honolulu: University Press of Hawaii, 1976.

Bird, Isabella L. *Unbeaten Tracks in Japan.* New York: G. P. Putnam's Sons, 1880. Reprint. London: John Murray (with Introduction by Pat Barr); Boston: Beacon Press, 1984.

Black, John R. *Young Japan: Yokohama and Yedo, 1858–1879.* London: Trubner & Co., 1880–81. Reprint. Tokyo, London, and New York: Oxford University Press, 1968.

Blum, Paul C., trans. "Father Mounicou's Bakumatsu Diary, 1856–64." *Transactions of the Asiatic Society of Japan* 13, 3d ser. (1976): 5–103.

Brooke, George M., Jr., ed. *John M. Brooke's Pacific Cruise and Japanese Adventure, 1858–1860.* Honolulu: University of Hawaii Press, 1986.

Centre for East Asian Cultural Studies. *The Meiji Japan through Contemporary Sources.* 3 vols. Tokyo: Centre for East Asian Cultural Studies, 1969–72.

Clement, Ernest W., ed. *Hildreth's "Japan As It Was and Is": A Handbook of Old Japan.* Introduction by William Elliot Griffis. London: Kegan Paul, Trench, Trubner & Co., 1907.

Cortazzi, Hugh. *Victorians in Japan: In and around the Treaty Ports.* London and Atlantic Highlands, N.J.: Athlone Press, 1987.

———, ed. *Mitford's Japan: The Memoirs and Recollections, 1866–1906, of Algernon Bertram Mitford, First Lord Redesdale.* London: Athlone Press, 1985.

D'Almeida, Anna. *A Lady's Visit to Manilla and Japan.* London: Hurst & Blackett, 1863.

Davies, Robert Bruce. *Peacefully Working to Conquer the World: Singer Sewing Machines in Foreign Markets, 1854–1920.* New York: Arno Press, 1976.

de Fonblanque, Edward Barrington. *Niphon and Pe-che-li; or, Two Years in Japan and Northern China.* 2d ed. London: Saunders Otley & Co., 1863.

Fortune, Robert. *Yedo and Peking: A Narrative of a Journey to the Capitals of Japan and China.* London: John Murray, 1863.

Fraser, Mary Crawford. *A Diplomat's Wife in Japan: Sketches at the Turn of the Century.* Ed. Hugh Cortazzi. New York and Tokyo: John Weatherhill, 1982.

Frei, Henry. "Japan Discovers Australia: The Emergence of Australia in the Japanese World-View, 1540's–1900." *Monumenta Nipponica* 39, no. 1 (Spring 1984): 55–81.

French, Cal. *Through Closed Doors: Western Influence on Japanese Art, 1639–1853.* Rochester, Mich.: Meadow Brook Art Gallery, Oakland University, 1977.

Fukuzawa Yukichi. *The Autobiography of Yukichi Fukuzawa.* Trans. Eiichi Kiyooka. New York and London: Columbia University Press, 1966.

Genshoku ukiyo-e dai hyakka jiten (Great encyclopedia of ukiyo-e in color). 11 vols. Tokyo: Daishukan shoten, 1982.

Griffis, William Elliot. *The Mikado's Empire.* New York: Harper & Brothers, 1876.

———. *Townsend Harris: First American Envoy in Japan.* Freeport, N.Y.: Books for Libraries Press, 1971. Reprint of 1895 edition.

Hauge, Victor, and Takako Hauge. *Folk Traditions in Japanese Art.* Tokyo, New York, and San Francisco: Kodansha International; Washington, D.C.: International Exhibitions Foundation and the Japan Foundation, 1978.

Hawks, Francis L. *Narrative of the Expedition of an American Squadron to the China Seas and Japan Performed in the Years 1852, 1853, and 1854 under the Command of Commodore M. C. Perry, United States Navy.* New York: D. Appleton & Company, 1856.

Heusken, Henry. *Japan Journal, 1855–1861.* Trans. and ed. Jeannette C. van der Corput and Robert A. Wilson. New Brunswick, N.J.: Rutgers University Press, 1964.

Ishii, Takashi. *Bakumatsu bōekishi no kenkyū* (Study of the history of trade at the end of the Tokugawa shogunate). Tokyo: Nihon Hyōronsha, 1944.

Jansen, Marius B., and Gilbert Rozman. *Japan in Transition from Tokugawa to Meiji.* Princeton: Princeton University Press, 1986.

Kanagawa Kenritsu Hakubutsukan (Kanagawa Prefectural Museum). *Shūtaisei Yokohama ukiyo-e* (Compilation of Yokohama prints). Yokohama: Yūrindō, 1979.

Kanagawa Prefectural Museum. *International Exchange Exhibition: Japan and the West in Japanese Prints.* Japan: Kanagawa Prefecture Exchange Executive Committee, 1982.

Kodansha Encyclopedia of Japan. 9 vols. Tokyo and New York: Kodansha and Kodansha International/USA, 1983.

La Farge, John. *An Artist's Letters from Japan.* London: Waterstone & Co.; New York: Hippocrene Books, 1986. Reprint of 1897 edition.

Lensen, George Alexander. *The Russian Push toward Japan: Russo-Japanese Relations, 1697–1875.* New York: Octagon Books, 1971.

Levy, Judith S., and Agnes Greenhall, eds. *The Concise Columbia Encyclopedia.* New York: Avon Books, 1983.

McMaster, John. "The Japanese Gold Rush of 1859." *Journal of Asian Studies* 19, no. 3 (1960): 273–87.

Markus, Andrew L. "The Carnival of Edo: *Misemono* Spectacles from Contemporary Accounts." *Harvard Journal of Asiatic Studies* 45, no. 1 (1985): 499–541.

Meech-Pekarik, Julia. *The World of the Meiji Print: Impressions of a New Civilization.* New York and Tokyo: John Weatherhill, 1986.

Mendenhall, Thomas C., III. *An American Scientist in Early Meiji Japan: The Autobiographical Notes of Thomas C. Mendenhall.* Asian Studies at Hawaii, no. 35. Honolulu: University of Hawaii Press, 1989.

Miyoshi, Masao. *As We Saw Them: The First Japanese Embassy to the United States (1860).* Berkeley, Los Angeles, and London: University of California Press, 1979.

Mody, N. H. N. *A Collection of Nagasaki Color Prints and Paintings Showing the Influence of Chinese and European Art on That of Japan.* 2 vols. London: Kegan Paul, Trench, Trubner & Co.; Kobe: J. L. Thompson and Co., 1939.

Nonogami Keiichi, ed. *Bunmei kaika nishiki-e shū* (Collection of color woodblock prints of civilization and enlightenment). Tokyo: Tarumi shobō, 1967.

Notehelfer, Fred G. "Before the Restoration: Francis Hall's Description of Bakumatsu Japan." *Zinbun: Memoirs of the Research Institute for Humanistic Studies, Kyoto University,* no. 21 (1986): 1–30.

———. "Visions of Early Yokohama: Francis Hall in Treaty Port Japan." *Asian Art* 3, no. 3 (Summer 1990): 9–35.

Oliphant, Laurence. *Narrative of the Earl of Elgin's Mission to China and Japan in the Years 1857, '58, '59.* 2 vols. Edinburgh and London: William Blackwood & Sons, 1859.

Paske-Smith, M. *Western Barbarians in Japan and Formosa in Tokugawa Days, 1603–1868.* Kobe: J. L. Thompson & Co., 1930.

Philadelphia Museum of Art. *Foreigners in Japan: Yokohama and Related Woodcuts.* Catalogue by Kneeland McNulty. Philadelphia: Philadelphia Museum of Art, 1972.

Preble, Rear Admiral George Henry. *The Opening of Japan: A Diary of Discovery in the Far East, 1853–1856.* Ed. Boleslaw Szczesniak. Norman: University of Oklahoma Press, 1962.

Sadahide, Gyokuransai. *Yokohama kaikō kembunshi* (Record of things seen and heard in the open port of Yokohama). Tokyo: Meicho kankōkai, 1967.

St. John, Captain H. C. *Wild Coasts of Nipon, with Chapters on Cruising after Pirates in Chinese Waters.* Edinburgh: David Douglas, 1880.

Sakamaki, Shunzo. "Japan and the United States, 1790–1853." *Transactions of the Asiatic Society of Japan* 18, 2d ser. (December 1939).

Sansom, George. *A History of Japan, 1615–1867.* Stanford: Stanford University Press, 1963.

———. *The Western World and Japan: A Study of the Interaction of European and Asiatic Cultures.* New York: Alfred A. Knopf, 1950.

Satow, Sir Ernest. *A Diplomat in Japan.* London: Seeley, Service & Co., 1921.

Seidensticker, Edward. *Low City, High City: Tokyo from Edo to the Earthquake.* New York: Alfred A. Knopf, 1983.

Shively, Donald H., ed. *Tradition and Modernization in Japanese Culture.* Princeton: Princeton University Press, 1971.

Smith, George, Bishop of Victoria (Hong Kong). *Ten Weeks in Japan.* London: Longman, Green, Longman, & Roberts, 1861.

Smith, Henry D., II. " World without Walls: Kuwagata Keisai's Panoramic Vision of Japan." In Gail Lee Bernstein and Haruhiro Fukui, eds., *Japan and the World: Essays on Japanese History and Politics in Honour of Ishida Takeshi.* London: Macmillan Press in association with St. Anthony's College, Oxford, 1988.

Smith, Henry D., II, and Amy G. Poster. *Hiroshige: One Hundred Famous Views of Edo.* New York: George Braziller and the Brooklyn Museum, 1986.

Smith, Thomas C. *Native Sources of Japanese Industrialization, 1750–1920.* Berkeley and Los Angeles: University of California Press, 1988.

Statler, Oliver. *Shimoda Story.* New York: Random House, 1969. Reprint. Honolulu: University of Hawaii Press, 1986.

Tamba, Tsuneo. *Yokohama ukiyo-e* (Reflection of the cultures of Yokohama in the days of the port opening). Tokyo: Asahi Shinbunsha, 1982.

Tanabe, Willa Jane. *First Impressions: Japanese Prints of Foreigners.* Honolulu: University of Hawaii Art Gallery, Department of Art, 1985.

Taylor, Bayard. *Japan in Our Day.* New York: Charles Scribner's Sons, 1892.

Tilley, Henry Arthur. *Japan, the Amoor, and the Pacific; with Notices of Other Places Comprised in a Voyage of Circumnavigation in the Imperial Russian Corvette "Rynda," in 1858–60.* London: Smith, Elder & Co., 1861.

Toby, Ronald P. "Carnival of the Aliens: Korean Embassies in Edo-Period Popular Art and Culture." *Monumenta Nipponica* 41, no. 4 (Winter 1986): 415–56.

Totman, Conrad. *The Collapse of the Tokugawa Bakufu, 1862–68.* Honolulu: University Press of Hawaii, 1980.

Westney, D. Eleanor. *Imitation and Innovation: The Transfer of Western Organizational Patterns to Meiji Japan.* Cambridge, Mass., and London: Harvard University Press, 1987.

Yokohama Kaikō Shiryōkan (Yokohama Archives of History). *F. Beato Bakumatsu Nihon shashinshū* (Collection of photographs of Bakumatsu Japan by F. Beatto). Yokohama: Yokohama Kaikō Shiryōkan, 1987.

CHRONOLOGY OF SELECTED WORLD EVENTS

A.D. 794–1868
Kyoto is the imperial capital of Japan

1542
Portuguese are the first Europeans to land in Japan; Portugal is officially excluded from Japan from 1639 until after 1868

1549
Saint Francis Xavier (1506–1552), Spanish Jesuit missionary, arrives in Japan

1603
Emperor of Japan names Tokugawa Ieyasu (1542–1616) as shogun

1603–1867
Tokugawa shogunate in Japan

1615–1868
Edo period in Japan

1635
Tokugawa shogunate institutes *sankin kōtai* (alternate attendance) system for daimyo

1639–1854
Japanese exclude all foreigners except the Dutch and Chinese

1641–1859
Dutch traders are confined to Deshima, an island in Nagasaki harbor

1644–1911
Qing dynasty in China

ca. 1746
Benjamin Franklin (1706–1790), American, begins experiments with electricity

1765
Japanese perfect techniques of multicolored woodblock printing

1769
James Watt (1736–1819) of Scotland patents improved design for the steam engine

1803
First panoramic view of Edo, by Kuwagata Keisai (1764–1824), is published

1827–38
The Birds of America by American John James Audubon (1785–1851) is published

1839
First Opium War between Great Britain and China begins

1842
Treaty of Nanking ends Opium War; China cedes Hong Kong to Great Britain and opens ports to foreign trade

Illustrated World begins weekly publication in London; is the first periodical to make extensive use of woodcuts and engravings for illustration

1844
U.S. and China sign treaty of peace, friendship, and commerce

Samuel Morse (1791–1872), American, sends the first telegraph message

1846
U.S. obtains right-of-way across the Isthmus of Panama

American inventor Elias Howe (1819–1867) patents a lockstitch sewing machine

U.S. Congress establishes the Smithsonian Institution with one thousand gold sovereigns ($.5 million) bequeathed by British chemist James Smithson (1765–1829)

1846–48
Mexican War between the U.S. and Mexico

1848
California is ceded by Mexico to the U.S.; California achieves statehood in 1850

1849–50
Zachary Taylor (1784–1850) serves as twelfth U.S. president

1850–53
Millard Fillmore (1800–1874) serves as thirteenth U.S. president

1851
Isaac Singer (1811–1875), American, patents a continuous-stitch sewing machine

1853
Commodore Matthew C. Perry (1794–1858), American, is sent to Japan by President Fillmore; U.S. fleet reaches Uraga in Edo Bay (modern Tokyo Bay)

1853–57
Franklin Pierce (1804–1869) serves as fourteenth U.S. president

1854
U.S. and Japan sign Treaty of Peace and Amity (Treaty of Kanagawa) at Kanagawa on 31 March

1855
Frank Leslie's Illustrated Newspaper (later *Leslie's Weekly)* begins publication in New York City

1856
Townsend Harris (1804–1878) arrives in Japan as first U.S. consul general to Japan; is U.S. minister resident, 1859–62

1857–61
James Buchanan (1791–1868) serves as fifteenth U.S. president

1858
U.S. and Japan sign Treaty of Amity and Commerce (Harris Treaty) on 29 July; similar treaties are negotiated between Japan and Great Britain, France, Russia, and the Netherlands (all five collectively known as the Ansei Treaties)

U.S. and China sign treaty of peace, friendship, and commerce

Treaty of Tientsin ends war between Great Britain and China; China opens additional ports to foreign trade

First successful transatlantic telegraph communication is made

1859
Yokohama—in lieu of Kanagawa, the site stipulated by the Ansei Treaties—opens to trade with the five treaty nations; Nagasaki is also opened

Sir Rutherford Alcock (1809–1897), first British consul general to Japan, arrives in June to oversee the opening of Kanagawa; the same year, he becomes British minister resident

China refuses admission of foreign diplomats to Peking

1860
Tokugawa shogunate sends the first Japanese embassy to the U.S. on the USS *Powhatan* and the *Kanrin Maru*

Ii Naosuke (1815–1860) is assassinated in Edo by samurai opposed to the shogunate's foreign policy

1861
Russia attempts unsuccessfully to take control of the Japanese islands of Tsushima

Transcontinental telegraph connects New York and San Francisco

1861–63
Prussia and the North German confederation negotiate a commercial treaty with Japan; first Prussian consulate in Japan is established in 1862;

Prussia's commercial treaty with Japan comes into force in 1863

1861–65
Abraham Lincoln (1809–1865) serves as sixteenth U.S. president
U.S. Civil War

1862
British merchant Charles Richardson is murdered near Yokohama; the crime is known as the Namamugi Incident
Sir Ernest Satow (1843–1929), British diplomat, arrives in Japan

1863
British naval attack (precipitated by Namamugi Incident of 1862) is made against Satsuma fleet in Kagoshima Bay
Chartered Mercantile Bank of India, London & China opens as Yokohama's first bank

1864
Allied expedition of British, Dutch, French, and U.S. warships bombard Chōshū forts at Shimonoseki

1865
First town council is formed in foreign settlement of Yokohama

1865–69
Andrew Johnson (1808–1875) serves as seventeenth U.S. president

1866
Japan signs tariff agreement with the U.S., Great Britain, France, and the Netherlands
On 16 November fire destroys one-third of Yokohama's Japanese town and one-fourth of its foreign settlement

1867
Tokugawa Yoshinobu (1837–1913; r. 1867) resigns as shogun; reign of the Emperor Meiji (1852–1912) begins
James Curtis Hepburn (1815–1911), American missionary, completes first Japanese-English dictionary
Paris international exposition displays Japanese art
U.S. buys Alaska from Russia

1868
Meiji Restoration returns Japanese government to direct rule by emperor; Edo (seat of Tokugawa shogunate) is renamed Tokyo (Eastern Capital)
Tsukiji Hoterukan opens as Japan's first Western-style hotel

1868–1912
Meiji period in Japan

1869–77
Ulysses S. Grant (1822–1885) serves as eighteenth U.S. president

1869
Emperor Meiji (1852–1912; r. 1867–1912) moves his residence from Kyoto to Tokyo, which replaces Kyoto as the imperial capital of Japan
Telegraph lines are installed between Tokyo and Yokohama
World's first transcontinental railroad line is completed in the U.S.

ca. 1870
Jinrikisha, a Japanese invention, is produced and in widespread use in Japan until 1923

1872
Japan establishes its Navy Ministry, and compulsory military service is introduced
Japan's first railroad, built to link Yokohama and Tokyo, opens on 14 October
First Japanese balloon is launched at Tsukiji
Ulysses S. Grant is reelected as U.S. president

1873
Japan adopts Gregorian calendar

1874
First exhibition of impressionist paintings is held in Paris

1875
Elihu Thomson (1853–1937), British-American, operates the world's first radio

1876
Alexander Graham Bell (1847–1922), Scottish-American educator and inventor, patents the telephone
Centennial Exposition is held in Philadelphia

1877
Japanese army suppresses Satsuma rebellion
Telephones are first used in Japan

1886
American painter John La Farge (1835–1910) arrives in Yokohama

1889
Meiji Constitution is enacted

1890
Imperial Diet (Teikoku Gikai), the legislative branch of the Japanese government, is established

1894–95
Sino-Japanese War

1899
Extraterritoriality in Japan ends with treaty with Great Britain

1904–05
Russo-Japanese War

1923
Great Kanto earthquake devastates Tokyo and surrounding region, including Yokohama

ARTISTS IN THE EXHIBITION

Artist	*Catalogue Number*
Anonymous	72–75
Hiroshige II (1826–1869)	2, 6, 15
Hiroshige III (1842–1894)	78, 79, 81–83
Kuniaki II (1835–1888)	26
Kunihisa (1832–1891)	30–32
Kuniteru II (1830–1874)	16, 77
Kunitoshi (1847–1899)	84
Sadahide (1807–ca. 1878)	1, 3–5, 8, 11, 13, 14, 21, 23, 27–29, 34, 46, 47, 49, 53
Tankei [Inoue Yasuji] (1864–1889)	85
Unsen (fl. ca. 1875)	12
Yoshifuji (1828–1887)	50
Yoshiiku (1833–1904)	9, 35, 44, 59
Yoshikazu (fl. ca. 1850–70)	7, 10, 17–20, 22, 24, 25, 36–38, 48, 51, 54, 57, 58, 60, 64, 66, 71
Yoshimori (1838–1884)	45
Yoshitora (fl. ca. 1850–80)	39–43, 52, 55, 56, 65, 67, 68, 76, 80
Yoshitoshi (1839–1892)	63, 69, 70
Yoshitoyo (1830–1866)	33, 61, 62

Typeset in Century Expanded
by Graphic Composition, Inc., Athens, Georgia
Printed on Warren's Cameo Dull
by Schneidereith & Sons, Baltimore, Maryland
Edited by Jane McAllister
Designed by Carol Beehler

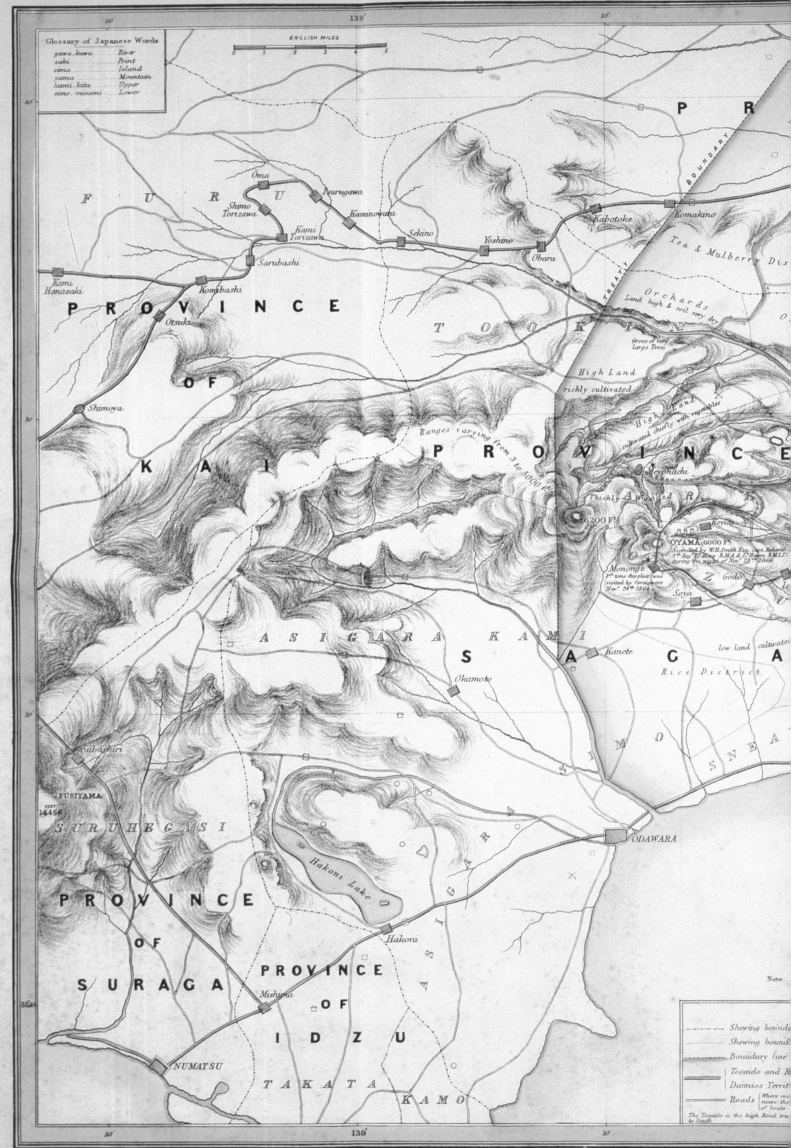

Glossary of Japanese Words
gawa, kawa — River
saki — Point
sima — Island
yama — Mountain
kami, kita — Upper
simo, minami — Lower

ENGLISH MILES
0 1 2 3 4 5

139°
50'
10'

F U R U

Ōma
Shimo Torizawa
Tsurugawa
Kaminowata
Kami Torizawa
Sarubashi
Sekino
Yoshino
Obara

Kabotoke
Komakino

P R

BOUNDARY

TREATY

Tea & Mulberry Dis

Orchards
Land high & soil very dry

Grove of very
large Trees

Kami Hanazaki
Komibashi

P R O V I N C E

Otsuka

O F

T O O K I N

High Land
richly cultivated

High Land
cultivated chiefly with vegetables

Shimoya

K A I P R O V I N C E

Ranges varying from 3 to 5000 ft

Meyonachi

Thickly Awooded R

6200 Ft

OYAMA 6000 Ft
Ascended by W.H.Smith Esq. Capt. Roberts
9th Regt R. King R.M.A & Lt Hawes R.M.L.I.
during the night of Nov. 29th 1866

Koyas

Mononge
2nd time this place was
visited by foreigners
Nov. 24th 1866

Godo

Soya

A S I G A R A K A M I

S A G A

Okamoto

Kanete

low land cultivated

Rice District

Suhashuri

SIMO

S U R U H E G A S I

FUSIYAMA
FEET
14456

Hakoni Lake

ODAWARA

A S I G A R

P R O V I N C E

O F

S U R A G A

P R O V I N C E

O F

I D Z U

Hakoni

Mishima

NUMATSU

T A K A T A K A M O

Note.

Shewing bound
Shewing bound
Boundary line
Tocaido and R
Daimios Territ
Roads
Where ro
rivers the
be boats
The Tocaido is the high Road tra
to South

Published by James Wyld.